DESIGN BASICS FOR APPAREL

VIRGINIA HENCKEN ELSASSER
JULIA RIDGWAY SHARP
CENTENARY COLLEGE, NEW JERSEY

DESIGN
BASICS FOR
APPAREL

PEARSON

Boston Columbus Indianapolis New York San Francisco Upper Saddle River
Amsterdam Cape Town Dubai London Madrid Milan Munich Paris Montreal Toronto
Delhi Mexico City São Paulo Sydney Hong Kong Seoul Singapore Taipei Tokyo

Editorial Director: Vernon R. Anthony
Acquisitions Editor: Sara Eilert
Editorial Assistant: Doug Greive
Director of Marketing: David Gesell
Executive Marketing Manager: Harper Coles
Senior Marketing Coordinator: Alicia Wozniak
Marketing Assistant: Les Roberts
Associate Managing Editor: Alexandrina Benedicto Wolf
Production Project Manager: Alicia Ritchey
Operations Specialist: Deidra Skahill

Art Director: Jayne Conte
Cover Art: TBD
AV Project Manager: Janet Portisch
Full-Service Project Management: Element Thomson North America
Composition: Element Thomson North America
Printer/Binder: Courier Kendallville, Inc.
Cover Printer: Lehigh Phoenix Color
Text Font: Helvetica Neue

Credits and acknowledgments borrowed from other sources and reproduced, with permission, in this textbook appear on the appropriate page within text.

Many of the designations by manufacturers and sellers to distinguish their products are claimed as trademarks. Where those designations appear in this book, and the publisher was aware of a trademark claim, the designations have been printed in initial caps or all caps.

Library of Congress Cataloging-in-Publication Data
Elsasser, Virginia Hencken.
 Design basics for apparel / Virginia Elsasser.—1st ed.
 p. cm.
 Includes index.
 ISBN 978-0-13-237528-3
 1. Fashion design—Textbooks. I. Title.
 TT507.E39 2013
 746.9'2—dc23
 2011038656

10 9 8 7 6 5 4 3 2 1

ISBN 10: 0-13-237528-1
ISBN 13: 978-0-13-237528-3

brief contents

Preface | xiii

CHAPTER 1: Introduction to the Aspects of Design 2

CHAPTER 2: Space 12

CHAPTER 3: Line 22

CHAPTER 4: Shape and Form 34

CHAPTER 5: Light 44

CHAPTER 6: Color 58

CHAPTER 7: Texture 82

CHAPTER 8: Repetition and Rhythm 98

CHAPTER 9: Contrast and Emphasis 108

CHAPTER 10: Balance 116

CHAPTER 11: Scale and Proportion 126

CHAPTER 12: Harmony, Variety, and Unity 136

CHAPTER 13: Individualism and Collection Development 146

GLOSSARY | 163
INDEX | 169

contents

Preface | xiii

Introduction to the Aspects of Design | 2

Introduction 4
Definition of Design 4
Traditional Versus Global Perspective of Design Principles 4
Introduction to Functional Design, Structural Design, and Decorative Design 6

Functional Design 6 • Structural Design 7 • Decorative Design 7

Design as Process and Product 8

Design as Process 8 • Design as Product 9

Creativity in Design 9
Evaluating the Success of a Design 10
Summary 11
Terminology 11
Activities 11

Space | 12

Introduction 14
Definition of Space 14
Variations of Space 15
Physical Effects of Space 15

Emotional Effects of Space 15
Application of Space in Apparel Design 15
Artistic Devices That Can be Used to Create Advancing and Receding Effects 16

Overlapping 16 • Nature of the Enclosing Line 16 • Difference in Sizes of Shapes 16 • Proximity of Shapes 17 • Filled Versus Empty Spaces 17

General Guidelines for the Application of Space in Apparel Design 17
Summary 20
Terminology 20
Activities 20

Line | 22

Introduction 24
Definition of Line 24
Types of Line 24
Characteristics of Line 25

Direction 25 • Length 26 • Thickness 27 • Contour 27 • Texture 28

Use of Lines in Apparel 29

Structural Lines 29 • Decorative Lines 29 • Controlling the Visual Effect of Lines 30

Summary 32
Terminology 32
Activities 32

4 Shape and Form | 34

Introduction 36
Definitions of Shape and Form 36
Relationship Between Shape and Form 36

Types of Shapes 37 • Classic Silhouettes in Apparel 38 • Types of Form 38

Physical Effects of Shape and Form 40
Emotional Effects of Shape and Form 40
Application of Shape and Form in Apparel Design 41

General Principles for Using Shape and Form in Apparel 41 • Combing Shapes and Form in Apparel 42

Summary 43
Terminology 43
Activities 43

5 Light | 44

Introduction to Light and Color 46
Definition of Light 46
The Perception of Light and Color 47

Light and the Eye 47 • Color Mixing 48

Sources of Light 51
Physical Effects of Light 52

Sharp and Diffuse Light 52 • Direction of Light 53 • Level of Illumination 53 • Light Intensity and Color Perception 54 • Color of Illumination 54 • Light and Surface Texture 54 • Light and Heat 55

Emotional Effects of Light 55
Application of Light in Apparel Design 55
Summary 57
Terminology 57
Activities 57

6 Color | 58

Introduction to The Concept of Color 60
Dimensions of Color 60

Hue 60 • Value 60 • Intensity 62 • Warm and Cool Colors 62

Color Theories 63

The Additive or Light Theory of Color 63 • The Subtractive or Pigment Theories of Color 63

Physiological Effects of Color and Their Use in Design 65
Physical Effects of Color and Their Use in Design 65

Effects Created by Contrasting Hues 65 • After-image 67 • Color Mixing 67 • Color and Apparent Size 68 • Color and Apparent Motion 68 • Effects Created by Contrasting Values and Intensities 69

Color, Temperature, and Moisture 69
 Emotional Effects of Color 70

Color and Culture 70 • Warm and Cool Colors 72 • Color and Moods 72 • Color and Gender 72 • Color, Age, and Sophistication 73 • Color and the Seasons 74

Application of Color in Apparel Design 74

Color Schemes 74 • Color Forecasting 74 • Personal Coloring and Clothing Design 77 • Colors for Special Occasions and Events 78 • The Effects of Color on the Figure 78

Summary 79
Terminology 79
Activities 80

Texture | 82

Introduction to Texture 84
Definition of Texture 84
Creation of Texture in Clothing 85

Fiber and Yarn Structure 85 • Fabric Structure 87 • Finishes 89 • Embellishments and Trim 89 • Appearance of Texture Created by Pattern 89 • Texture from Garment Structure 89

Physical Effects of Texture 90

Color 90 • Texture and Body Temperature 90 • Illusions of Body Size 90

Emotional Effects of Texture 90

The Application of Texture in Apparel Design 92

Texture and Garment Function 92 • Textures and Ease of Care 93 • Texture for Comfort 93 • The Effect of Texture on Drape and Fit 93 • Combining Textures 94 • Texture and Personal Attributes 94

Summary 95
Terminology 95
Activities 95

Repetition and Rhythm | 98

Introduction to Repetition and Rhythm 100
Repetition 100

The Effects and Application of Repetition in Apparel Design 101 • Parallelism 102 • Alternation 102 • Sequence 103 • Gradation 103• Radiation 104 • Concentricity 104

Rhythm 105

Definition of Rhythm 105 • Physical Effects of Rhythm 105 • Emotional Effects of Rhythm 105 • Application of Rhythm in Apparel Design 106

Summary 107
Terminology 107
Activities 107

 9 Contrast and Emphasis | 108

Introduction 110
Definitions of Emphasis and Contrast 110
Contrast 110

Physical Effects of Contrast 110 • Emotional
Effects of Contrast 110 • Use of Contrast in
Apparel 110

Emphasis 113

Physical Effects of Emphasis 113 •
Emotional Effects of Emphasis 113 • Use of
Emphasis in Apparel 113

Summary 115
Terminology 115
Activities 115

 10 Balance | 116

Introduction 118
Definitions of Balance 118
Types of Balance 118

Symmetrical Balance 118 • Asymmetrical
Balance 118 • Radial Balance 119

Physical Effects of Balance 121
Emotional Effects of Balance 122
Application of Balance in Apparel
Design 123

Space, Line, Shape, and Form 123 • Light
and Color 123 • Texture 124 • General
Guidelines for the Use of Balance 124

Summary 125
Terminology 125
Activities 125

 11 Scale and Proportion | 126

Introduction 128
Definitions of Scale and Proportion 128
Scale 128

Physical Effects of Scale 128 • Emotional
Effects of Scale 129 • Use of Scale in
Dress 130

Proportion 132

The Golden Mean 132 • Physical and
Emotional Efects of Proportion 133 • Use of
Proportion in Dress 133

Summary 135
Terminology 135
Activities 135

 12 Harmony, Variety, and Unity | 136

Introduction to Harmony, Variety, and
Unity 138
Harmony 138

Definitions of Harmony 138 • The Effects of
Harmony 138 • The Application of Harmony
in Dress 138

Variety 140

Definition of Variety 140 • The Effects of
Variety 141• Use of Variety in Dress 141

Unity 142

Definition of Unity 142 • Unity and the Gestalt
Theory 142 • The Effect of Unity 143 • Use
of Unity in Dress 143

Summary 145
Terminology 145
Activities 145

13 Individualism and Collection Development | 146

Introduction 148

Designing and Selecting Clothing for An Individual 148

Fashion and Social Expectations 148 • Price and Quality 149 • The Occasions for Which a Garment Will Be Worn 149 • Personal Attributes: Size, Body Shape, and Coloring 149 • Taste, Personality, and Individual Expression 150

Collections and Lines 151

Definition of Collection and Line 151 • The Overall Effect of a Collection or Line 152

The Stages in the Creation of a Collection 154

Determine the Target Market 155 • Research Trends 155 • Inspirations 157 • Execute the Plan 157 • Evaluate the Collection 159

Criteria for a Successful Collection 159
Summary 161
Terminology 161
Activities 161

GLOSSARY 163
INDEX 169

preface

Design Basics for Apparel is a handbook for students and professionals in the fashion industry who need a good understanding of visual design. It is a logical presentation of visual design as it is applied in the apparel industry. This book provides valuable information for both fashion design and merchandising students. The book covers the aspects of design in an easy to access format with examples and charts that explain the use and application of the aspects.

The book starts with an introductory chapter that discusses functional, structural, and decorative design; design as process and product; creativity; and evaluation of a design. Traditionally, the study of design includes examination of both elements (building blocks of design) and principles (manipulation of design elements to create an effect). This book presents a more global perspective of design. The elements and principles of design have been combined in the aspects of design. The reader is encouraged to consider design as a whole with emphasis on the emotional and physical effect of clothing. The aspects of design operate in conjunction with each other. Each aspect is a component of the whole design.

Chapters 2 to 12 present the basic aspects of design: space, line, shape and form, light, color, texture, repetition, emphasis and contrast, balance, scale and proportion, and unity and harmony. Each aspect is presented with numerous illustrations. Guidelines for the use of the aspects of design are included in each chapter. These guidelines should not be considered as rigid, unbreakable formulas–but as suggestions. Since fashion reflects the social, political, and economic circumstances of the time in which it exists, often designers deliberately break a rule in order to make a statement or express the current style. Highlights of Chapters 2 to 12 include: analysis of the physical and emotional effects of design concepts; presentation of techniques for creating effects and moods; and application of concepts to create desired effects.

The book concludes with Chapter 13 Individualism and Collection Development. This chapter discusses factors to consider when designing or selecting clothing. These factors include social expectations, price, quality, purpose, body style, and personal taste. Collection development differentiates between a collection and a line; and examines the effects of a collection, the creation of a collection, and a description of the criteria for a successful collection.

The pedagogical features of the book include:

1. Numerous illustrations and tables.
2. End-of-chapter review activities that will develop "an eye for design" and encourage thoughtful decision making, by guiding the reader through exercises and experimentation with the aspect covered in the chapter.
3. Terminology from each chapter compiled in a glossary of key terms.
4. Chapter summaries highlighting the main topics of the chapter

We encourage readers to become immersed in the study of visual design for apparel. For those in the apparel industry, the ability to apply the design aspects to apparel design and merchandising is essential. We have thoroughly enjoyed researching and writing this book. We hope both students and instructors will enjoy it as well. Design inspires the spirit in all of us.

Download Instructor Resources from the Instructor Resource Center

All instructor resources can be downloaded from the Pearson Instructor Resources website at www.pearsonhighered.com/irc.

MyInteriorDesignKit for Perspective and Sketching for Designers
MyInteriorDesignKit™

MyInteriorDesignKit is a resource site containing tutorial videos to accompany each lesson in the text as well as additional student and instructor resources. Students can purchase access to MyInteriorDesignKit directly at www.myinteriordesignkit.com with a credit card, or they can purchase an access card bundled with their textbook. To request this package ISBN, please visit www. pearsonhighered.com or contact your local Pearson Rep:

http://www.pearsonhighered.com/educator/replocator/. Students may also purchase an e-text upgrade directly through MyInteriorDesignKit.

Acknowledgements

First and foremost, we would like to thank our husbands, Cornelius Elsasser and Raymond Sharp. Their unwavering support and enthusiasm for this project encouraged us through the long hours spent in research, writing, and compiling illustrations.

We also greatly appreciate the guidance and support from the staff at Pearson: Sara Eilert, Doug Greive, and Alicia Ritchey and the reviewers: Sue Schroeder, University of Houston; Laura Chapuis, Wade College; Ann Paulins, Ohio University; and Marianne Bickle, University of South Carolina. Thank you also to Jessie Davis and Joseph Khawane for the use of some of their images in this book.

We owe much to our many current and former students, whose questions and comments shaped not only this book but also our perspective on the teaching and learning process. Their contributions are greatly appreciated.

Julia Ridgway Sharp
Virginia Hencken Elsasser

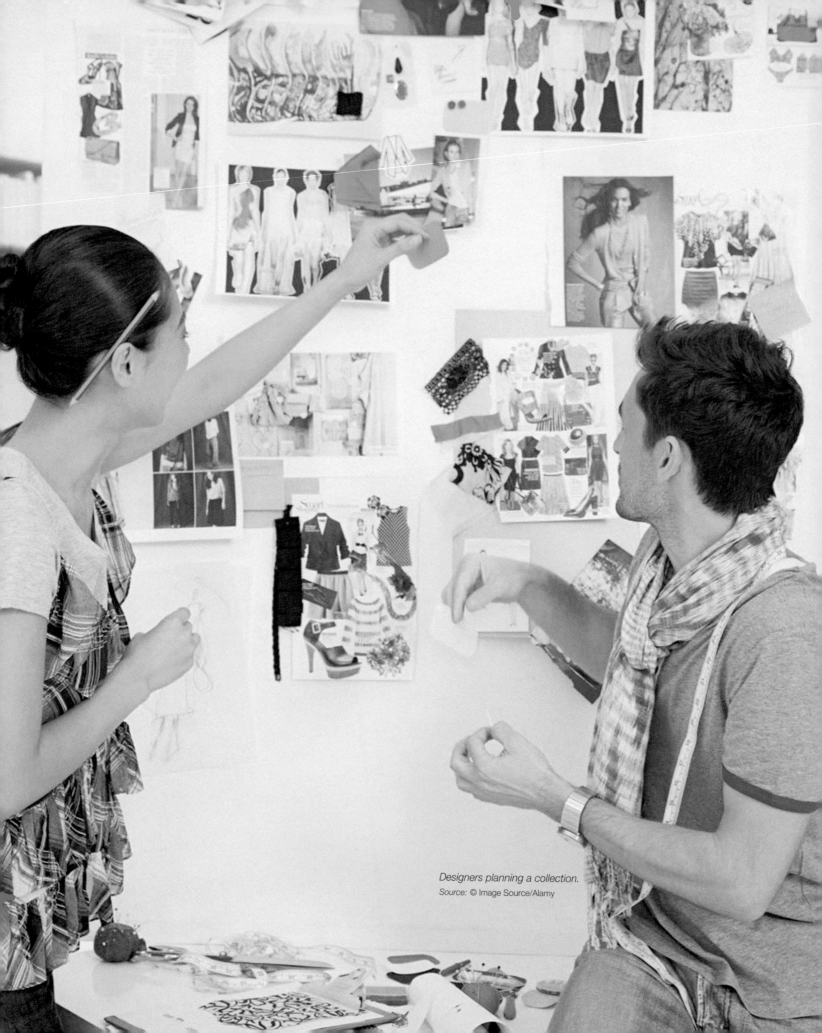

Designers planning a collection.
Source: © Image Source/Alamy

INTRODUCTION to the ASPECTS of DESIGN

After studying this chapter you should be able to:

1. Define design.
2. Discuss functional, structural, and decorative design.
3. Describe design as a process and a product.
4. Discuss the importance of creativity in fashion design.
5. Discuss the evaluation of successful designs.

1

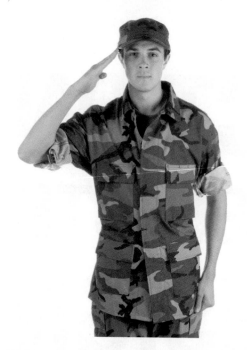

FIGURE 1.1 *Is this a photograph of soldier in camouflage, a hunter, or a very realistic Halloween costume?*
Source: Tad Denson/Shutterstock.com

Introduction

Designers, stylists, merchandisers, and individual consumers can manipulate the aspects of design to create a desired appearance. Anyone involved in the study of fashion will be able to use these aspects to appeal to a specified target market. There are an infinite variety of combinations of the aspects of design and the thoughtful application of these aspects can produce a desired effect.

Definition of Design

Design is the conscious creation of a visual experience. The purpose of design is to communicate. The expressive qualities of clothing represent the perspective of the designer and evoke a response in the viewer. For example, examine the image in Figure 1.1 to determine the message that is being sent. Consider the many different interpretations that the clothing may suggest. In apparel the visual experience is combined with a functional experience since apparel is created to be worn. Design that is both aesthetic and functional is often called **applied design**.

Traditional Versus Global Perspective of Design Principles

Traditionally, the study of design includes examination of both elements and principles. The **design elements** are the building blocks of design. They include line, space, form, light, color, and texture. The **design principles** involve the manipulation of design elements to create an effect. For example, the color black can be manipulated to represent serious business wear, seductive dancewear, and religious solemnity. See Figure 1.2. Design principles include repetition, rhythm, contrast, emphasis, proportion, scale, balance, harmony, and unity. Various designers have other ways of grouping the elements and principles. For example, some designers also include sequence, radiation, alternation, and so forth as principles.

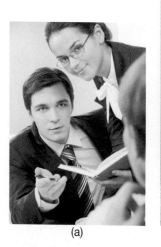
(a)

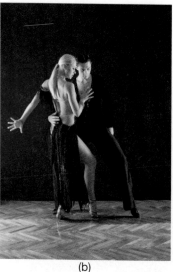
(b)

(c)

FIGURE 1.2 *(a) Serious business wear; (b) seductive dancewear; (c) religious solemnity*
Sources: a. Dmitriy Shironosov/Shutterstock.com; b. akva/Shutterstock.com; c. Monika Wisniewska/Shuttestock.com

TABLE 1.1

Aspects of Design

Design Aspect	Definition
Alternation	A pattern in which two different units repeat in turn
Balance	The sensation of evenly distributed weight
Color	The range of visual wavelengths of light
Concentricity	A progressive increase in size of layers of the same shape each with the same center
Contrast	The sense of distinct difference or opposition
Emphasis	The creation of a center of interest or a focal point
Form	Three-dimensional space
Gradation	The use of a series of gradual/transitional changes in adjacent units
Harmony	Agreement or accord
Light	A form of electromagnetic radiant energy that makes things visible
Line	An extended mark that connects two dots
Parallelism	The use of lines, in the same plane, that are equidistant apart at all points
Proportion	The comparative relationship of not only sizes but also distances, amounts, or parts
Radiation	The use of design lines that spread out in all directions from a central point
Repetition	The use of the same thing more than once in different locations
Rhythm	The feeling of organized movement
Scale	A consistent relationship of sizes to each other and to the whole regardless of shape
Sequence	A serial arrangement in which things follow in a casual or logical order
Shape	Two-dimensional space
Space	The area that the designer has to work with
Texture	The surface quality of an object
Unity	A feeling of completeness that is achieved through the effective use of the aspects of design. It occurs when a design is seen as a whole, and not as separate aspects; when all aspects of the design complement one another rather than compete for attention.
Variety	The use of dissimilar aspects, or the use of different variations of an aspect

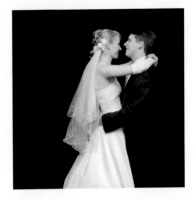

FIGURE 1.3 *Traditional bride and groom*
Source: Losevsky Pavel/Shutterstock.com

(a)

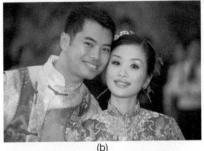

(b)

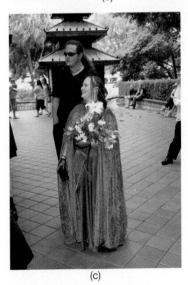

(c)

FIGURE 1.4 *(a) Wedding couple in Peru; (b) wedding couple in China; (c) bride and bride's man at a Discordian Goth wedding*
Sources: a. © Glow Images/SuperStock; b. © PhotoAlto/SuperStock; c. © doug steley/alamy

This book presents a more global perspective of design. The elements and principles of design have been combined in the aspects of design. You are encouraged to consider design as a whole with emphasis on the emotional and physical effect of clothing. Table 1.1 lists the design aspects and their definitions. Guidelines for the use of the aspects of design are included in this book. These guidelines should not be considered as rigid, unbreakable formulas—but as suggestions. Often designers deliberately break a rule in order to make a statement or express the current style. Fashion reflects the social, political, and economic circumstances of the time in which it exists.

The aspects of design operate in conjunction with each other. In order to effectively design apparel, it is essential to remember that each aspect is a component of the whole design. For example, most people expect that a bride will wear a white dress at a traditional wedding ceremony in a Western culture or in a culture that has been heavily influenced by the West. See Figure 1.3. But, in addition to the color, the designer must also consider the texture of the fabric, the repetition of decoration such as lace, beading, and such, the overall form of the gown, and so much more. Of course, other colors are used in Western subcultures and in non-Western cultures or when the wedding is not traditional. See Figure 1.4.

Introduction to Functional Design, Structural Design, and Decorative Design

All clothing serves a purpose, whether it be protection as seen in a winter jacket, identity as seen in a pilot's uniform, modesty as seen in a burqa, or adornment as seen in a tattoo. See Figure 1.5. All the design aspects of the clothing must conform to the purpose of the clothing. For example, the color red would not be used for a pilot's uniform but might be very appropriate for a winter jacket. Well-designed clothing will successfully integrate three characteristics: functional design, structural design, and decorative design.

Functional Design

Functional design allows the clothing to perform in the manner that the wearer expects. The term **working** is sometimes used in place of functional. For example, a functional or working zipper allows a person to put on a pair of pants; a functional or working pocket can hold items.

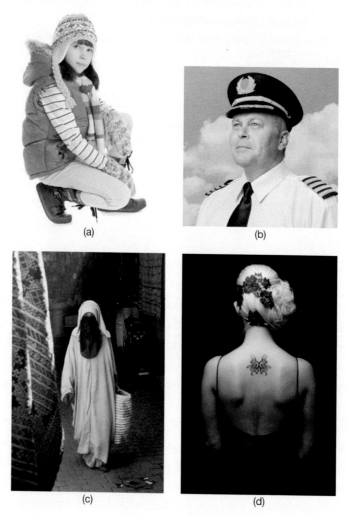

(a)

(b)

(c)

(d)

FIGURE 1.5 *(a) Protection: child in winter vest with hat; (b) identity: pilot in uniform; (c) modesty: woman wearing a burqa and veil; (d) adornment:tattoo on the back of a woman*

Sources: a. MaszaS/Shutterstock.com; b. RTimages/Shutterstock.com; c. © MELBA PHOTO AGENCY/Alamy; d. konstantynov/Shutterstock.com

Sometimes fake or nonworking zippers, pockets, buttons, and such, are added to a garment. These are decorative, not functional.

Three basic needs are common to most garments: movement, protection, and safety. In order for the wearer to maintain mobility, the designer must consider that all garments must provide space for movement and accommodate change in body measurements during movement. For example, when the elbow is bent it increases in length, as does the knee when it is bent. Clothing provides protection from such things as extremes in temperature, rain and snow, wind, sun, insects, and chemicals. All clothing should be safe to wear. Extremely high heels or platform shoes and flowing sleeves can cause serious accidents. Additionally, all garments are required to meet flammability standards to prevent serious burns.

Functional design should also meet the requirements of specialized markets such as athletes, specific age groups, and occupations such as law enforcement and the military. Compare the general need for movement in apparel to the specific need for movement for a dancer. See Figure 1.6. Adaptive clothing for the disabled is another specialized market.

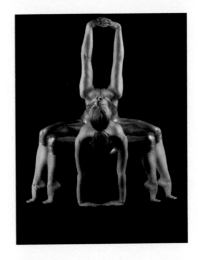

FIGURE 1.6 *Motion needs for dancers*
Source: Courtesy of Copious Dance Theatre, San Francisco, Hemali Photography.

Structural Design

Structural design is fundamental to all garments. It is the construction of the garment and includes fabric, seams, collars, pockets, and so on. There are two important factors when considering the structure of a garment: the intended function of the garment and the structure of the body that will wear it. The challenge for the apparel designer is to transform the flat fabric into forms that meet the functional requirements of the wearer. Fabric is essentially two-dimensional; it has length and width. Its thickness can vary from minimal, such as a thin batiste, to a thicker fake fur; but the thickness is far less than the length and width. The human body is an assortment of cylinders, ovals, and circles. The apparel designer must make many structural decisions. Some of those considerations are:

- Where will the openings be?
- What fabric will be used?
- Will there be a zipper, buttons, snaps, hooks and eyes, or some other closure?
- Where will the seams be?
- Will the garment be lined?

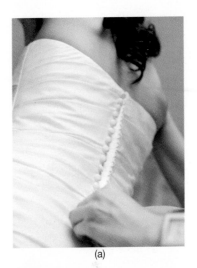

(a)

Additionally the designer must realize that when structural design can be seen, it also becomes decorative design. Seams, darts, tucks, pleats, top stitching, and such are construction techniques that are visible. Also, the structural decision to use buttons becomes a decorative decision because the buttons can be seen. See Figure 1.7.

Decorative Design

Decorative design, or **aesthetic design**, is purely visual. It is secondary to functional and structural design. Decorative design does not affect fit or performance, but it may contribute to the overall performance of the garment. For example, the color chosen for police uniforms identifies the wearer as a police officer and the color of athletic apparel identifies the members of a team. See Figure 1.8. Decorative design can also effectively emphasize the wearer's positive physical characteristics and minimize the wearer's negative physical characteristics. Decorative design can be incorporated into a garment by the color and pattern of the fabric,

(b)

FIGURE 1.7 *(a) Wedding dress with buttons; (b) child's dress with pleats and top stitching*
Sources: a. RomanSo/Shutterstock.com; b. © PhotoAlto/Alamy

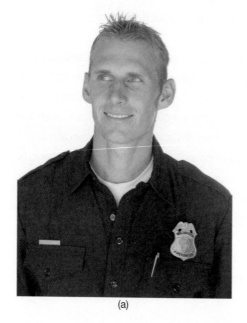

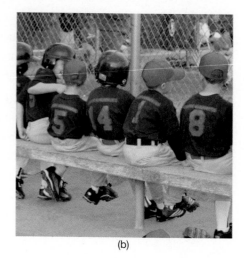

(a) (b)

FIGURE 1.8 *(a) Police officer in uniform; (b) baseball team in uniform*

Sources: a. Stieglitz/Shutterstock.com; b. J. McPhail/Shutterstock.com

by construction details such as topstitching, ruffles, and tucks, and by the use of decorative trim or fabric attached to the surface of a garment.

There are guidelines for incorporating decorative design in a garment.

- The placement of trim should be related to the structural lines of the garment.
- Decorative design should be appropriate to the texture, size, and shape of the garment.
- Decorative design should never appear to be an afterthought. It should be an integral component of the overall design.

Design as Process and Product

Design is both a process and a product. The process involves all the steps needed to create a product. In apparel design, the product is the final garment.

Design as Process

The apparel design process involves answering questions at each step of the process. Questions that need to be answered early in the design process are: Who will wear the clothes and when and where will they wear them? The designer will use the design aspects to answer these questions. For example, the design criteria for athletic wear may be very different from the criteria for men's formal wear. It is easy to see that color and texture choices will be different for each. See Figure 1.9.

The basic steps in the design process are:

1. **Define and clarify the problem.** The apparel designer will need to know the target market, the category of apparel, and the season. The criteria should be fully understood before moving on to Step 2.

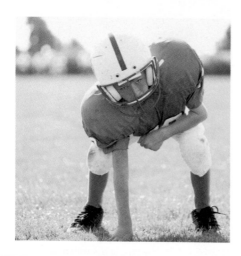

FIGURE 1.9 *Compare the design criteria for a football uniform to that of a business suit in Figure 1.2a.*

Source: © Exactostock/SuperStock

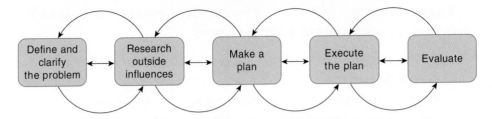

FIGURE 1.10 *A flow chart of the design process with ongoing evaluation*

2. **Research outside influences.** This includes fabric and color trends, economic and political conditions, and sources of inspiration. The designer needs to be aware of all influences that will impact on the success of the design. The sources of inspiration are especially important since they can provide creative stimulus.
3. **Make a plan.** The designer collects fabric swatches, trims, thread, buttons, zippers, or anything that will be needed to create the apparel.
4. **Execute the plan.** At this stage a sample of the garment is produced. Often at this stage the designer realizes that more thought was needed at previous stages and the plan must be adjusted.
5. **Evaluate.** At this stage the garment is evaluated to determine how well it meets the criteria established in Step 1. It is important to note that although evaluation is the last step in the design process, it is essential to critically evaluate progress at each step. See Figure 1.10.

Design as Product

The product of apparel design is clothing, hanging in stores and closets, and being worn on a body. The two main components of product design are sensory and behavioral.

Products that are experienced through the senses—sight, smell, taste, touch, and sound—are sensory design. The most common sensory experience of clothing is touch. Consider the roughness of terry cloth, the smooth texture of satin, the crispness of worsted wool, and the softness of flannel. Each of these appeals to the sense of touch. Some fabrics can be heard, for example, the rustle of taffeta or the rubbing of corduroy. Some can be smelled, such as leather and suede.

Products that affect human actions are behavioral design. Examples include the distinctive police officer's uniform that can cause a dramatic reaction if one has been speeding on a highway, the romantic and sensual appeal associated with black velvet, and the professional crispness of a worsted wool suit.

Creativity in Design

Since the world of fashion is continually evolving, the apparel designer is constantly challenged to be creative and "come up with something new." *Creativity* can be defined in many ways. It appears to have as many definitions as there are artists or designers. Many will agree that it involves the creation of original ideas or products. Some of the words associated with creativity are *novel*, *innovative*, *unique*, *effective*, *imaginative*, and *inspired*. Often creativity uses old or ordinary processes and products in a new way.

Everyone has some creativity and has the potential to maximize their creativity. The following three suggestions will help develop that potential:

1. Creativity requires an open mind that enjoys exposure to a wide variety of stimuli. For example, be open to many styles of music, dance, movies, books, and so forth. Take in as much stimulation as possible. Be aware of the world around you.

2. Creativity requires knowledge of the basic skills in your field and also the willingness to learn new skills. Basic knowledge for a fashion designer will include: an understanding of the characteristics of textile products in order to determine the best fabric for a design, draping, pattern making, and apparel construction. If knowledge about working with different materials such as suede or leather is necessary, the creative person will learn how to work with them. Knowledge is never complete; there is always something new to learn or experience.

3. Creativity requires a positive attitude and motivation. The creative person is willing to take risks and enjoys the challenge of a new project.

Evaluating the Success of a Design

The last step in the design process is to evaluate (see above) and the designer is cautioned to evaluate at the end of each previous step. The final evaluation of the success of a design is determined by the consumer. Does anyone purchase the garment? Has the designer created what the consumer wants to wear? The criteria to consider when evaluating the overall success of a garment are:

- Does the garment meet the requirements for its intended end use?
- Does the garment suit the personality of the intended wearer?
- Does the garment compliment the physical characteristics of the intended wearer?

summary

Design is the conscious creation of a visual experience. In this book you are encouraged to consider design as a whole with emphasis on the emotional and physical effect of clothing. The aspects of design operate in conjunction with each other. In order to effectively design apparel, it is essential to remember that each aspect is a component of the whole design.

Well-designed clothing will successfully integrate three characteristics: functional design, structural design, and decorative design. Functional design allows the clothing to perform in the manner that the wearer expects. The structural design of clothing is the construction of the garment and includes fabric, seams, collars, pockets, and so forth. Decorative design, or aesthetic design, is purely visual. It is secondary to functional and structural design. Decorative design does not affect fit or performance, but it may contribute to the overall performance of the garment.

Design is both a process and a product. The process involves all the steps needed to create a product. In apparel design, the product is the final garment.

Since the world of fashion is continually evolving, the apparel designer is constantly challenged to be creative. Many agree that creativity involves the creation of original ideas or products. Some of the words associated with creativity are *novel*, *innovative*, *unique*, *effective*, *imaginative*, and *inspired*. Often creativity uses old or ordinary processes and products in a new way.

The last step in the design process is to evaluate; the designer is cautioned to also evaluate at the end of each previous step. The final evaluation of the success of a design is determined by the consumer.

terminology

aesthetic design 7
applied design 4
decorative design 7

design 4
design elements 4
design principles 4

functional design 6
structural design 7
working 6

activities

1. Find three print or Internet images of people wearing clothing that could have multiple interpretations. Show the images to the students in your class for their impressions.

2. Consider the motion requirements for a dancer versus a businessperson. Describe the appropriate fabric for each and justify your decision. If possible, find examples of the fabrics you chose.

3. Select random print or Internet images of people wearing clothing. Discuss how successfully the clothing provides for the general needs common to most clothing: movement, protection, and safety.

4. Do an Internet search for clean room clothing. Discuss how clean room clothing differs from general wearing apparel.

5. Select random print or Internet images of people wearing clothing. Identify the function, structure, and decoration of each garment.

6. Expose yourself to a new activity and write a short reaction paper on how the new activity encourages creativity.

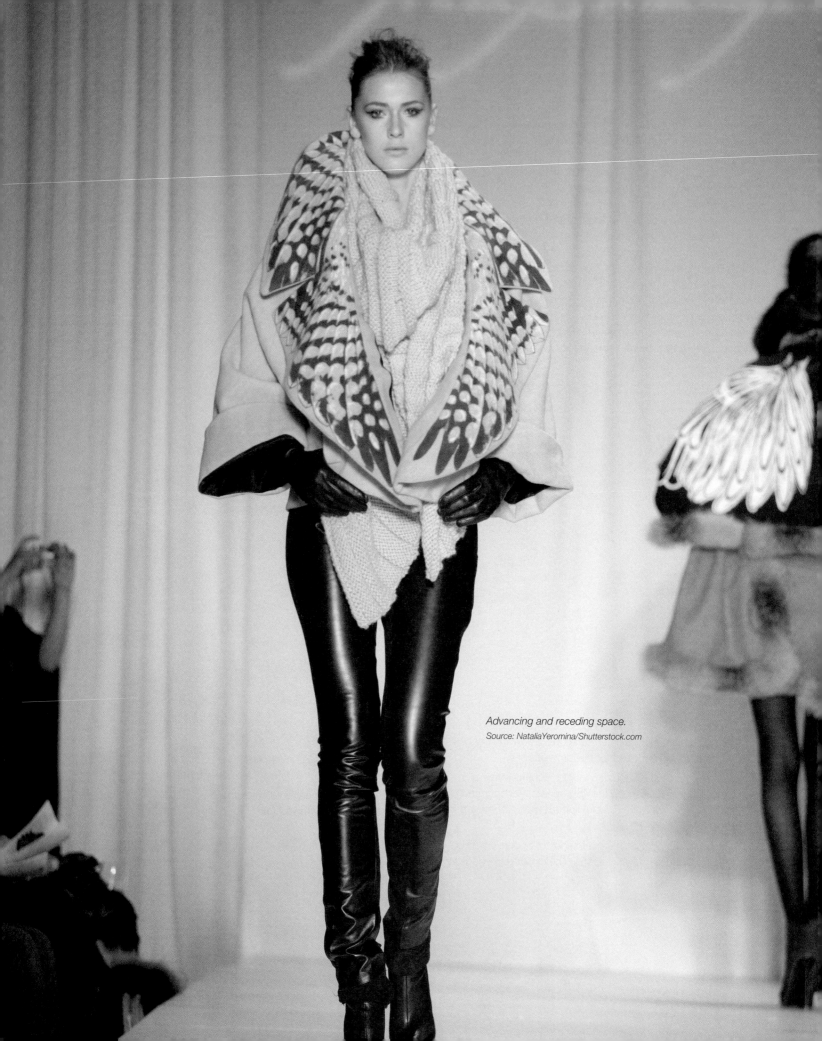

Advancing and receding space.
Source: NataliaYeromina/Shutterstock.com

SPACE

After studying this chapter you should be able to:

1. Define space.
2. Discuss the advancing and receding variations of space.
3. Evaluate the physical effects of space.
4. Evaluate the emotional effects of space.
5. Discuss the application of space in apparel.
6. Summarize the use of space as a design apsect.

2

Enclosed Space	Unenclosed Space
Advancing space	Receding space
Shape	Space
Figure	Ground
Foreground	Background
Positive	Negative
Internal	External
(a)	(b)

FIGURE 2.1 *(a) and (b) Enclosed space advances and unenclosed space recedes.*

Introduction

Space is the beginning of the design process. It is the blank canvas or the blank sheet of paper that inspires creativity. The designer organizes the space with line and then adds the other design aspects to create apparel that meets the physical and emotional needs of the consumer.

Definition of Space

Space is the area that the designer has to work with. This space may be filled with color, line, pattern, and texture or the space may be left unfilled. Designers are challenged to use space to achieve a desired impact. For example, appropriate use of filled and unfilled space in a garment can influence the perception of the wearer's size.

Space may be two-dimensional or three-dimensional. Two-dimensional space is also called **flat space** and is often referred to as **shape**. It has length and width. Shape is created by drawing a line around some space. The resulting enclosed space is called shape.

Space may also be three-dimensional. Frequently three-dimensional space is called **form**. It has length, width, and volume. A rectangle is a shape and a box is a form. Shape and form are covered more completely in Chapter 4. This chapter will primarily deal with the relationship between space and shape.

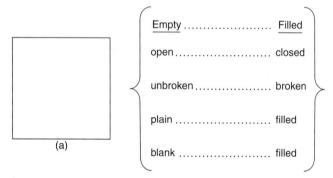

Empty Filled

open closed

unbroken broken

plain filled

blank filled

(a)

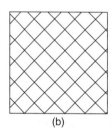

(b)

FIGURE 2.2 *(a) and (b) Terminology used to describe space*

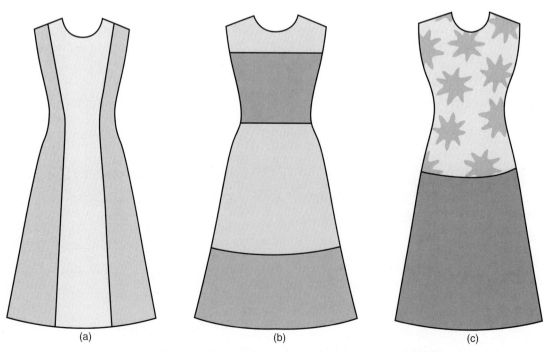

(a)　　　　　(b)　　　　　(c)

FIGURE 2.3 *(a), (b), and (c) Spatial divisions affect appearance of size. Example (a) lengthens the silhouette, (b) widens the silhouette, and (c) has a filled top that increases the apparent size of the top.*

Variations of Space

It is important to distinguish between space and shape because both are important aspects of design. If one considers a painting canvas with a square drawn in the middle of the canvas, the square is the enclosed space and the surrounding area is unenclosed space. See Figure 2.1a and b. Once the shape has been established, it can be filled. See Figure 2.1b.

The world of art and design has several pairs of words to describe the space/shape relationship. In Figure 2.2 a and b the shape is a square, but the relationship between the enclosed space and the unenclosed space differs. The advancing/receding aspects of space are important considerations in apparel design.

Physical Effects of Space

The spatial divisions of a filled space can affect the appearance of size. **Advancing space** draws attention to the area of the body that it covers and increases apparent size. **Receding space** is background and reduces apparent size. See Figure 2.3 a–c. The same silhouette has been manipulated to create different impressions. Figure 2.3a has been divided into three long, narrow spaces that encourage the eye to move vertically, thus increasing the apparent length of the silhouette. Figure 2.3b has been divided into four horizontal spaces that encourage the eye to move horizontally across the silhouette, thus widening the silhouette. Figure 2.3c is divided approximately in half with the top half further divided with a pattern. The pattern "fills" the top, thus making it appear larger. Additionally, the motifs are floating in the space of the top. As such, they are advancing and further increasing the apparent size of the top. See the section on Proximity of Shapes later in this chapter.

Emotional Effects of Space

Emotions can be manipulated through careful use of space in apparel. Unbroken spaces, such as solid color garments or even entire outfits, are often seen in apparel. The simplicity of one color suggests drama and sophistication. Unbroken spaces are often perceived as calm and serene. Emotionally, unbroken space can also seem to be boring because the eye will seek an area of interest or dominance. See Figure 2.4.

Broken spaces are busier and more complex than unbroken spaces. Small broken spaces are often used in women's and children's apparel because they suggest daintiness and frailty. See Figure 2.5. Larger broken spaces are stronger and suggest vigor and sturdiness. They are often used in men's wear. See Figure 2.6.

Application of Space in Apparel Design

The designer can selectively use artistic devices to create either advancing or receding effects. The advancing devices create depth and increase the distance from the background to the foreground. The receding devices minimize the feeling of depth and shorten the

FIGURE 2.4 *The unbroken space of this dress seems to need embellishment.*
Source: © Dellnesco/Alamy

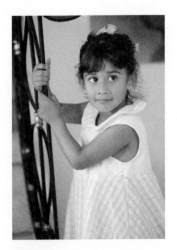

FIGURE 2.5 *Small motifs are often used in children's wear.*
Source: © Kablonk/SuperStock

distance from the background to the foreground. These devices include: overlapping, the nature of the enclosing line, difference in size of shapes, filled versus empty spaces, and proximity of shapes.

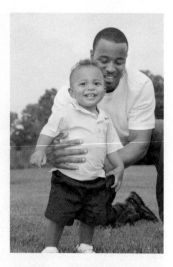

FIGURE 2.6 *Solid colors are often seen in men's and boys' wear.*
Source: © SOMOS/SuperStock

Artistic Devices That Can be Used to Create Advancing and Receding Effects

Overlapping

Shapes that overlap suggest that the shape on the top is advancing or in the foreground. The shape that is underneath is receding or in the background. Shapes that are next to each other do not create a feeling of depth. See Figure 2.7 a and b.

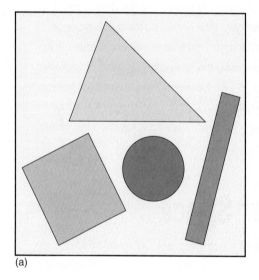
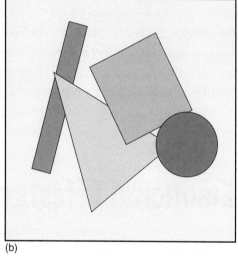

(a) (b)

FIGURE 2.7 *(a) and (b) Shapes that do not touch appear to be on the same plane, whereas shapes that overlap create depth.*

Nature of the Enclosing Line

The nature of the line that creates the shape can impact on the perception of depth. Bold thick lines create shapes that appear to advance. Shapes created with narrow, vague, or hazy lines seem to flatten. See Figure 2.8 a and b.

Difference in Sizes of Shapes

Shapes or motifs of different size within the composition create more depth than motifs of the same size. The larger motifs appear to advance, whereas the smaller motifs appear to recede. See Figure 2.9a. The apparent depth created by difference in size can be increased if the receding motifs are made to blend in with the background. See Figure 2.9b.

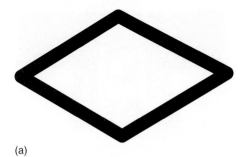
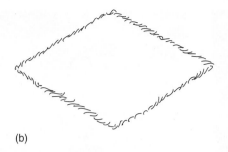

(a)

(b)

FIGURE 2.8 *(a) and (b) Strong solid lines appear to advance, but thin, fuzzy lines appear to recede.*

Proximity of Shapes

Shapes that float freely in space and do not touch other shapes appear to advance more than shapes that touch each other. The shapes that touch appear to be flat or on the same plane. See Figure 2.10a and b.

Filled versus Empty Spaces

Empty spaces are perceived to be flatter than filled spaces. The empty space in Figure 2.11a appears to be flat, but the filled space in Figure 2.11b appears to be advancing.

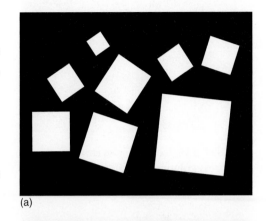

(a)

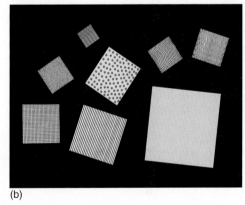

(b)

FIGURE 2.9 *(a) and (b) Larger motifs appear to advance, whereas the smaller motifs appear to recede. Shapes that appear to blend into the background (b) create additional depth.*

General Guidelines for the Application of Space in Apparel Design

Effective use of space in apparel can influence the apparent size and shape of a form. The techniques described previously—overlapping, the nature of enclosing line, differences in sizes of shapes, the proximity of shapes, and filled versus empty shapes—can be applied to apparel to create illusions that affect perception. The physical and emotional effects of advancing or receding space can be strengthened by consistent use of artistic devices. For example, overlapping spaces with strong bold lines uses two of the devices to create depth.

(a)

(b)

FIGURE 2.10 *The freely floating shapes of (a) appear to advance more than the shapes that touch.*

(a)

(b)

FIGURE 2.11 *(a) and (b) Filled space advances while unfilled space does not.*

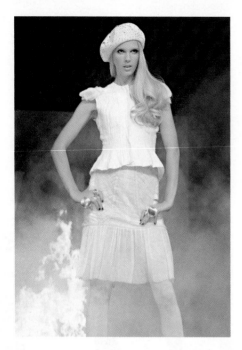

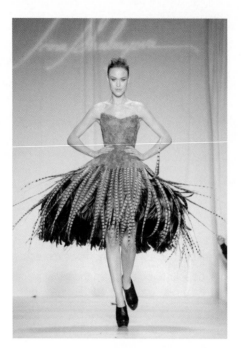

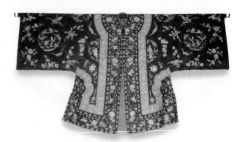

FIGURE 2.14 *Chinese jacket.*
The large floating figure on the sleeves advances and appears to be even larger.
Source: Godwin-Ternbach Museum, Queens College, the City University of New York

FIGURE 2.12 *The overlapping jacket advances, suggesting a small waist underneath.*
Source: Alexander Gitlits/Shutterstock.com

FIGURE 2.13 *The feathers create a fuzzy silhouette that creates the illusion of a smaller shape.*
Source: ©NataliaYeromina/Shutterstock.com

General guideline lines for the use of space in apparel are:

1. Overlapping can be used to create depth in apparel. See Figure 2.12.
2. When compared to sharp advancing lines, a fuzzy line or silhouette is flatter and creates the illusion of a smaller shape. A distinct line suggests the volume that is trapped within the fabric of the garment. See Figure 2.13.

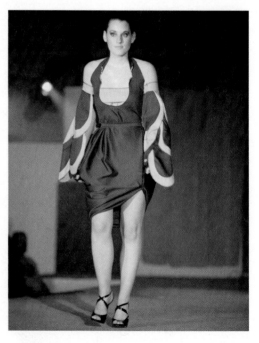

FIGURE 2.15 *Floating motifs of the border pattern advance and make the space appear larger.*
Source: hifashion/Shutterstock.com

FIGURE 2.16 *The filled space of the sleeves advance and appear larger.*
Courtesy of Joseph Khawane and Hartandsohl Photography, Hackettstown, NJ

3. When large shapes are placed next to small shapes, the large shape advances and appears to be even larger. See Figure 2.14. The opposite is also true: When a loosely fitted bodice is place next to a slim skirt, the bodice will appear to be larger.

4. The placement of motifs in a design can affect apparent size. Freely floating shapes advance, whereas shapes that are touching appear to be on the same plane. See Figure 2.15.

5. Filled space appears to be larger than unfilled space. See Figure 2.16. The sleeves on the dress appear to be larger because they have been filled. The broken space of the dress enlarges the wearer. See Figure 2.17.

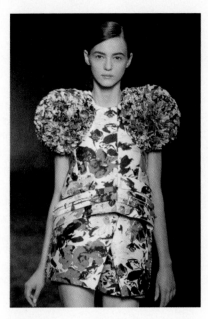

FIGURE 2.17 *The filled space of the dress enlarges the wearer.*
Source: Cavan Pawson/Rex Features/Alamy

summary

Space is the area that the designer has to work with. This space may be filled or it may be left unfilled. Designers use space to achieve a desired impact. Appropriate use of filled and unfilled space in a garment can influence the perception of the wearer's size.

Space may be two-dimensional or three-dimensional. Two-dimensional space is also called flat space and is often referred to as shape. Shape has length and width. Space may also be three-dimensional. Frequently three-dimensional space is called form. It has length, width, and volume. A rectangle is a shape and a box is a form.

The designer can selectively use devices to create either advancing or receding effects. The advancing devices create depth and increase the distance from the background to the foreground. The receding devices minimize the feeling of depth and shorten the distance from the background to the foreground. These devices include: overlapping, the nature of the enclosing line, the difference in size of shapes, filled versus empty spaces, and the proximity of shapes. Effective use of space in apparel can be used to create illusions that affect perception.

Emotions can be manipulated through careful use of space in apparel. Unbroken spaces suggest drama and sophistication and are often perceived as calm and serene. Emotionally, unbroken space can also seem to be boring because the eye will seek an area of interest or dominance. Broken spaces are more complex than unbroken spaces. Small broken spaces are often used in women's and children's apparel because they suggest daintiness and frailty. The emotional effects of advancing or receding space can be strengthened by consistent use of artistic devices.

terminology

advancing space 15
flat space 14

form 14
receding space 15

shape 14
space 14

activities

1. Do an Internet search to find images of the following works of art:

 Christina's World—Andrew Wyeth
 Memories of Palisades Park—Ann Reeves

 Discuss how the artist manipulated space in these paintings.

2. Using construction paper, each student should create a collection of motifs of their choice. The motifs should be of a variety of sizes—for example, several sizes of simple flowers, stars, or other geometric shapes. Arrange the shapes on another piece of construction paper to show advancing and receding space.

3. Using lengths of patterned fabric, evaluate the use of space. Determine the enclosed space and the unenclosed space. Suggest appropriate end uses for the fabric and discuss the impact of advancing and receding space on perceived body size and/or shape.

4. Using historic and ethnic costume books, find examples of advancing and receding space in historic and ethnic apparel. Analyze the impact of the use of space on perceived body size and/or shape.

5. Using magazines, catalogs, or the Internet, find examples of advancing and receding space in contemporary apparel. Analyze how the designer's use of space affects perception of body size and/or shape.

6. Using fellow students as models, the class members can evaluate the use of space in each other's apparel and discuss the impact of the space on perception.

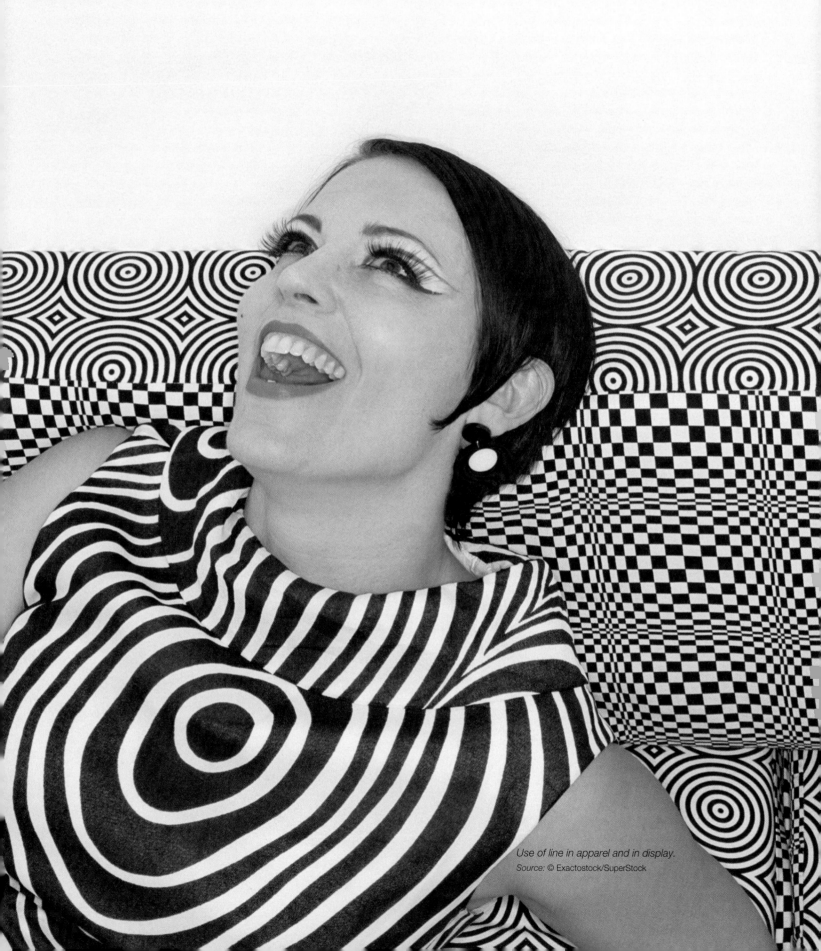

Use of line in apparel and in display.
Source: © Exactostock/SuperStock

LINE

After studying this chapter you should be able to:

1. Define line.
2. Discuss the characteristics of lines.
3. Evaluate the physical effects of lines.
4. Evaluate the emotional effects of lines.
5. Discuss the application of line in apparel design.
6. Summarize the use of line as a design aspect.

3

Introduction

Line is a fundamental aspect of design because it establishes the framework of a garment. It leads the eye along its path. Lines are created by the body and also by clothing on the body. The designer uses line as an expressive tool that can control physical and emotional effects that influence perception.

Definition of Line

A **line** is an extended mark that connects two dots. It is also used to establish the perimeter of a shape. There are three types of line: real, suggested, and psychic. Every line can be defined by its characteristics: length, direction/course, texture, thickness, and contour.

Types of Line

The three types of line are: real, suggested, and psychic. See Figure 3.1a. Real lines, or actual lines, exist in space. They are created by the silhouette of a garment and are printed or woven into the pattern of a fabric. A **silhouette** is the shape of the outline or boundary of an image. Silhouettes are discussed more fully in Chapter 4. Real lines are also created by seams, pleats, tucks, darts, or folds of a garment. **Suggested lines** are the result of the eye "connecting the

(a)

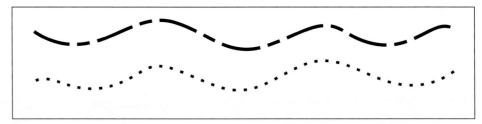

(b)

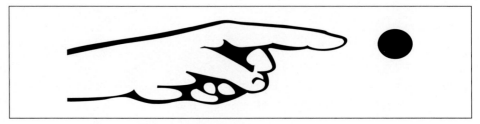

(c)

FIGURE 3.1 *Real lines (a), suggested lines (b), and psychic lines (c).*

dots." The line does not exist in space. An example of a suggested line in apparel would be a row of beads on a dress or the row of buttons down the front or back of a garment. See Figure 3.1b and Figure 3.2. A **psychic line** is psychologically created between two objects. We have learned that a pointing finger indicates a desired path that can be followed with the eye. See Figure 3.1c.

Characteristics of Line

There are limitless variations of line. The five characteristics of line that can be modified are direction, length, thickness, contour, and texture. For example, a line may be short or long and a line may be thick or thin.

Each characteristic of line can be analyzed for physical and emotional effects. Since line has a directional aspect, it moves the eye along its direction. The emotional effect of line direction can be compared to common associations. For example, horizontal lines are often associated with the horizon. It is important to consider that discussion about the effects of line variations is subjective and open to interpretation. Statements often should start with the words "generally" or "usually." Additionally, each variation of a line characteristic can change the overall impact of the whole. For example, a thick vertical line has a different impact than a thin vertical line.

FIGURE 3.2 *The yellow beads on the front of the bodice are a suggested line.*
Source: © Design Pics/SuperStock

Direction

The direction of a line refers to its course or path. The direction of a line has strong physical and emotional associations. There are three basic directions: vertical, horizontal, and diagonal.

PHYSICAL AND EMOTIONAL EFFECTS OF LINE DIRECTION

Physically, a vertical line moves the eye up and down and tends to emphasize that direction on the body. Conversely, horizontal lines move the eye across the space and tend to emphasize that direction on the body. In general, the physical effect of vertical lines is to lengthen and narrow the figure; the physical effect of horizontal lines is to shorten and widen the figure. Diagonal lines have characteristics of both vertical and horizontal lines. Figure 3.3 demonstrates the physical effect of line direction on the body.

(a) (b) (c) (d)

FIGURE 3.3 *Physical effect of line direction on the body. (a) The vertical line appears to lengthen and slim as the eye moves up and down. (b) The horizontal line appears to shorten and widen as the eye travels across. (c) This diagonal line appears to shorten and widen, since the angle of the diagonal is closer to the horizontal. (d) This diagonal line appears to lengthen and slim, since the angle of the diagonal is closer to the vertical.*

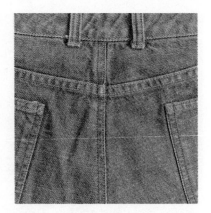

FIGURE 3.4 *Diagonal lines with a horizontal effect.*
Source: Ragne Kabanova/Shutterstock.com

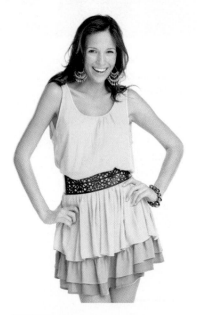

FIGURE 3.5 *Strong horizontal lines carry the eye across the figure.*
Source: Yuri Arcurs/Shutterstock.com

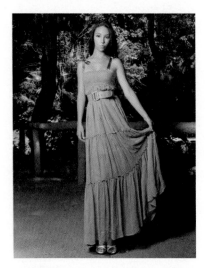

FIGURE 3.6 *Strong vertical lines increase apparent height.*
Source: CURAphotography/Shutterstock.com

Emotionally, a person who is vertical or standing is associated with being alert and attentive. Trees and tall buildings often have strong vertical lines and are associated with being rigid and firm. These qualities are associated with vertical lines in dress. Conversely, a person who is horizontal or lying down is associated with passivity, serenity, and tranquility. Horizontal lines in dress suggest similar qualities. Diagonal lines can be at any angle other than completely vertical or completely horizontal. Diagonal lines that are more horizontal than vertical have a more horizontal impact, whereas diagonal lines that are more vertical have a more vertical impact. See Figure 3.3 c and d. Figure 3.4 demonstrates how diagonal lines that are more horizontal than vertical can lead the eye across the figure. Since diagonal lines are neither horizontal nor vertical, emotionally they suggest activity, restlessness, and drama.

APPLICATION OF LINE DIRECTION IN APPAREL

Line direction can be incorporated into apparel in many different ways. A simple black pant suit with no decoration is one vertical line. All garment edges, seams, darts, pleats, hems, stitching, and decorative fabric or trim have line direction. These lines impact on the physical and emotional effect that the garment creates. In general, horizontal lines will draw the eye across the figure creating a widening effect, but vertical lines will create a taller, slimmer effect than horizontal lines. Compare the effects of the horizontal lines in Figure 3.5 with the effects of the vertical lines in Figure 3.6. The length of the line, as discussed in the next section, impacts the effect of the line.

Because diagonal lines are neither vertical nor horizontal, their effects tend to be weaker. Diagonal lines are often used in sportswear to suggest activity. Frequently, in apparel, lines are chevroned in order to create balance. When diagonal lines meet with the point in an upward direction, the effect is lighter and often considered to be more youthful. When the point is in a downward direction, the effect is heavier and often considered to be older. See Figure 3.7. Figure 3.8 demonstrates the effect of chevroned lines that have the point in a downward direction.

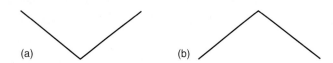

(a) (b)

FIGURE 3.7 *Effect of chevroned lines.*

Length

All lines have a measurable length. In simplest terms, all lines may be defined as short or long. However, measurements are relative. For example, a long skirt on a petite woman could be a short skirt on a tall woman.

PHYSICAL AND EMOTIONAL EFFECTS OF LINE LENGTH

Long lines emphasize their direction. Physically, they tend to elongate and carry the eye along the length of the line. Emotionally, they suggest a smooth flow and continuity. Short lines physically break up the space and create a sense of activity. Emotionally, they are disjointed and suggest action. See Figure 3.9.

APPLICATION OF LINE LENGTH IN APPAREL

As with line direction, all garment edges, seams, darts, pleats, hems, stitching, and decorative fabric or trim have length. All components of a garment can be measured. Length of lines can alter the impact of line direction. Figure 3.10 demonstrates how line length impacts the effect of direction. Long vertical lines carry the eye up and down and short vertical lines carry the eye horizontally. Conversely, long horizontal lines carry the eye across and short horizontal lines carry the eye up and down. In Figure 3.11 the panel of horizontal lines carries the eye up and down, creating a lengthening effect. Figure 3.12 demonstrates the widening effect of the jean shorts.

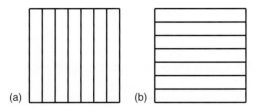

FIGURE 3.10 *The impact of line length on direction. (a) Many vertical lines can widen as the eye moves across. (b) Many horizontal lines can lengthen as the eye moves up and down.*

Thickness

Thickness refers to the width of a line. Lines may be any thickness from very narrow to very wide. For example, a man's necktie may have a pinstripe, or very narrow stripe, or it may have a very wide stripe.

PHYSICAL AND EMOTIONAL EFFECTS OF LINE THICKNESS

Physically wide stripes tend to add weight, whereas pinstripes will minimize weight. Please refer to the chapter cover photo. Emotionally, thin lines suggest daintiness and passivity. They tend to be perceived as feminine, gentle, and subtle. The emotional effect of thick lines is forcefulness and aggression. They suggest masculinity and assertiveness. See Figure 3.13.

APPLICATION OF LINE THICKNESS IN APPAREL

Line thickness can be seen in the components of a garment. The apparel designer will determine whether the borders, trims, fabric pattern, belts, or cuffs are wide or thin. Usually, seams edges, darts, and construction details are thin. Thickness can modify the effect of other characteristics of line. For example, a thick long vertical line has more impact than a thin long vertical line. Notice that the thickness of the line created by the jean shorts in Figure 3.12 increases the horizontal widening effect.

Contour

Contour refers to the evenness or uniformity of a line. Lines have unlimited possibilities of contour. See Figure 3.14. Lines may be completely even or completely uneven. Lines may be straight, curved, jagged, looped, or wavy.

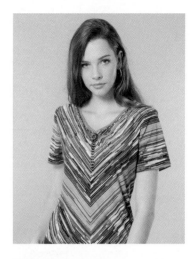

FIGURE 3.8 *Effect of chrevroned lines that have the point in a downward direction.*
Source: hifashion/Shutterstock.com

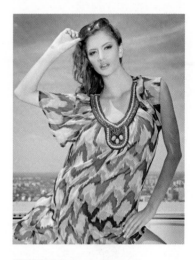

FIGURE 3.9 *Short diagonal lines create an active busy mood.*
Source: bart78/Shutterstock.com

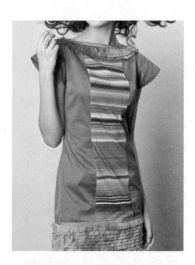

FIGURE 3.11 *Vertical effect of horizontal lines.*
Source: © Makarova zhanna/Fotolia

FIGURE 3.12 *Horizontal line created by the short jean pants creates a widening effect.*
Source: Erik Reis/Dreamstime

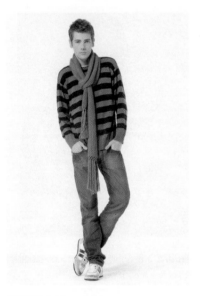

FIGURE 3.13 *Thick lines suggest men's wear influence.*
Source: new vave/Shutterstock.com

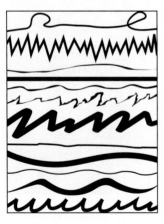

FIGURE 3.14 *Variations of line contour.*

PHYSICAL AND EMOTIONAL EFFECTS OF LINE CONTOUR

An even line provides physical steadiness, but an uneven line accents lumps and bulges. Emotionally an even line is secure, smooth, and firm; an uneven line is unsteady and insecure. Straight lines are rigid, emphasize body angularity, and counter roundness. Curved lines are softer and feminine and will emphasize body curves and counter angularity and thinness. As combinations of diagonal lines, jagged lines will have similar physical and emotions effects and will emphasize angularity. Looped and wavy lines are made up of curved lines and will also emphasize roundness. See Figure 3.15. Variations in the contour of a line will impact on the physical and emotional effects of the line. For example, as the unevenness of a line increases, so will the appearance of lumps and bulges and the unsteady and insecure feelings.

APPLICATION OF LINE CONTOUR IN APPAREL

Even line contour is most commonly seen in seams, edges, pleats, trim, and sometimes in fabric pattern. Uneven line contour can be seen in fabric pattern and trim. As discussed in Chapter 1, cultural goals determine figure preferences and, thus, apparel choices. When it is fashionable to appear very thin, even lines would usually be preferred over uneven lines.

Texture

Texture refers to the consistency of a line. A line may be solid or it may be porous. A bold black line on white fabric is solid. A soft feathering of transparent color creates a porous line.

PHYSICAL AND EMOTIONAL EFFECTS OF LINE TEXTURE

Physically, a solid line advances and is emotionally strong and assertive. A porous line will not advance as much as a solid line and suggests delicate and fragile emotions. A very porous line can recede in space.

FIGURE 3.15 *Strong contoured lines increase apparent width and suggest bulky unevenness.*
Source: Andy Dean Photography/Shutterstock.com

APPLICATION OF LINE TEXTURE IN APPAREL

Line texture is often seen in fabric pattern and trims. Examples of solid lines in trim are seen in binding, ribbon, rickrack, border trims, belts and sashes, and ribbon. Porous lines in trim are seen in lace, eyelet, crocheted bands, shirring, belts, and fringe. Since the texture of a line can cause it to advance or recede, it is recommended to review Chapter 2 Space.

Use of Lines in Apparel

Because the actual construction of most garments requires the stitching of seams and may also include many other stitched items such as darts and tucks, lines are an integral part of every garment. Lines in apparel can be viewed as either outer lines or inner lines. **Outer lines** establish the edge between the environment and the body and garment. The overall silhouette is an outer line. **Inner lines** decorate the fabric or separate the body and garment into smaller parts. Fabric decorations include prints and plaids. Seams and darts divide the body and the garment into smaller parts. Trims can be also be used as inner lines.

Lines may also be classified as either structural or decorative lines. A dart is a structural line, but an eyelet trim around a neckline is decorative. Both structural and decorative lines can be manipulated by the apparel designer.

Structural Lines

In clothing there are three types of **structural lines**:

1. Construction, or sewing, lines such as seams, tucks, and darts
2. Edges of garment parts such as the overall silhouette of the garment, edges of sleeves, belts, hems, openings, and so forth
3. Folds or creases created by pleating, tucking, gathering, or draping

During the design process many decisions are made that affect the placement of structural lines. For example: Will the garment have sleeves or will it be sleeveless? Will the sleeves be short? Long? Three-quarter length? The overall function of the garment will guide some of the designer's decisions. For example, a winter coat will most likely have long sleeves.

Decorative Lines

Decorative lines must agree with the functional and structural lines of the garment. They include woven-in or knitted-in designs and decorative trim such as top stitching, lace, etc. Woven-in or knitted-in designs and printed fabrics must be evaluated carefully by the designer. For example a large plaid with predominately horizontal lines will carry the eye across the figure and may increase apparent size. If the plaid is to be used for a pleated skirt, the width of the pleats must be considered to create a pleasing effect. Decorative lines can also be introduced through the use of trims such as braid, rick rack, piping, lace edging, ribbon, top stitching, ruffles, and fringe. Linear application of sequins and embroidery also creates a decorative line. Figure 3.16 demonstrates various decorative lines.

FIGURE 3.16 *Decorative use of line in apparel.*
Source: Mayer George Vladimirovich/Shutterstock.com

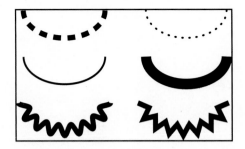

FIGURE 3.17 *Effect of variations on line characteristics. All of the lines are curved but variations of their characteristics affect the mood.*

Controlling the Visual Effect of Lines

It is important to remember that the designer has control over the lines in a garment. If the seam lines in a black dress are simply stitched and pressed, their effect on the body is minimized. If the seams are topstitched with black thread, they are subtly emphasized. The emphasis is increased if they are topstitched with contrasting thread. If the seams are trimmed with white piping, the impact of the lines on the body is increased significantly. See Figure 3.17 for an example of the effect of variations of line characteristics. All the lines are curved, but there are variations in thickness and texture. As stated earlier, each variation of a line characteristic can change the overall impact of the whole. The physical and emotional impact of each line is modified.

The designer can also use reinforcing or countering lines to emphasize or minimize existing body lines. Desirable features can be emphasized, while undesirable features can be minimized. For example, if wide shoulders are in fashion, as they were in the 1980s, diagonal necklines or a strong horizontal line at the shoulders can be used to emphasize the width of shoulders. See Figure 3.18 a and b. Figure 3.19 also shows how garment lines can be used to reinforce and counter body lines. In Figure 3.19a the straight lines of the garment reinforce the straight lines of the body, but the curved lines of Figure 3.19b counter the straight lines of the body. Note that in Figure 3.19c the rounded lines of the body are reinforced by the rounded lines of the garment and in Figure 3.19d the rounded lines of the body are countered by the straight lines of the garment.

Table 3.1 summarizes the physical and emotional effects of line features.

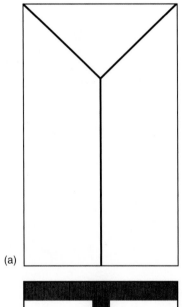

(a)

(b)

FIGURE 3.18 *Using line to create the illusion of wide shoulders.*

(a)　　　(b)　　　(c)　　　(d)

FIGURE 3.19 *Reinforcing and countering body lines: (a) reinforcing angularity; (b) countering angularity; (c) reinforcing roundness; (d) countering roundness.*

TABLE 3.1

Physical and Emotional Effects of Line Characteristics and Variations

Characteristic	Variations	Physical Effect	Emotional Effect
Direction	Vertical	Taller, reduces weight	Alert, attentive
	Horizontal	Shorter, adds weight	Passive, serene
	Diagonal	If the line is more vertical, the effect will be taller, slimmer; if the line is more horizontal, the effect will be shorter, wider	Active, restless, drama
Length	Long	Elongates	Continuity
	Short	Breaks up the space	Activity
Thickness	Thick	Adds weight	Assertiveness, masculine
	Thin	Reduces weight	Daintiness, passivity, feminine
Contour	Even	Stability	Secure
	Uneven	Unsteady, may add weight	Insecure
	Straight	Emphasizes body angularity	Rigid
	Curved	Emphasizes body curves	Soft, feminine
	Jagged	See discussion about diagonal lines	See discussion about diagonal lines
	Looped, wavy	See discussion about curved lines	See discussion about curved lines
Texture	Solid	More advancing	Strong, assertive
	Porous	Less advancing	Delicate, fragile

summary

A line is an extended mark that connects two dots. There are three types of line: real, suggested, and psychic. Every line can be defined by its characteristics: length, direction, texture, thickness, and contour. Line moves the eye along the course of the line. The designer uses line as an expressive tool that can control physical and emotional effects that influence perception.

Each characteristic of line can be analyzed for physical and emotional effects. Physically a line moves the eye along its direction. The emotional effect of line direction can be compared to common associations. It is important to consider that discussion about the effects of line characteristics is subjective and open to interpretation. Additionally, each variation of a line characteristic can change the overall impact of the whole.

The direction of a line has strong physical and emotional associations. There are three basic directions: vertical, horizontal, and diagonal. All lines have a measurable length. In simplest terms, all lines may be defined as short or long. Thickness refers to the width of a line. Lines may be any thickness from very narrow to very wide. Contour refers to the evenness or uniformity of a line. Lines have unlimited possibilities of contour.

Outer lines established the edge between the environment and the body and garment. The overall silhouette is an outer line. Inner lines decorate the fabric or separate the body and garment into smaller parts. Fabric decorations include prints and plaids. Seams and darts divide body and garment into smaller parts. Trims can be also be used as inner lines. Lines may also be classified as either structural or decorative lines. Both structural and decorative lines can be manipulated by the apparel designer.

The designer can also use reinforcing or countering lines to emphasize or minimize existing body lines. Desirable features can be emphasized, while undesirable features can be minimized.

terminology

decorative lines 29
inner lines 29
line 24

outer lines 29
psychic line 25
silhouette 24

structural lines 29
suggested line 24

activities

1. Do an Internet search to find images of the following works of art:
 a. *Child in White*—Auguste Renoir
 b. *American Gothic*—Grant Wood
 Discuss how the artist manipulated lines in these paintings.

2. Using construction paper and patterned paper, each student should create examples of line characteristics: direction, length, thickness, contour, and texture. Analyze the examples for physical and emotional impact.

3. Using lengths of striped and patterned fabric, evaluate the use of line. Determine the physical and emotional effects. Suggest appropriate end uses for the fabric and use on specific body shapes and sizes.

4. Using historic and ethnic costume books, find examples of lines in historic and ethnic apparel. Analyze the impact of the use of line on perceived body size and/or shape.

5. Using magazines, catalogs, or the Internet, find examples of line in contemporary apparel. Analyze how the designer's use of line affects perception of body size and/or shape.

6. Using fellow students as models, the class members can evaluate the use of line in each other's apparel and discuss the impact of the line on perception.

Silhouette on the runway.
Source: © Isis Ixworth/Shutterstock.com

SHAPE
and FORM

After studying this chapter you should be able to:

1. Define shape and form.
2. Discuss the relationship between shape and form.
3. List examples of classic silhouettes.
4. Evaluate the physical effects of shape and form.
5. Evaluate the emotional effects of shape and form.
6. Discuss the application of shape and form in apparel design.
7. Summarize the use of shape and form as a design aspect.

4

Introduction

Shape and form offer a myriad of opportunities and challenges because they can be molded by the designer. Consider the challenge of creating apparel for individuals of different sizes. The designer must create garments in which the shape and form of the apparel complement the shape and form of the wearer. Shape and form are dependent on line and space.

Definitions of Shape and Form

Shape is two-dimensional space and form is three-dimensional space. Please review Chapter 2 Space. Shape is enclosed by a line and form has volume. For example, a square is a shape and a cube is a form. Apparel uses both shape and form. The physical and emotional effects of shape and form borrow their characteristics from both space and line.

Relationship Between Shape and Form

The complementary relationship between line and space is used to create shape and form. Shape, which is two-dimensional, is flat space enclosed by a line. It can be found in silhouettes, fabric patterns, and some garment parts that have little or no depth such as cuffs, lapels, and pocket flaps. Form, which is three-dimensional, is volume space enclosed by a surface. If the enclosed space is empty, it is said to have volume. If the enclosed space is full, it is said to have mass. The human body is a form that has mass. Because flat shapes are often used to represent forms, as in a photograph, people have developed the ability to switch easily between two-dimensional and three-dimensional representations. We can interpret the three-dimensional form that a two-dimensional shape represents.

(a) Square (b) Circle (c) Equilateral triangle

(d) Pentagon (e) Hexagon (f) Octagon

FIGURE 4.1 *Geometric shapes with equal sides.*

Types of Shapes

There are two types of shape: geometric or organic. **Geometric shapes** are simple shapes studied in basic geometry. With the exceptions of circles and ovals, they have straight lines and angles. Geometric shapes may be equally sided, such as a square or equilateral triangle. See Figure 4.1. They may also be unequally sided such as a rectangle or an isosceles triangle. See Figure 4.2. A print based on geometric shapes can be seen in Figure 4.3. **Organic shapes** are curvilinear and are similar to figures found in nature. See Figure 4.4. A print based on organic shapes can be seen in Figure 4.5.

(a) Oval (b) Scalene triangle (c) Isosceles triangle

(d) Rectangle (e) Parallelogram (f) Trapezoid

FIGURE 4.2 *Geometric shapes with unequal sides.*

FIGURE 4.3 *Pattern with geometric shapes.*
Source: Crystalfoto/Shutterstock.com

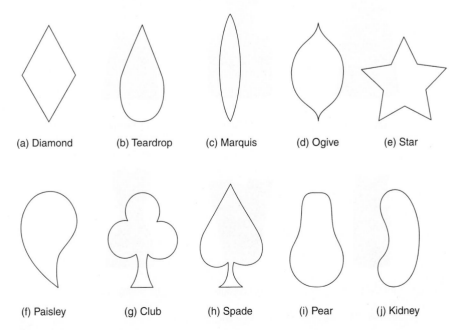

(a) Diamond (b) Teardrop (c) Marquis (d) Ogive (e) Star

(f) Paisley (g) Club (h) Spade (i) Pear (j) Kidney

FIGURE 4.4 *Organic shapes.*

FIGURE 4.5 *Pattern with organic shapes.*
Source: Irmak Akcadogan/Shutterstock.com

FIGURE 4.6 *Ordered pattern.*

Source: Yuri Arcurs/Shutterstock.com

Shapes are often arranged into larger shapes or patterns. The arrangement may be an ordered pattern or a random pattern. An **ordered pattern** is systematic and regular. A gingham check is an example of an ordered pattern. See Figure 4.6 for an example of another ordered pattern. A **random pattern** has no organization or uniformity. An abstract pattern is random. See Figure 4.7.

Classic Silhouettes in Apparel

A silhouette is the shape of the outline or boundary of an image. In apparel it usually refers to the entire garment and body form. There are six classic silhouettes in apparel: A-line, bell, bustle, hourglass, cylinder, and wedge. See Figure 4.8. It is important to realize that the popularity of silhouettes will be dictated by evolving fashion trends. Figure 4.9 illustrates modern silhouettes.

Types of Form

Forms develop from shapes. For example, a triangle can become a pyramid or a three-sided tube. As with shapes, forms may be equally sided, such as a cube. See Figure 4.10. They may also be unequally sided such as a cone. Other examples of unequally sided forms include: cylinder, cube, bell, dome, ovoid (egg shapes), barrel, hourglass, and trumpet. See Figure 4.11.

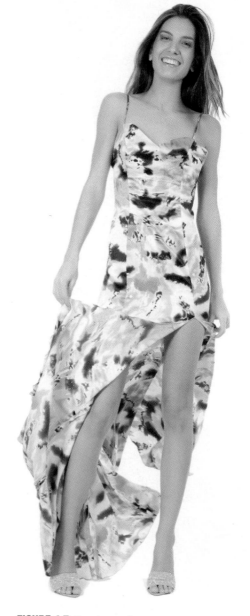

FIGURE 4.7 *Random pattern.*

Source: Fashion B/Shutterstock.com

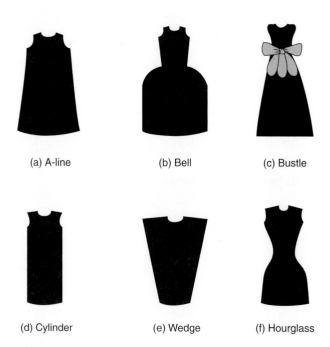

(a) A-line (b) Bell (c) Bustle

(d) Cylinder (e) Wedge (f) Hourglass

FIGURE 4.8 *Classic silhouettes: (a) A-line; (b) bell; (c) bustle; (d) cylinder; (e) wedge; and (f) hourglass.*

FIGURE 4.9 *Modern silhouettes.*
Source: Olira/Dreamstime

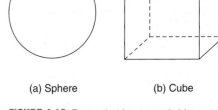

(a) Sphere (b) Cube

FIGURE 4.10 *Forms that have equal sides.*

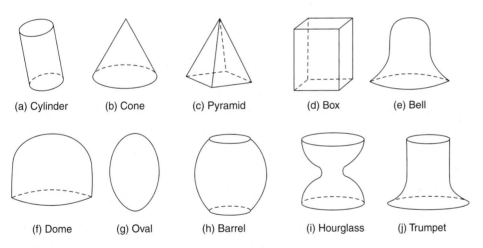

(a) Cylinder (b) Cone (c) Pyramid (d) Box (e) Bell

(f) Dome (g) Oval (h) Barrel (i) Hourglass (j) Trumpet

FIGURE 4.11 *Forms that have unequal sides.*

(a) (b)

(c)

FIGURE 4.12 *The geometric forms of women, men, and children are ovoids, cylinders, cones, domes or spheres. However, the dominant form is a cylinder.*

The human form is a combination of geometric forms: ovoids, cylinders, cones, domes or spheres, but the dominant form is a cylinder. See Figure 4.12. Although they are not exact replicas of traditional forms, many parts of the body and a garment are similar to traditional forms. For example, an arm or leg is somewhat cylindrical in shape, as are the sleeve or pant leg that covers them. Constructed garments have their own form, which is volume. The volume of clothing is designed to accommodate the mass of the body. Clothing must accommodate the natural contours of the body and provide room for movement. See Figure 4.13 for examples of shapes used in apparel. Figure 4.13 a and b relate well to the human body, but Figure 4.13 c and d do not.

(a) (c)

(b) (d)

FIGURE 4.13 *Clothing forms must complement the human form. The forms of (a) and (b) agree with the female form, whereas the forms of (c) and (d) do not.*

Physical Effects of Shape and Form

Shapes and forms are developed from lines and the spaces that the lines create. Therefore, shape and form assume the physical effects of the lines and resulting space. For example, compare the shapes in Figure 4.14 a and b. The physical effect of an oval outlined by a thin solid line with a solid, or unbroken, interior space will have quite a different impact than a rectangle outlined with a thick solid line and filled with short intersecting lines. The curved lines of the oval will emphasize body curves; thin lines reduce weight; and the resulting space is flat since it neither advances nor recedes. The straight lines of the rectangle emphasize body angularity; the thickness of the line adds weight; and the filled space advances.

Shape or forms of unequal proportions, such as a rectangle or an oval, are more interesting than shapes or forms of equal proportions, such as a square or circle. When shapes or forms have unequal proportions, the dominant direction determines the effect. For example, a long shape such as a pant leg will heighten and narrow.

In order to fully understand and appreciate the physical effects of shape and form, it is necessary to understand the interaction of space and line. Chapter 2 Space and Chapter 3 Line should be reviewed carefully.

Emotional Effects of Shape and Form

As with the physical effects, the emotional effects of shape and form develop from the lines and the spaces that the lines create. In general rectangles and squares suggest stability and confidence because the lines are horizontal and vertical and meet at right angles. Shapes with diagonal edges, such as triangles, pentagons, parallelograms, and cones, seem more dynamic but less stable. Again, use the examples in Figure 4.14. The curved outline of Figure 4.14a suggests softness and femininity; its thinness suggests daintiness and passivity; and the unbroken interior space is seen as calm and serene. The straight outline line of Figure 4.14b suggests stability; its thickness suggests assertiveness and masculinity; and its filled interior is busier and more complex. Again, the concepts presented in Chapter 2 Space and Chapter 3 Line should be reviewed carefully.

(a) (b)

FIGURE 4.14 *The mood of shapes is related to the lines and spaces used to create them.*

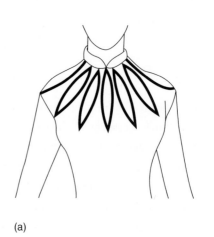
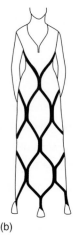

(a) (b)

FIGURE 4.15 *Two-dimensional decorative shapes: (a) applied neck interest; (b) overall design.*

Application of Shape and Form in Apparel Design

The silhouette (shape) of a garment takes its shape from the body (form) that supports it. The designer is challenged to use flat fabric (space) to create garments (form). Darts, tucks, seams, and so forth are used to manipulate fabric into garments. Both shape and form are essential and must interact successfully.

Two-dimensional shapes are usually decorative. There are two types of decorative design.

1. Woven or knitted fabric designs and patterns printed on fabrics are decorative designs. Sometimes fabrics can be cut out or otherwise embellished with designs. See Figure 4.15 a and b.
2. Garment parts that appear to be flat, such as some pockets, plackets, cuffs, and collars, are decorative design. See Figure 4.16.

The three-dimensional form is the structural design of the garment. It covers the body and affects performance and fit. See Figure 4.17 for examples of structural form. Structural design may also be decorative. For example, interesting use of darts reduces excess fabric, while providing design interest. Figure 4.17e uses princess seams as a decorative replacement for traditional waist and bust darts.

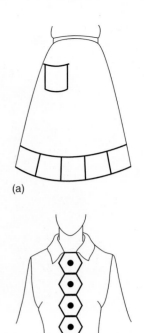

FIGURE 4.16 *Two-dimensional garment parts: (a) pocket, (b) flat placket.*

General Principles for Using Shape and Form in Apparel

The overall cylindrical shape of the human body is fairly constant. The apparel designer is challenged to manipulate shape and form into constantly evolving designs that pique the interest of consumers, while still maintaining the function and comfort of the clothing.

The designer can also use shape and form to modify the apparent contour of the human body. As discussed in Chapter 1, general cultural goals and fashion trends determine the desired body style. For example, in the 1950s an hourglass shape (see Figure 4.18) was desirable; in the late 1960s an A-line (see Figure 4.19) was popular; and in the 1980s a wedge (see Figure 4.20) was popular. Examine the difference between Figure 4.15a and Figure 4.15b. Figure 4.15a would have been more popular in the 1980s because the extended sleeve cap and the shoulder interest increase the apparent width of the shoulders. Figure 4.15b would have been more acceptable in the 1960s because the vertical interest decreases apparent width.

Basic principles can guide the designer to develop garments that meet the expectations of consumers within the ever-evolving world of fashion. Once again, the student is encouraged to review the physical and emotional effects of space and line.

1. Shapes/forms emphasize their dominant direction. For example, slender vertical shapes increase apparent height and decrease apparent width, and thick horizontal shapes increase apparent width and decrease apparent height.
2. Forms that extend away from the body increase apparent size.
3. Loosely fitted styles increase apparent size. They may also camouflage extremes. Large sleeves may hide very thin arms or very heavy arms.
4. Closely fitted garments accent body contours and tend to increase apparent size.

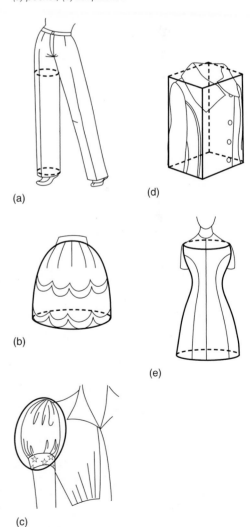

FIGURE 4.17 *Structural forms in dress: (a) cylinder; (b) dome; (c) ovoid; (d) box; (e) hourglass.*

FIGURE 4.18 *1950s hourglass silhouette.*
Source: From the collection of Julia Sharp

FIGURE 4.19 *1960s A-line silhouette.*
Source: From the collection of Julia Sharp

FIGURE 4.20 *1980s wedge silhouette.*
Source: From the collection of Julia Sharp

5. Reinforcing and countering shapes can be used to emphasize or minimize existing body shapes.
6. Advancing and receding techniques can be used to create depth or flatten.

Combining Shapes and Form in Apparel

Clothing is initially seen as a whole and secondly as the sum of its component parts. The basic silhouette of the garment is seen first. Then the viewer breaks the garment down into its component parts.

Garments may be one single form. For example, a simple solid-colored sleeveless shift is a single form. It is a simple silhouette with no component parts. But often garments are combinations of shapes and forms. The silhouette is seen first and then the viewer breaks the garment down into its component parts. For example, a blazer has a silhouette but it also has sleeves, pockets, lapels, a collar, and buttons.

Each component of a garment must be selected in relation to the other components. Several basic guidelines for effectively combining shapes and forms can help the apparel designer create the desired effect. It is important to remember that these are only suggestions and the designer should carefully evaluate the overall effect.

1. Component parts should agree with the purpose and function of the garment.
2. Major components should agree with the silhouette. Minor components can provide variety and interest.
3. In general, it is more attractive if there is some countering of the human body.
4. The function and appearance of the garment in motion should be carefully considered. How do the garment and the wearer appear when walking, sitting, bending, and turning? Is there enough ease for the wearer to engage in desired activities? The designer needs to keep in mind the function of the garment. For example, clothing for professional and amateur athletes will need to meet the motion requirements of the sport.

summary

The designer is challenged to create garments in which the shape and form of the apparel complement the shape and form of the wearer. Shape and form are dependent on line and space. The physical and emotional impact of shape and form are closely related to the physical and emotional impacts of both line and space.

Shape is two-dimensional space. Shape is flat space enclosed by a line. There are two types of shape: geometric and organic. Shapes may be equally sided or they may be unequally sided. Shapes are often arranged into larger shapes or patterns. The arrangement may be an ordered pattern or a random pattern. Form is three-dimensional space. Form is space enclosed by a surface. Empty space has volume. Full space has mass. The human body is a form that has mass.

A silhouette is the shape of the outline or boundary of an image and it usually refers to the entire garment and body form. There are six classic silhouettes in apparel: A-line, bell, bustle, hourglass, cylinder, and wedge.

Forms develop from shapes and may be equally sided or unequally sided. The dominant form of the human body is a cylinder. Constructed garments have volume that is designed to accommodate the mass of the body. Shape or forms of unequal proportions are more interesting than shapes or forms of equal proportions. When shapes or forms have unequal proportions, the dominant direction determines the effect.

The silhouette (shape) of a garment takes its shape from the body (form) that supports it. The designer is challenged to use flat fabric to create garments. Two-dimensional shapes are usually decorative. The three-dimensional form is the structural design of the garment. It covers the body and affects performance and fit. Structural design may also be decorative. Shape and form can be used to modify the apparent contour of the human body.

Clothing is first seen as a whole and then as the sum of its component parts. The basic silhouette of the garment is seen first. Then the viewer breaks the garment down into its component parts. The designer must ensure that each component of a garment be selected in relation to the other components.

terminology

geometric shapes 37
ordered pattern 38

organic shapes 37
random pattern 38

activities

1. Using construction paper and patterned paper, each student will create examples of shapes. Analyze the examples for physical and emotional impact.

2. Using lengths of patterned fabrics, identify various shapes used in the design. Determine the physical and emotional effects. Suggest appropriate end uses for the fabric and use on specific body shapes and sizes.

3. Using historic and ethnic costume books, find examples of shapes and forms in historic and ethnic apparel. Analyze the impact of the shapes and forms on perceived body size and/or shape.

4. Using magazines and catalogs, find examples of shapes and forms in contemporary apparel. Analyze how the designer's use of shapes and form affects perception of body size and/or shape.

5. Using fellow students as models, the class members can evaluate the use of shape and form in each other's apparel and discuss the impact of the shape and form on perception.

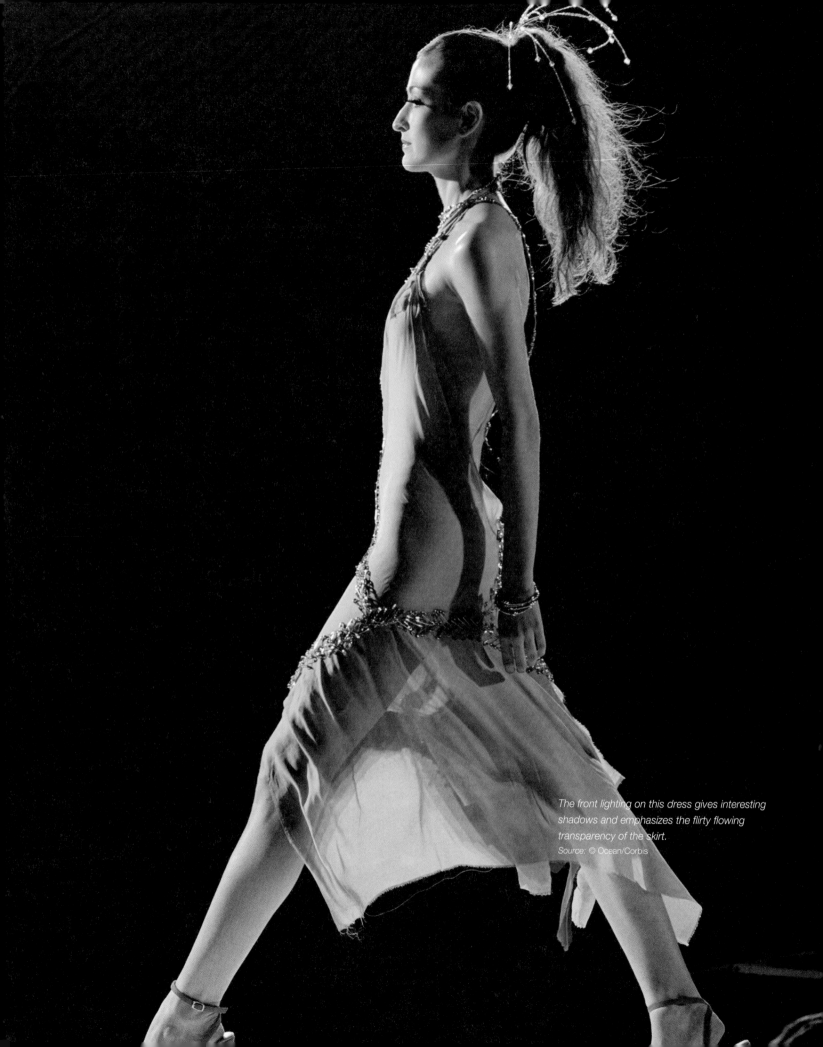

The front lighting on this dress gives interesting shadows and emphasizes the flirty flowing transparency of the skirt.
Source: © Ocean/Corbis

LIGHT

After studying this chapter you should be able to:

1. Define light.
2. Discuss how light and color are perceived.
3. Evaluate light sources.
4. Evaluate the physical effects of light.
5. Evaluate the emotional effects of light.
6. Discuss the application of light in apparel design.
7. Summarize the use of light as a design aspect.

Introduction to Light and Color

Light is the most essential aspect of design, but it is the one over which the designer has the least control. Without light, nothing can be seen. The color and intensity of light affect how colors are perceived. A designer can determine the light used at a fashion show and a merchandiser can control the light used in displays, but the customer generally has little control over the **ambient lighting** (the available light in a space) in which a garment may be seen. This may be bright sunlight, the fluorescent light of an office, the flickering light of a candle in a restaurant, the flashing red bulbs of a dance club, or light from other individual or combined sources.

Definition of Light

Although light is familiar to everyone, it is difficult to define. Light is a form of electromagnetic radiant energy that can travel freely through space. Light moves out from its source. It acts like particles—like little bullets streaming from a machine gun, but at the same time it acts like waves—ripples in space rather like the ripples on water created by throwing a stone into a lake. Waves have high and low points. The distance between one of those high points and the next, as shown in Figure 5.1, is called a **wavelength**.

Different wavelengths of light are sensed as different colors by the **cone cells** in the human eye (and those of some animals). The wavelengths of energy visible to the eye are between violet with a wavelength of approximately 380 **nanometers** and red at approximately 650 nanometers. One nanometer, nm, is 0.000000001 meters or 0.00000004 inches. Light from the sun, which appears to have no color, is called **white light**. It is made up of a combination of light of different colors, with different wavelengths. When white light is passed, at certain angles, through a **prism** (a clear wedge-shaped form) or reflected from the surfaces of raindrops, it is separated into its different colored components creating a rainbow effect as shown in Figure 5.2. The colors of the rainbow—red, orange, yellow, green, blue, indigo, and violet—are identified as the **visible spectrum** of light. The same effect of splitting light can be caused when white light is reflected off an oil slick, soap bubble, or some shiny, highly reflective fabrics or trims, creating the appearance of a surface covered in wavy rainbow-colored patterns. If lights of all the colors of the rainbow are shone into a space, such as a stage or runway show, the area where the lights converge will appear to be lit with white light.

FIGURE 5.2 *The effect of passing white light through a prism.*
Source: vlorzor/Fotolia

FIGURE 5.1 *Wavelength is the distance from the highest point of one wave to that of the next.*

FIGURE 5.3 *A version of Newton's color wheel.*
Source: Michal Heciak/Dreamstime

Sir Isaac Newton (1642–1727) created a color wheel on which wedges of paper with the seven colors of the visible spectrum were pasted on the surface. When the wheel was rotated quickly, the colors combined in the eye and the wheel appeared to be white. Figure 5.3 shows a version of **Newton's color wheel**.

The brightness of light depends on the amount of energy radiating from a source and the distance the viewer is from the source. So a bright light seen from a long distance will appear dim.

The Perception of Light and Color

The perception of light and color are determined by the structure of the eye and combinations of color.

Light and the Eye

The ability to see light and color is a mental sensation. Humans are capable of perceiving light and color because of light and color-sensitive receptor cells in the eye. (Not all animals are able to "see" colors.) **Rod cells** are receptive to different amounts of light. They work at low light intensities, but do not produce sharp images or color. Cone cells are sensitive to colors, but not in low-intensity light. There are three types of cone cells—L, M, and S. Each cone type

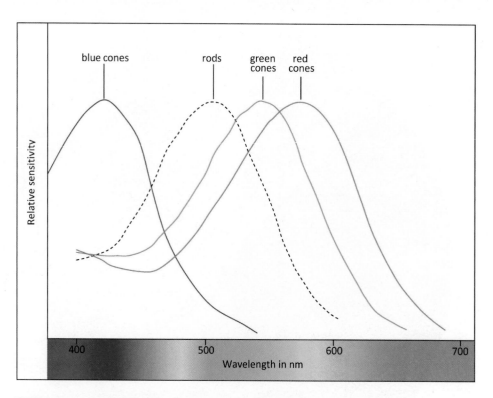

FIGURE 5.4 *The sensitivity of human rod and cone cells to different colors of light.*
Source: Vlue/Shutterstock.com

responds best to particular wavelengths of light. L cones respond to the long wavelengths of red light, M cones to the medium wavelengths of green light, and S cones to the short wavelengths of blue light. The perception of a color depends on the brain's interpretation of the interaction between the stimulation of at least two different types of cones. For example, red light stimulates L cones much more than M cones, and L and M cones respond equally strongly to yellow light, which stimulates S cones only weakly. Figure 5.4 shows the shows how different colors are perceived by the cone cells in the human eye.

Each person's perception of color is different. It is believed that people with different colored eyes perceive colors differently. Some people are said to be color-blind because they lack certain cone cells and cannot perceive a difference between colors such as red and green. **Color-blindness** is more common in males than in females because many of the genes involved in color vision are on the X chromosome. (Women have two X chromosomes, but men have only one X chromosome and one Y chromosome.) Some people can see only in shades of gray. It is difficult for a color-blind person to be a fashion designer because color is such an important factor in clothing appreciation.

Color Mixing

The **additive color theory** explains how the eye interprets the mixing of light of different wavelengths (color), based on the stimulation of cone cells. A **primary color** is one that cannot be created by mixing other colors. In the additive color theory red, green, and blue are the primary colors. When equal amounts of light of these colors are mixed together, the perception of white light is produced, as shown in Figure 5.5. This can be confusing, because we learn as small children that if we mix these colors from our paint box, we will get black or a dark muddy brown color. However, as noted above, these three colors together stimulate all the cone cells in the eye and so the brain identifies the light as white.

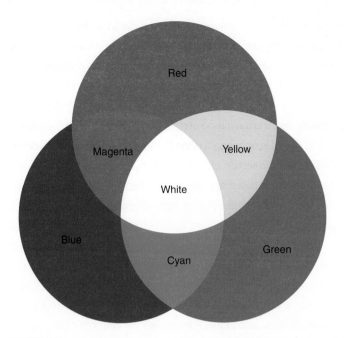

FIGURE 5.5 *Additive color system—the effect of combining red, green, and blue light.*

By combining different intensities of red, blue, and green light, the perception of other colors of light can be made. (The results of mixing colors of light are not the same as mixing the same colors of pigments.) Table 5.1 shows how additive mixing of colored light is perceived.

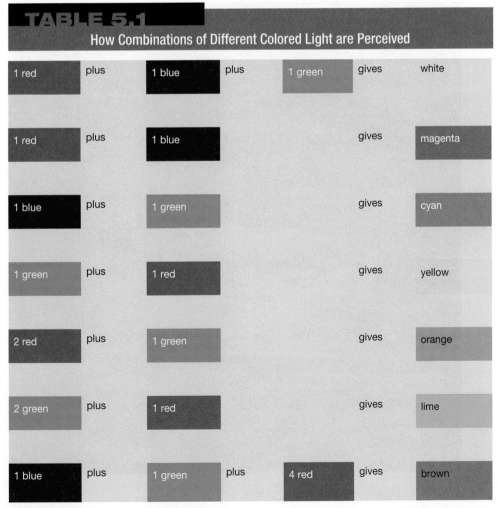

TABLE 5.1

How Combinations of Different Colored Light are Perceived

1 red	plus	1 blue	plus	1 green	gives	white
1 red	plus	1 blue			gives	magenta
1 blue	plus	1 green			gives	cyan
1 green	plus	1 red			gives	yellow
2 red	plus	1 green			gives	orange
2 green	plus	1 red			gives	lime
1 blue	plus	1 green	plus	4 red	gives	brown

The number indicates the intensity of each light color used.

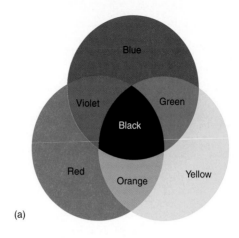

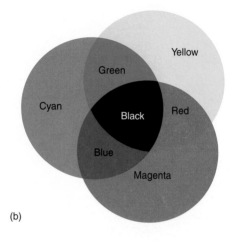

(a)

(b)

FIGURE 5.6 *Subtractive color system—(a) the effect of combining red, green, and blue pigments, paints, or dyes or (b) the effect of combining yellow, magenta, and cyan pigments, paints, or dyes.*

Additive color mixing occurs in the eye. It is the response of the eye to a light stimulus, and how the brain interprets light wavelengths perceived by the eye. There is a difference between yellow light, with a wavelength of approximately 580 nm, and a mixture of red and green light. However, as shown in Figure 5.4, both stimulate our eyes in a similar manner, so we do not detect that difference.

The **subtractive color theory** explains the mixing of dyes and pigments to create a range of colors. The color of a perceived object is dependent upon the light in which it is seen and on the pigments or dyes used. The color is a reflection of light. Every object reflects some colors of light and absorbs other colors. An apple appears red because it reflects red light and absorbs all other colors of light. A white dress will reflect all colors of light, whereas a black suit absorbs all colors of light. A purple garment reflects blue and red light, but absorbs green and yellow light. Mixing more pigments together means more light waves are absorbed or "subtracted" and less are reflected. This changes the color of the light reflected and the perceived color of an object. This accounts for why mixing paint colors or dyes gives a dark color, whereas mixing different colored lights produces lighter colors. Figure 5.6a shows the effect of mixing red, yellow, and blue paints, pigments, or dyes, and Figure 5.6b shows the effect of mixing yellow, magenta, and cyan paints, pigments, or dyes.

Care should be taken when lighting a runway or display. Changes in light will cause changes in the perceived color of an object. For example, an apple in a green light will appear black, since there is no red light to be reflected; a white dress will appear red in a red light, but

FIGURE 5.7 *Light affects the perception of color.*
Source: CURAphotography/Shutterstock.com

blue in a blue light. Skin with peach undertones will look gray in green or blue light, but will have a healthy-looking rosy glow in pink or yellow light (Figure 5.7).

Sources of Light

The source of daytime light is the sun. All light is produced by energizing atoms in some way. The most common way to do this is to use heat. When the energy used to create light comes from heat, the source is called incandescent light. The sun, fires, candles, gas lamps, flashlights, **incandescent bulbs**, and **halogen bulbs** all use heat to produce light. **Fluorescent lamps**, **high-intensity discharge (HID) lamps**, such as **metal halide lamps**, and **light-emitting diodes** (**LED** lamps) use electricity to directly energize atoms without the use of heat (although HID lamps produce heat). Figure 5.8 shows some of the lightbulbs used in the United States. The most commonly used bulbs are incandescent. They are very inefficient, produce a lot of heat, and are not good for the environment. The sale of these bulbs will be phased out in the United States between 2012 and 2014. An overview of lightbulb characteristics is provided in Table 5.2.

FIGURE 5.8 *Commonly used lightbulbs: clockwise from the bottom left, compact fluorescent, halogen, incandescent, metal halide, metal halide, and decorative incandescent.*
Source: © Exactostock/SuperStock

TABLE 5.2

Different Types of Lightbulbs				
Name	**How light is produced**	**Use**	**Value**	**Color and effect**
Incandescent (tungsten)	Electricity passes through a metal filament and produces heat and light.	Until recently, the most commonly used form of light in homes. Being phased out. Used by department stores and specialty apparel stores.	Cheap to buy but inefficient, and so expensive to use.	Give a soft, warm, yellowish, relaxing light, which intensifies yellows, reds, and oranges. Can be made to give a full spectrum white light.
Halogen incandescent	Similar to incandescent bulbs except a small amount of a halogen gas has been added to the inside.	Can be too bright for living rooms, but used in department and apparel stores. Lightbulbs and fixtures can become very hot and so should be used with care.	More expensive than incandescent bulbs, but more efficient and last longer.	Produces true white light. This is the closest to daylight. It makes colors seem brighter. Used for enhancing the visual image in retail stores.
Fluorescent	Electricity passes through mercury vapor in a glass tube; invisible light given off interacts with the coating in the glass and produces visible light.	Most commonly used lighting in retail and offices spaces. With the phasing out of incandescent bulbs, it will be used more often.	Gives off a lot of light and is very energy-efficient. Produces only a very small amount of heat.	Cool white fluorescent bulbs give a white light that brightens most colors. Warm white fluorescent bulbs are friendlier to skin tones and good in living or working areas, but not good for applying makeup.
Compact fluorescent	These are similar to traditional fluorescent bulbs, but smaller.	Used to replace incandescent bulbs in homes and workplaces.	See above	See above
Light emitting diodes (LED)	Electricity passes through certain metals and light is given off.	Used for display, theatre, and flood lighting. Only recently becoming available for home use.	Consumes very little energy and lasts longer than any other lights. Gives off very little heat.	Creates light in a variety of colors, including bright white. Often used for changeable color mood lighting in clubs.
High intensity discharge (HID) metal halide lamps	Light is produced when electricity passes through a mixture of gases.	Used in areas that need a lot of light, such as parking lots and gymnasiums, and where bulbs cannot be changed easily. Used in specialty and department stores. Bulbs and fixtures can become very hot and so should be used with care.	Small bulbs that produce a very large amount of light. Very cost effective.	Creates a very bright white light. Used for concentrated lighting and shadows.

FIGURE 5.9 *The spotlight on the upper part of the body highlights the drapes of the garment, and produces shadows that emphasize the body contours.*
Source: .shock/Shutterstock.com

It is important for designers to consider in what type of light a garment will be viewed. Swimwear and summer dresses will often be seen in sunlight, whereas winter office clothing will be seen in fluorescent or incandescent lighting. It is very important to consider light sources when matching trim or notions with a fabric.

The brightness of a lamp is measured in **foot-candles** or **lumens**. For most everyday use, the brightness of an incandescent bulb is indicated by the watts of electricity it uses. Fluorescent lamps are often labeled by being compared to incandescent bulbs; for example, a fluorescent lamp package may state that the lamp is equivalent to a 100-watt bulb.

For visual display and theatre use, filters, known as color **gels**, may be placed in front of lamps to change the color of the light. These are thin sheets of colored, but transparent, polycarbonate or polyester that absorb all but one color of light.

Physical Effects of Light

The physical effects of light depend upon the light, its source, its brightness, its color, its location, and its direction, and on the color and surface texture of the object it strikes. Light creates shadows and affects the perception of body contours and surface texture (Figure 5.9).

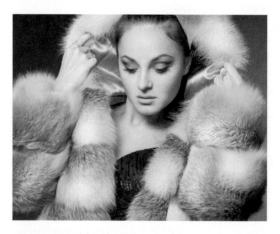

FIGURE 5.10 *The light focused on the fur delineates the ribbed pattern, making it appear more lush and luxurious.*
Source: KULISH VIKTORIIA/Shutterstock.com

Sharp and Diffuse Light

- Spotlights give sharp, hard, dark shadows and emphasize contours, and surface qualities such as textures (Figure 5.10).
- Diffuse light, such as sunlight or light from multiple overhead sources in well-lit stores and workplaces, minimizes shadows and flattens contours (Figure 5.11).

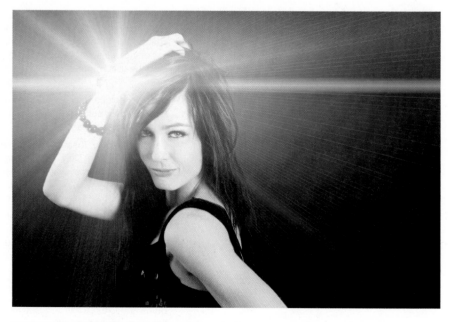

FIGURE 5.11 *The bright light close to the model flattens the contours of the face.*
Source: Phase4Photography/Shutterstock.com

Direction of Light

- Overhead lighting makes figures look squat, short, and wide, and textures flattened. Facial features and garment details may also be lost (Figure 5.12).
- Lighting from below may create a dramatic effect but may distort the figure, creating an almost camouflaged appearance (Figure 5.13).
- Front lighting gives general illumination.
- Back lighting makes it difficult to see the details on the front of a garment; only the silhouette is clear (Figure 5.14). Lighting a model from in front and behind may create a halo effect. When some fabrics are lit from behind, they become semitransparent and show the silhouette of the body in a garment as seen in the chapter opening figure.
- Side lighting will create interesting and dramatic effects.
- Low-angle lighting produces long shadows, which often intensify the appearance of textures. Low-angle light such as that from a setting sun can make some fabrics, which are normally opaque, appear transparent.

Level of Illumination

- The eye is attracted to light and to contrasts in lighting effects (Figure 5.15).
- In bright light, the texture and edges of light-colored garments appear blurry (Figure 5.16).
- Objects will appear larger in bright light than dull light, since more light is reflected from the surface.
- When more light is reflecting from the surface of an object, the color will appear brighter.
- Both bright light and dim light can make the eyes feel tired.

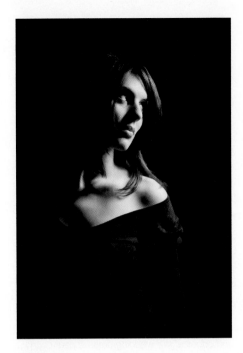

FIGURE 5.12 *Facial details are lost by overhead lighting.*
Source: Netfalls/Shutterstock.com

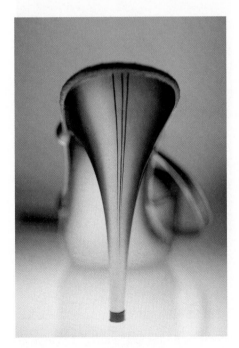

FIGURE 5.13 *Lighting this shoe from below makes it appealing and fascinating.*
Source: © Exactostock/SuperStock

FIGURE 5.14 *Back lighting makes it difficult to see the details on the front of a garment.*
Source: 101imges/Shutterstock.com

FIGURE 5.15 *The eye is drawn to the light reflecting from the face and sleeves.*
Source: Andrew Buckin/Alamy

FIGURE 5.16 *Bright light has made the texture and edges of this wedding dress appear blurry, but dreamy and romantic.*
Source: © Alithenake/Fotolia

Light Intensity and Color Perception

The intensity of a light affects color perception. When light dims, blue and green objects retain their reflective ability and brightness longer than red and yellow ones, which darken comparatively quickly. For example, in bright sunlight, yellow or red petals of a flower will appear bright against dull green leaves, but in dim light, the leaves will appear bright and the petals dull. This is known as the **Purkinje effect** after the nineteenth-century scientist who discovered the phenomenon.

Changes in the level of illumination also change color perception. This is known as the **Bezold-Brücke shift**. As light intensity increases, the appearance of colors with a wavelength below 500 nm shifts toward blue, and colors with a wave length above 500 nm shift toward yellow (reds and yellow-greens appear yellower, yellow looks almost white, and blue-greens appear bluer). For three wavelengths, known as invariant wavelengths, 478 nm, 503 nm, and 578 nm for blue, green, and yellow, respectively, the color perceived does not change with changes in light intensity.

Color of Illumination

The physical effects of different colors of light are included in Chapter 6 Color.

Light and Surface Texture

- The eye is attracted to shiny areas that reflect light (Figure 5.17).
- Shiny surfaces reflect light and increase the apparent size of an object. If part of a garment is shiny, that area will appear to advance (Figure 5.18). Dull-surfaced garments absorb light and so make an object appear smaller.

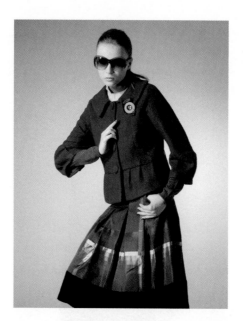

FIGURE 5.17 *The center of attention in this garment is the shiny light-reflecting band around the skirt. The silver pin attracts some attention, but is not forceful enough to draw the eye away from the skirt.*
Source: crystalfoto /Shutterstock.com

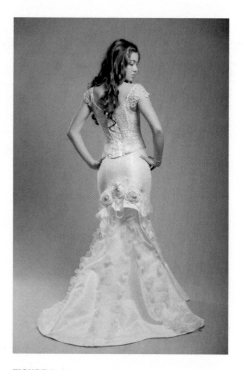

FIGURE 5.18 *The light-reflecting shiny areas of this dress appear to advance and the dull areas to recede.*
Source: Alena Ozerova/Shutterstock.com

Light and Heat

Light and heat are interchangeable forms of energy. As such, light can literally affect the temperature of a surface it strikes. Dark surfaces absorb light rays, which are converted to heat. Light-colored surfaces reflect light and the reverse side of the surface stays cool. The smoothness of a surface also affects how much light is reflected or absorbed. In hot climates, clothing, buildings, and cars are often light-colored in order to reflect sunlight, whereas winter coats in cold climates are often dark in order to absorb any sunlight that reaches them. An unlined bathing suit in a contrasting dark and light pattern may lead to a patterned suntan.

Emotional Effects of Light

Light has important **physiological effects** on the human brain. It causes changes in the function of the body. Bright light activates the production of brain serotonin, a brain hormone associated with mood elevation. Dark and cloudy days deplete serotonin levels, and increase the production of melatonin, a hormone that causes feelings of tiredness. Warm-colored light (yellow, orange, red, and pink) makes people feel good and improves productivity. Light in these colors increases brainwaves for calmness and relaxation and enhances the mood for romance. Females and people over 65 prefer warm light. Cool white and bluish light is preferred by males and younger adults. White light is generally perceived as stimulating and uplifting, expressing happiness, safety, openness, clarity, goodness, spirituality, intelligence, and completeness. See Figure 5.19.

Deep in the human subconscious there are primitive feelings about light and darkness. Although superstitions and beliefs related to light vary with different cultures, there are many cross-cultural basic similarities; for example, most of us are afraid to go into unknown dark places. In most cultures darkness suggests fear of the unknown, evil, emptiness, gloom, a threat, or a mystery (Figure 5.20). It may also suggest seriousness, or ignorance. In Western cultures darkness may suggest sadness and mourning. Funeral homes may have dim lighting. Dim lighting as used in a restaurant or homes may provide a quiet sophisticated atmosphere or indicate a quiet life style.

The emotional effect of colored light is covered in Chapter 6 Color.

Application of Light in Apparel Design

A good designer should understand the effect that light will have on different fabric surfaces, and be able to imagine what the effect of light will be on different types of draping and other construction techniques. The best way to gain this expertise is by constant observation. Figures 5.21 through 5.23 show some of the different effects of light.

Generally a designer has little or no control over the lighting in which clothing will be worn. However, a good designer should be able to anticipate the general conditions in which a garment will be seen. Casual styles are most often worn in bright lighting, particularly daylight. Suits and business wear are usually seen in under artificial light, often **fluorescent light**. If clothing is being designed for specific lighting conditions, a designer should take into account the Pukinje effect and the Bezold-Brucke shift. For example, for a green dress to be worn in bright light, a designer may want to choose a yellow-green fabric to counter the effect of high-intensity light in

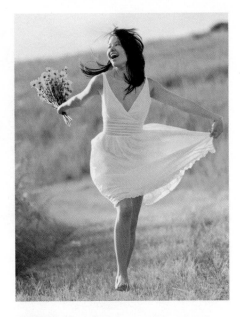

FIGURE 5.19 *Bright light and light-colored clothing are perceived as wholesome and uplifting.*
Source: Warren Goldswain/Shutterstock

FIGURE 5.20 *The shadows in this photograph suggest sophistication and excitement with a tinge of tension and danger.*
Source: Justin Black/Shutterstock.com

FIGURE 5.21 *The transparency of these shoes will make the wearer appear to be floating through the air.*
Source: © Corbis/SuperStock

FIGURE 5.22 *The light reflects off the flat surfaces accenting the creases. The back lighting on the smoke creates a halo effect and a surrealistic mood.*
Source: Aleksandr Doodko/Shutterstock.com

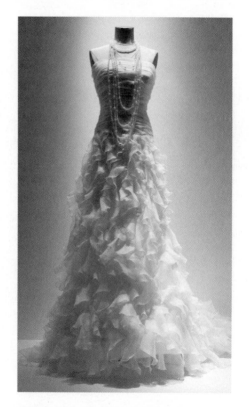

FIGURE 5.23 *Beautiful draped garments like this dress need to be lit carefully for maximum effect. On the right, the lighting is so bright that the texture is lost. On the left, the duller light creates shadows that heighten the appearance of the texture, but the dullness takes away from the light airyness of the dress.*
Source: Pixtal Images/Photolibrary, Inc. Photolibrary

shifting the appearance of green toward blue. Consideration should also be given to the climate in which a garment will be worn. Shiny, light-colored garments will keep the wearer cool in hot bright sunlight, and dark-colored clothing will help to keep a wearer warm in cold situations.

Designers who create garments for special events, such a film or music award ceremonies, must be particularly aware of lighting issues. Many film stars have unintentionally shown their body silhouette beneath their clothing when they stood in front of a stage or television light. Others have worn garments made of shiny fabrics, which, when lit from above, have shown every bump and bulge on the body, including "underwear lines."

For fashion shows and garment display, lighting plays a crucial role. It can generate interest, attract attention, create a comfortable ambiance, and create mood. For more on this topic, refer to books on visual merchandising and fashion show production.

summary

Light is the most essential aspect of design. Without light, nothing can be seen. The color and intensity of light affect how colors are perceived. Light is a form of electromagnetic radiant energy. Light from the sun is called white light. It is made up of light of different colors. Mixing lights of all the colors of the rainbow will give white light. The brightness of light depends on the amount of energy radiating from a source.

The ability to see light and color is a mental sensation. Humans perceive light and color by using color-sensitive receptor cells in the eye—rod cells that are receptive to different amounts of light and cone cells that react to different colors of light. Additive color mixing explains how the eye interprets the mixing of light of different wavelengths (color), based on the stimulation of cone cells. The subtractive color mixing theory explains how the color of an object is perceived. The color is a reflection of light; it is dependent upon the pigments or dyes used and on the light in which it is seen. As pigments are mixed, more light is absorbed and color changes as less light is reflected. Mixing pigments of all the colors of the rainbow will produce black.

Light can come from a variety of sources. All light is produced by energizing atoms in some way. The most common lamp of the past, the incandescent bulb, uses heat to do this. Fluorescent lamps, high-intensity discharge lamps, and light-emitting diodes, which use electricity to directly energize atoms, are becoming more popular because they are better for the environment—they do not produce heat and they use less electricity than traditional incandescent bulbs. Different sources of light produce light with different spectrums and a designer should consider in what type of light a garment will be viewed.

The physical effects of light depend upon the light, its source, its brightness, its color, its location, and its direction, and on the color and surface texture of the object it strikes. Bright light activates the production of brain serotonin, a hormone associated with mood elevation. Light easily evokes emotional reactions in humans. Light suggests safety and happiness; darkness suggests fear and sorrow.

A clothing designer must anticipate the lighting in which a garment will be worn. Consideration should be given to the contours, texture, and colors of a garment and whether it will be subject to the Pukinje effect or the Bezold-Brucke shift.

terminology

additive color theory 48

ambient lighting 46

Bezold-Brücke shift 54

color-blindness 48

cone cells 46

fluorescent lamp 51

fluorescent light 55

foot-candle 52

gels 52

halogen bulbs 51

high-intensity discharge (HID) lamps 51

incandescent bulbs 51

light-emitting diodes (LED) 51

lumen 52

metal halide bulb 51

nanometer 46

Newton's color wheel 47

physiological effects 55

primary color 48

prism 46

Purkinje effect 54

rod cells 47

subtractive color theory 50

visible spectrum 46

wavelength 46

white light 46

activities

1. Cut a circle with a six-inch diameter out of display board or heavy paper. Color the paper as shown in Figure 5.3. Place the point of a pair of compasses though the center of the circle. Spin the circle as fast as possible and observe the colors.

2. Gather a selection of scarves or fabric swatches in different colors. Observe the colors in daylight, moonlight, incandescent light, fluorescent lighting, and nighttime street lighting. Try to have only one source of light available, for example, when inside, close drapes so that sunlight will not affect your observations. Explain why the colors look different in the different types of lighting.

3. Make PPT slides that are each just a solid color. In a darkened classroom, place different colored fabrics in the light of the slides and observe what color each fabric appears to be. Explain what you see.

4. Using magazine, catalogs, or the Internet, find examples of clothing that is shown in outdoor and indoor settings. Note any differences in the types of clothing shown in the different types of lighting.

5. In a darkened room, use a powerful flashlight to illuminate a fellow student from in front, behind, above, and below. Note the effect of changing the location of the light.

Color is the most exciting design aspect. Responses to color are immediate and lasting.
Source: Olga Fesko/Fotolia

COLOR

After studying this chapter you should be able to:

1. Define the dimension of color.
2. Evaluate different color theories.
3. Evaluate the physiological effects of color.
4. Evaluate the physical effects of color.
5. Evaluate the emotional effects of color.
6. Discuss the application of color in apparel.
7. Summarize color as a design aspect.

6

Introduction to The Concept of Color

Color sells. It is the first thing a customer looks at when selecting clothing. Color is the most exciting design aspect. Responses to color are immediate and lasting. Color has strong physical, emotional, symbolic, and cultural connotations; it can indicate mood, personality, social status, and cultural affiliations.

Dimensions of Color

As we learned in the last chapter, the perception of color is dependent upon the pigments or dyes used, the light in which it is seen, and on the eyes of the beholder. The color of a material is the reflection of different wavelengths of light from its surface, as was seen in Figure 5.7. Color may be defined by its wavelength, but for most people this is meaningless. For artists and designers color is discussed using some of the following the terms—hue, value, intensity, shades and tints, chroma, intensity, and luminosity.

Hue

The term **hue** simply means the name of a color, such as red, yellow, green, blue, purple, and so forth. It is determined by the wavelength of the light that is reflected from an object. The same hue will look different in different lights.

People have agreed to give certain colors different names. People who speak the same language have a similar understanding of basic color names. For example, most English-speaking people who are not color-blind know what red looks like. However, there are many variations of red and not everyone agrees on which color should be termed *red*. In addition, there are many names for differed types of red—scarlet, crimson, tomato, candy apple red, ruby. (Use Activity 1 at the end of this chapter to see if you agree with other people's names for different variations of red.)

The naming of colors is arbitrary. Designers may call their latest color creations by any names they choose. This may confuse customers. In the fashion industry, to avoid misunderstandings, most companies use the Pantone standards for colors. The Pantone Company provides a standardized color matching system that allows designers and manufacturers in different locations to match colors accurately. The Pantone textile palette has 1,925 different colors, each with an identifying number and a name. Figure 6.1 shows a Pantone color book.

When designers select a name for the color of a garment or collection, they are usually trying to relate to a particular target market and define the style of garment. For example, daiquiri pink, watermelon pink, and bubble gum pink are almost identical colors but one name suggests sophistication, one relaxation, and one fun. Look at Figure 6.2a, b, and c and decide which color name you would use for each garment.

Value

Value is the relative lightness or darkness of a color or the amount of light reflected from a hue. Light hues are said to have a high value and dark hues a low value. The value of a hue is changed by adding black or white to the pigment or dye. Lightened hues are called **tints**

FIGURE 6.1 *A Pantone textile color book.*
Source: Oleksiy Mark/Shutterstock.com

FIGURE 6.2 *Which of these garments would you call daiquiri pink; which watermelon pink; and which bubble gum pink?*
Source: a. S. Belyaev/Shutterstock.com b. Patrizia Tilly/Shutterstock.com c. Lana K/Shutterstock.com

and darkened ones are called **shades**. The term **tone** is sometimes used to indicate that a color has a value that is not a pure hue. The surface texture of a fabric will affect the amount of light reflected and the value of the color seen. For color on computer monitors and television screens the term **luminosity** is used instead of value. Maximum luminosity of a hue is white and minimum luminosity is black. Every hue has its own natural level of lightness or darkness at which it looks the purest. Yellows are naturally light and blues and violets are naturally dark. Figure 6.3 shows the change in values of hues from tints on the left to shades on the right. The pure hue of each color is indicated by the letter in the color.

Lightening hues can make them seem clear, and darkening them can make them appear rich and sumptuous (Figure 6.4). However, adding black or white to a color may actually

FIGURE 6.4 *The dark shade of this dress makes it appear rich and sumptuous.*
Source: Belovodchenko Anton/Shutterstock.com

FIGURE 6.3 *The change in values of hues from tints on the left to shades on the right. The pure hue of each color is indicated by the letter in the color.*

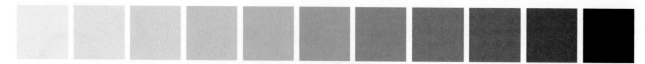

FIGURE 6.5 *Shades of gray—value without hue.*

change the perception of a color. For example, adding black will cause yellow to shift in hue to green; red with added black seems violet; and when violet is lightened, it seems to be pink, as seen in Figure 6.3 and Figure 6.9.

Black, white, and gray are true **neutrals**; they have value but no hue (Figure 6.5). In theory, a white object reflects all light and a black one absorbs all light. In reality, we never experience a pure white or pure black fabric or other surfaces, since even the whitest surface absorbs some light and the darkest fabric reflects some light. In a colloquial sense the term *neutral* is often used for beige, ivory, and taupe, but these are really hues, because they absorb some specific wavelengths of light.

FIGURE 6.6 *Changes in intensity. High-intensity hues are at each end, and dull hues are at the center.*

Intensity

Intensity is the brightness or dullness of a hue. A color is at full intensity when it is a pure hue. The intensity of a color will be lowered by adding its complement. The complement or **complementary color** of a hue is the color that when added will change that hue to gray. When a hue is strong and bright, it is said to be high in intensity. When a hue is dull and gray, it is called a low-intensity color (Figure 6.6). The terms **chroma** and **saturation** are often used as synonyms of *intensity*, particularly in reference to computer graphics. A fully saturated color is very bright.

Warm and Cool Colors

Colors are often referred to as **warm** or **cool** (Figure 6.7). This is a convenient way of grouping colors with similar effects and is related to the emotional and physiological effects of a color. The cool colors are blue, green, and violet. They have short wavelengths. Red, yellow, and orange are warm colors with long wavelengths. Colors from green-yellow to green, and from violet-blue to violet-red are usually considered as neither warm nor cool.

FIGURE 6.7 *Warm and cool colors; warm colors on the left and cool colors on the right.*

Color Theories

Theories of color are practical guides for mixing colors and for discussing the visual impact of specific color combinations. Numerous theories have been developed based on scientific knowledge and artistic appreciation. All theories are based in either an additive color model based on mixing light, or a subtractive color model based on pigment mixing. These are covered in the previous chapter. In the past, artists and designers had a good understanding of subtractive color theories (the theories based on colored pigments, dyes, and inks). Nowadays, with the increased use of computer graphics, designers also need to understand the additive color theory, covered in Chapter 5.

Most theories of color use a color wheel/disc, triangle, cone, cube, or sphere to help explain the relationship between different colors. The first color wheel is attributed to Sir Isaac Newton, who arranged the seven colors of the visible light spectrum as segments of a circle. Figure 5.3 in the previous chapter shows a version of Newton's color wheel.

In both subtractive and additive theories there are certain colors that cannot be created by combining other colors. These are called the **primary colors**. **Secondary colors** are those created by combining two primary colors; and **tertiary colors** are created by combining a primary color and an adjacent secondary color.

The Additive or Light Theory of Color

As noted in Chapter 5, the additive theory of color is based on the fact that white light can be split into different colors and that different-colored light can be overlapped or combined to create other colors or white (colorless) light. The three primary colors of light are red, green, and blue, and the secondary colors are cyan, magenta, and yellow, as shown in Figure 5.5.

The Subtractive or Pigment Theories of Color

Subtractive color theories are based on the light reflected from an object. As noted in Chapter 5, pigments absorb some colors of light and appear to be the color of the light they reflect. In the past artists observed firsthand that red, blue, and yellow were primary colors for mixing paint pigment and that these colors along with black and white, could be used to form most other colors. Other pigment hues when mixed could not create red, yellow, and blue.

THE PRANG SYSTEM

This system will be used for discussion of colors in this book. It is the simplified, but very practical, color system we were all taught in elementary school. It was devised by a printer, Louis Prang, in 1860, in order to be able to reproduce colors in print. Prang is sometimes referred to as the father of the American Christmas card.

In the **Prang color system**, there are three primary colors—red, blue and yellow. The secondary colors, violet, orange, and green are formed by mixing of red and blue, red and yellow, and blue and yellow, respectively, as shown in the **Prang color wheel**, Figure 6.8a, b, and c. The tertiary colors are red/orange, yellow/green, blue/green, blue/violet, red/violet, and yellow/orange. The colors that are opposite each other on the Prang wheel—for example, red and green, yellow and violet—are complementary colors. If complementary colors are mixed together, they will form gray. Colors that are next to each other on the wheel are said to be **analogous**.

FIGURE 6.8 *The basic Prang Color Wheel.*

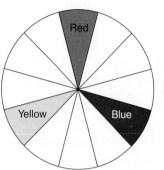
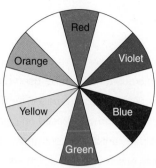
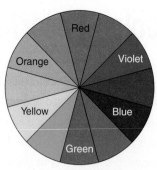

(a) *Primary colors: red, blue, and yellow*

(b) *Secondary colors: green, violet, and orange added*

(c) *Tertiary colors: red-violet, blue-violet, blue-green, yellow, green, yellow-orange, and red-orange added to make a full 12-color Prang wheel.*

The Prang color system also has a simple way to quantify color intensity and color value. For value, there is a nine-step scale from white to black, to indicate the tints and shades (Figure 6.9). For intensity the scale has seven steps from a hue to its complement.

The Prang color system is extremely useful for discussing color interactions but it does have some problems. In reality, primary-colored pigments or inks cannot be used to create all possible colors, and the colors created are often dull. Printers, dyers, and painters usually prefer to use pure hue pigments rather than mixing primary colors. In an art shop you can buy oil paints in a wide variety of hues.

THE MUNSELL COLOR SYSTEM

This system, devised in 1905, uses a three-dimensional model, often called the Munsell Color Tree. All colors are arranged according to hue, value, and chroma. There are no primary colors but rather five principal colors: red, yellow, green, blue, and purple; and five intermediate colors: yellow-red, green-yellow, blue-green, purple-blue, and red-purple. These are arranged around a wheel with a number that indicates locations. Figure 6.10 shows the arrangement of hues, values, and chroma in the **Munsell color system**.

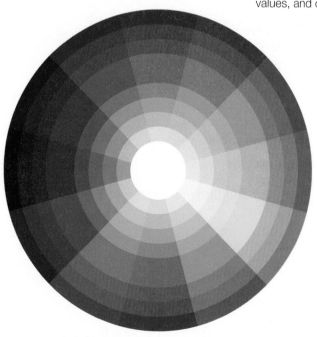

FIGURE 6.9 *A Prang color wheel showing different values of each color.*

Source: Litwin Photography/Shutterstock.com

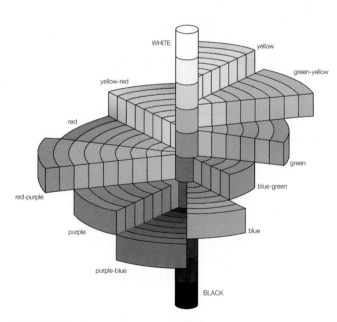

FIGURE 6.10 *Diagram of the Munsell Color System.*

Source: Encyclopaedia Britannica/Alamy

THE CMYK COLOR SYSTEM

The **CMYK color theory** is the color system used in the print industry and by most computer printers. The primary colors are **C**yan (a blue with a slight greenish tinge), **Y**ellow, and **M**agenta (a violet-red). The fourth color, black, is designated by **K**. The secondary colors in this system are red, green, and blue—the primary colors in the additive theory of color.

Physiological Effects of Color and Their Use in Design

Color, like light, can cause **physiological effects**—actually changes in the body. Color affects the nervous and hormonal systems of humans and some animals. This fact is used by advertisers, product developers, home decorators, and designers of office space, schools, and other institutions. It is also used, perhaps subconsciously, by individuals as they select clothing.

Color can cause feelings of boredom and calmness, or stimulation and liveliness. Studies analyzing brain activity found that colorful interiors are more stimulating; for example, red interiors appeared to be more stimulating than blue and gray interiors. Exposure to something red causes an increase in blood pressure, pulse, and respiration; exposure to blue lowers blood pressure, pulse, and respiration. Color may also lead to changes in body temperature with warm colors raising the temperature, and cool colors having the opposite effect. The continuum from exciting to inhibiting colors is believed to be red, orange, green, blue, and violet, with black and white having neutral physiological effects. However, a particular shade of pink, known as Baker Miller pink, has been shown to be relaxing if observed for a short period of time, and has been used in jail cells and other institutions for its calming effect.

If a designer or stylist wants to create excitement in the eye and heartbeat of a beholder, she might use bright red—think of all the red dresses at awards events, and at clubs where young women might be trying to catch the attention of young men. At least 15 songs (rap, rock, and country) have been written about red dresses. On the other hand, a designer creating clothing for a stressful work environment might want to consider using blue fabric for a calming effect. Figures 6.11 and 6.12 show the different effects of red and blue.

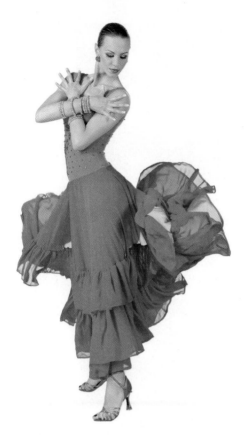

FIGURE 6.11 *Red is a color that can raise blood pressure and cause excitement.*
Source: Andy-pix/Shutterstock.com

Physical Effects of Color and Their Use in Design

Colors are used in many optical illusions, and a good fashion designer should be aware of how color in clothing can be used to change the perceived shape or size of a body.

Effects Created by Contrasting Hues

1. Complementary hues next to each other intensify and brighten each other. This effect is called **simultaneous contrast**. A violet top will brighten blond hair and a green top will intensify the effect of a suntan. Full value complementary colors used

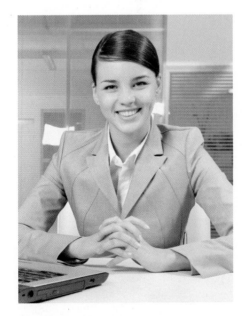

FIGURE 6.12 *This young woman looks calm and efficient in her pale blue suit.*
Source: Hasloo Group Production Studio/Shutterstockcom

FIGURE 6.13 *An example of simultaneous contrast.*

FIGURE 6.14 *Staring at the green square will make the gray area appear to be orange.*

in a pattern will create a bright active look. However, care should be taken using complementary colors next to each other. Because each color takes on the hue of its complement, the colors may appear to vibrate—a very disconcerting effect as shown in Figure 6.13.

2. An intense hue gives the effect of its complement to a nearby dull or neutral color. For example, a bright red shirt may make dull blond hair appear green. White trim on a blue dress may appear orange. This effect shown in Figure 6.14.

3. Hues that are closely related, but not adjacent on the color wheel tend to repel each other. For example, Figure 6.15a shows that placing green next to blue will make the green appear more yellowish and the blue more violet.

4. Using colors that are adjacent on the color wheel, next to each other emphasizes their similarities. For example, placing blue-green between the green and blue in the previous example reduces the contrasts, as seen in Figure 6.15b. In clothing, using adjacent colors on the color wheel will give a more subdued effect than selecting colors that are close but not adjacent on the color wheel.

5. The same hue against different backgrounds may appear to be a different color. A background color will push a hue towards the complement of the background. Red against a green-yellow background will take on a violet hue; the same red against a blue-green background will appear to be more orange. This effect is illustrated in Figure 6.16. A designer should be aware of this effect when creating pieces that should work together such as separates, collections, and accessories.

6. Reds, oranges, and white tend to spread and merge with other colors. Greens, blues, and blacks separate and delineate. Shapes with white outlines look light and merge with the surroundings. Shapes with black outlines are sharp and distinct, and appear larger, as shown in Figure 6.17.

(a)

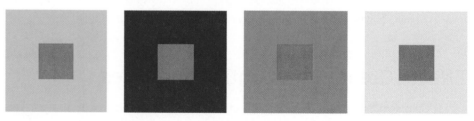

(b)

FIGURE 6.15 *(a) Similar hues push each other apart. (b) Adding the intermediary hue emphasizes their similarity.*

FIGURE 6.16 *The effect of a background color on the perception of a hue. The center of each of these blocks is the same hue, but is pushed towards the complement of the background.*

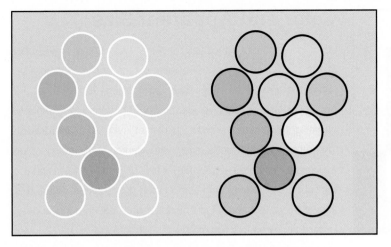

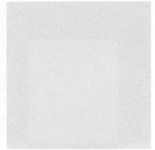

FIGURE 6.18 *After-image—stare at the red square for 15 seconds, then look at the plain gray square.*

FIGURE 6.17 *The effect of outline color on the perception of size.*

After-image

If one looks at a colored area for more than a few seconds and then looks at something else, an **after-image** of the colored area is seen. This effect is created by high-intensity hues and dark values including values of gray. The after-image is the color of the complement of the area observed. In the case of dark gray the after-image will be a lighter color. Figure 6.18 can be used to see this effect.

Staring at a red dress and then looking at the white collar of the dress will give the collar a green tinge. A purple shirt might make skin look yellowish. After extended viewing of a bright or dark color, the eyes tire and an after-image appears over the color, dulling it.

Color Mixing

If dots of different hues, intensities, or values are placed close together, from a distance the eye will mix the colors like mixing pigments to create the perception of a hue that is not present. This is known as **pointillism**. For example, dots of yellow and blue placed close together will create the impression of green. Colors created this way have depth and richness. Look at Figure 6.19 and then look at it from 10 feet away and note the difference in how the colors appear.

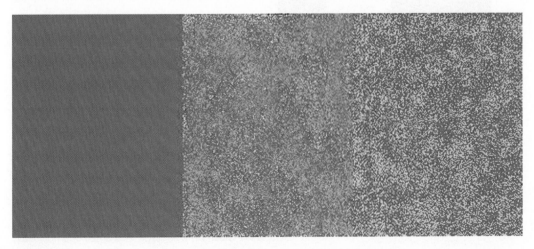

FIGURE 6.19 *An example of pointillism—the colors in the blocks mix in the eye to create a color that is not present.*

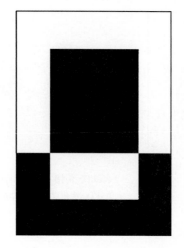

FIGURE 6.20 *The two diagrams are mirror images, but in each, the white area appears larger than it is.*

Color and Apparent Size

Light values, bright intensities, and the warm colors make areas of the body that they cover appear larger, and dark colors will shrink the areas they cover. The warm colors (red, orange, and particularly yellow), light values, and bright intensities reflect a lot of the light that reaches them. This effect is known as **irradiation**. The reflected light "spills over" into darker surrounding colors making the light area appear larger and giving the impression that the light area is closer than surrounding darker areas. Figure 6.20 shows this effect. Any hue against a dark background appears larger than when it is against a light background, as can be seen in Figure 6.26.

A light top and dark pants or skirt will make the bust look bigger and the hips look smaller (Figure 6.21). A dark or dull-toned suit with the jacket open over a light-colored shirt gives a very slimming effect. Care has to be used when using blocks of colors or tints and shades in a garment. This may lead to a distorted appearance with one area of the body appearing to be excessively large or small. Skin should be considered as a block of color. Many one-shouldered dresses give the impression that one breast is substantially larger than the other.

To emphasize the bulk of an athlete, bright or light colors are often used on the sleeves of a team uniform or as a band or yolk across the shoulders. Epaulets on military uniforms have the same effect. (Note: This is an effect that is not usually desired by women in fashionable clothing.) Figure 6.22 shows how a light color can have a widening effect. When using a patterned textile, care has to be taken with the placement of bright and dull parts of the pattern on the body.

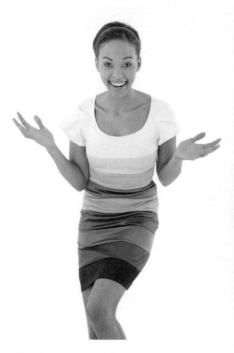

FIGURE 6.21 *The light-colored top and darker skirt makes the bust appear larger and the hips slimmer.*

Source: StockLite/Shutterstock.com

FIGURE 6.22 *The white area across this athlete's shoulders increases the width and suggests power. The aim is to intimidate the other team.*

Source: © LatinStock Collection/Alamy

Color and Apparent Motion

Light values and warm colors appear to advance, and dark and cool colors recede.

A person wearing a bright color will stand out and someone in a dull color will recede into the background. Politicians often wear bright ties so that they will be noticed; the mother-of the-bride may wear a subdued hue in order to recede into the background to not overshadow the bride.

Bright and light areas on a garment will be perceived as advancing and command attention, as seen in Figure 6.23. A bright area against a dark or dull background will draw the eye (Figure 6.24). It is important to avoid placing bright colors in areas a customer might not want to emphasis, such as a thick waist, an over-large or a small bust, or heavy legs. Attention can be drawn to the face by having

FIGURE 6.23 *The white areas on this dress appear to advance and the dark areas to recede.*
Source: Mksim Toome/Shutterstock.com

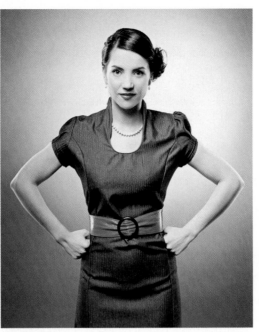

FIGURE 6.24 *The eye is immediately drawn to the bright red belt and away from the face.*
Source: Serg Zastavkin/Shutterstock.com

FIGURE 6.25 *The orange area on the shoulder contrasts with the gray of the rest of the garment and attracts attention toward the face.*
Source: © Image Source/Corbis

bright or light colors or bright jewelry near the face (Figure 6.25). For men, this effect can be created by the use of a bright colored tie.

Effects Created by Contrasting Values and Intensities

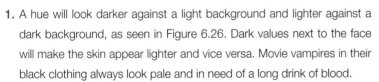

FIGURE 6.26 *A hue against a dark background appears lighter than when it is against a light background.*

1. A hue will look darker against a light background and lighter against a dark background, as seen in Figure 6.26. Dark values next to the face will make the skin appear lighter and vice versa. Movie vampires in their black clothing always look pale and in need of a long drink of blood.

2. Extreme value contrasts can overwhelm the perception of color. For example, a small area of dark blue on a white dress may appear black (Figure 6.27).

3. Different intensities push each other apart. Dull hues make intense ones appear brighter, and bright hues make dull ones appear duller. A garment with an intense color will make dull skin appear even duller. For example, bright orange will cause a low-intensity peach skin to appear duller.

4. Large areas of high-intensity colors are very tiring to the eyes.

5. Hues that are of similar value seem to merge together. If clothing has the same value as the skin, the face will not stand out. A patterned textile with several low-intensity hues of the same value will tend to be monotonous and boring.

Color, Temperature, and Moisture

Color can create an impression of temperature and moisture. This is generally a physical effect, but emotional and physiological components may also have a role in these effects.

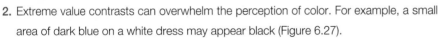

FIGURE 6.27 *Extreme value contrasts: the collar stripe is blue but appears to be black.*
Source: Jupiterimages

Reds, oranges, and yellows are considered warm colors. These are the colors of the sun, fire, and molten metal; all of which are hot. Blue and violet are cools colors. They are associated with ice, glaciers, the sky, and misty mountain tops.

1. Light values are cool and dark ones warm. Dark colors absorb more heat than light ones, so they are literally warmer. In the desert or on a very hot day, light-colored clothing helps to keep the wearer cool because it reflects light and absorb less heat than darker colors.

2. Different impressions of moisture or wetness are created by different hues, values, and intensities. Yellow-greens, greens, blue-greens and blues seem wet, and reds, oranges, orange-yellows, and beiges seem dry. Dark values and dull intensities seem more humid and light values and bright intensities seem drier.

Emotional Effects of Color

Color has the most profound emotional effects of any of the aspects of design. Color affects our moods and our moods affect our clothing color choices. Feelings and color are so closely linked that that there are many common expressions relating the two, such as green with envy, yellow with fear, white with anger, feeling blue, and seeing red.

Color and Culture

No color has any inherent intrinsic "meaning." Color conveys meanings in two primary ways— through natural associations and through psychological symbolism. The emotional effects of color that are similar across cultures are evoked by the colors of nature. Because the sky appears blue and is above us, the color light blue is often associated with heaven, spirituality, and protection. For many people, red, orange, and yellow—the colors of fire—suggest danger. In farming cultures, green is the color of growth and renewal; in societies near jungles, green may be seen as dangerous. The effect of a color also depends on the intensity, value, and precise shade; for example, electric blue will not evoke the same response as pale sky blue.

In different cultures some colors take on psychological symbolism that is understood by the members of that society. These may be based on local geography, religion, politics, or any number of other factors. Sometimes, the emotions evoked by a color depend upon an individual's experiences; for example, a political prisoner locked and tortured in a yellow cell may forever hate and fear the color yellow.

Any color association may change over time with fashion, changing social awareness, and input from other cultures. For example, green was banned by early Christians because it was used in pagan ceremonies; in the fifteenth century, it was used for wedding dresses as a symbol of fertility; and in recent years, it has become associated with ecological awareness and concern for the environment (Figure 6.28).

Even within a culture a color may have several different associations. In Western societies, black has been associated with poverty and sophistication, authority and humility, sin and holiness (Figure 6.29).

As we now have a global economy, designers should be aware of the major symbolic associations of colors in non-Western societies. Table 6.1 lists some of the more common color associations in America and most Western countries, and a selection of other cultures.

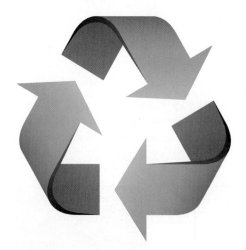

FIGURE 6.28 *A green recycling symbol.*
Source: Roman Sotola/Shutterstock.com

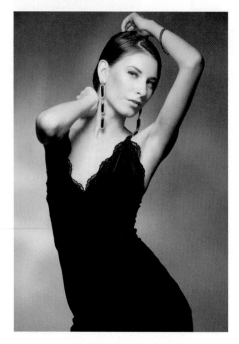

FIGURE 6.29 *A black dress suggesting sophistication.*
Source: konstantynov/Shutterstock.com

TABLE 6.1

Some of the Most Common Color Associations in Most Western and Some Other Cultures

Red	• Positive: heat, love (hearts and roses), passion, sexiness (red dresses, lipstick), power (Figures 6.30 and 6.31), courage, vitality, excitement (red cars), patriotism, Christmas, Valentine's Day • Negative: heat, danger (code red), the stop traffic light, sin and the devil, war and revolution (blood), sacrifice, fire • *China: good luck, celebration, joy, happiness, worn by brides and groom (Figure 6.32)* • *India: purity, worn by brides, married women have a red dot on the forehead as a symbol of commitment* • *Japan: life* • *South Africa: color of mourning*
Pink	• Positive: femininity, sweetness, prettiness, softness, babyish, tranquility (Figure 6.33) • Negative: feminine, babyish when associated with a man
Orange	• Positive: warmth, brightness, cheerfulness, energetic, lively, spice, Halloween, Thanksgiving • Negative: danger, brashness • *Ireland: Protestant Christians* • *Japan: courage, love*
Yellow	• Positive: cheerfulness, happiness, vitality, optimism (Figure 6.34) • Negative: sickness, caution, cowardice, caution (traffic light, crime scene tape), danger (particularly when with black) • *China: royalty, nourishing* • *India: commerce* • *Japan: courage, nobility* • *Mexico: mourning*
Green	• Positive: environmentally friendly, freshness, nature, youth, health, peace, cool, calmness, refreshing, wealth, St. Patrick's Day • Negative: poison, greed, envy, inexperience, immaturity, nausea (particularly yellow-green), sourness • *China: disgrace, cheating* • *India: Muslims* • *Ireland: Catholic religion, the country*
Blue	• Positive: masculinity, coolness, the sky and the ocean (and anything to do with the ocean), purity (pale blues used on health product and food packaging), tranquility, truth, heaven, loyalty and dependability, order (police uniforms are almost universally dark blue) • Negative: depression, sadness, cold • *China: immortality* • *Israel: holiness* • *Iran: heaven, immortality, spirituality* • *Scandinavia: cleanliness*
Purple/violet	• Positive: bravery, aristocracy, spirituality, mystery, mists, coolness, Easter. Lavender is seen as feminine, romantic, dainty, and nostalgic. • Negative: death, mourning, rage, pomposity, conceit, shadows • *China: nobility* • *India: reincarnation* • *Thailand: mourning, widows*
Brown	• Positive: earth, comfort, reliable, stability, simplicity, coffee and chocolate • Negative: gloom, melancholy, sad and wistful, boredom
Gray	• Positive: practicality, stability, reliability • Negative: sadness, boredom

(continued)

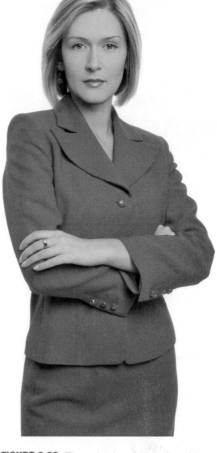

FIGURE 6.30 *The red color of this suit and its tailored style suggest that this woman is in a position of authority.*

Source: Carlosphotos/Dreamstime

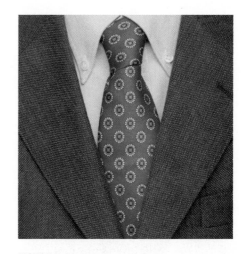

FIGURE 6.31 *Red ties are often known as power ties. They are frequently seen on politicians and leaders of industry.*

Source: Nfsphoto/Dreamstime

FIGURE 6.32 *Chinese bride and groom wearing red, a symbol for good luck.*
Source: chinatiger/Fotolia

Beige	• Positive: neutral, wealth, earthy • Negative: plain and boring
Black	• Positive: authority, power, sophistication, good, religion (priests and nuns), wealth • Negative: authority, power, evil and the devil, sin, sadness and death, poverty, heavy and depressing • *China: for young boys, trust, high quality* • *Thailand: bad luck, unhappiness*
White	• Positive: purity, goodness, innocence, cleanliness, pristine, wholeness, simplicity, weddings and brides, hospitals, doctors, nurses, angels, newness, fresh start • Negative: cold, isolating and empty, sterile, detachment and disinterest, fastidious, boring • *China: death and mourning, age, misfortune. Modern Chinese women, often want Western style wedding dresses, but usually choose a cream- or ecru-colored dress rather than a white one.* • *India: unhappiness, death, rebirth, funerals, coldness. Married Indian women would never wear unrelieved white as it is seen to be inviting widowhood and unhappiness.* • *Japan: peace, death* • *South Africa (Zulu): goodness*

FIGURE 6.33 *Western cultures consider pink to be feminine and usually youthful.*
Source: blessings/Shutterstock.com

Warm and Cool Colors

In most cultures the terms *warm* and *cool* have emotional connotations and suggest different personalities. A very pale skinned woman, with silvery blond hair, wearing a pale blue formal suit will appear cool and may be perceived as having a "cool temperament," and being aloof and unfriendly, but competent and efficient. On the other hand, a woman with a ruddy complexion and auburn hair, wearing a red, yellow, and green patterned dress will be perceived as warm and friendly.

Color and Moods

- Warm colors may create passion.
- Bright colors and warm colors evoke happiness.
- Bright colors are stimulating (Figure 6.35).
- Dark colors, particularly dark cool colors, and low-intensity (drab) colors suggest unhappiness or depression.
- Cool colors tend to have a calming effect (Figure 6.36).
- Dark, dull colors are relaxing.
- Cool, dull, subtle colors are intriguing.

FIGURE 6.34 *This yellow hat and jacket suggest youth, happiness, and vitality.*
Source: © T.Tulic Fotolia

Color and Gender

- In America, warm light colors are perceived as soft and feminine.
- In America, cool, dark, and bright colors are perceived as masculine.

FIGURE 6.35 *The high-intensity hues of this boot are exhilarating and stimulating.*
Source: © Glow Images/SuperStock

FIGURE 6.36 *This blue dress creates a sense of calmness and serenity.*
Source: dhorsey/Shutterstock.com

FIGURE 6.37 *Gray suggests sophistication and maturity.*
Source: crystalfoto/Shutterstock.com

- Western cultures consider pink to be feminine as seen in Figure 6.33, and blue as masculine.
- For sports uniforms dark bright colors are seen as masculine. (In America not even the toughest football or hockey player would wear a pink uniform.)
- In China the yin/yang symbol represents the balance of natural forces. The dark area represents feminine energy and the light area masculine energy.

Color, Age, and Sophistication

When considering color, age, and sophistication, there are two separate issues—the colors preferred by different ages, and the perception of age and sophistication created by different colors. Both are culture dependent.

- Research suggests that at three to four months, babies prefer primary colors.
- Traditionally, in Western societies babies have been dressed in white or pastel colors. In recent years, baby outfits in bright and dark colors have become available.
- As children grow, they start to notice secondary and tertiary colors.
- Bright, intense colors seem to be young and often look inappropriate on an older person.
- Primary colors suggest youthfulness and vitality (Figure 6.34).
- Teenagers often go through a rebellious stage when they like to wear dark drab clothing.
- Bright, warm colors and tints seem young and carefree.
- Dull colors and shades suggest age and mellowness.
- Light colors suggest innocence and youth.
- Black and dark values suggest experience and sophistication.
- Beige and gray are often perceived as sophisticated (Figure 6.37).
- Primary colors suggest simplicity and tertiary colors sophistication.
- Research suggests that educated and richer women prefer complex secondary and tertiary colors.

Color and the Seasons

Certain colors evoke certain seasons.

- Pastel colors and bright hues suggest spring and summer.
- Dull shades and less intense hues suggest the fall and winter.
- Shades of warm colors, browns, and earth tones suggest autumn.
- Light blue and bright white may suggest the cold of winter.

Application of Color in Apparel Design

The color (or colors) selected for a garment may be based on the simple fact that the designer likes the color. Often the instincts of a designer are based on the designer's awareness of fashion trends and of the life style and preferences of the target market. However, in order to successfully market a clothing line, a designer should have a good understanding of color. The right color *will sell* a garment; the wrong color will not sell at any price. The problem is to know what is the right color for a given set of customers.

Some factors a designer should consider when selecting colors were discussed earlier in this chapter. These include: the physical effects of colors, the physiological effects of color, the emotional effects of colors, colors appropriate for different seasons and climates, and colors appropriate for the age of the customer. Designers should also consider the following aspects of color: color schemes and how colors work together, fashion color trends and color forecasting, personal coloring and clothing, colors for different special occasions and events, and the effects of color on the figure.

Color Schemes

Designers and stylists may use any combination of colors they wish, as long as the colors are appealing to the customer. See Table 6.2. However, there are certain traditional color schemes that are considered to be harmonious. A young designer should be aware of these and be able to discuss them (if for no other reason than she/he does not want to appear ignorant when new to the work-world).

There are two traditional types of color schemes—related and contrasting. Related color schemes use hues that are close together on the color wheel and tend to produce more subdued and calming effects. Contrasting schemes use opposing hues and tend to create a more active dramatic effect. For all color schemes it is important to consider not just hue, but the intensity and value of the colors and the amount of a particular color that is used. Do not forget that a small amount of a bright hue will balance a larger amount of a duller color.

Color Forecasting

Each season new colors become fashionable. Color follows the typical fashion cycle. Garments in new colors are introduced, usually at a high price point, and only a few fashion-forward customers buy them. Over time, the color is used on lower-priced garments and many people

TABLE 6.2

Types of Color Schemes

Name and Example	Description	Effect
Monochromatic color scheme	Uses one hue in a variety of values (light to dark) or intensities (dull to bright).	Provides a feeling of peace and quiet, unity and harmony (Figure 6.38).
Analogous color scheme 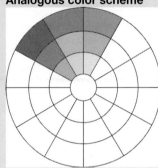	Uses three or more hues that are next to each other on a 12 hue color wheel, for example, green-blue, blue, blue-lilac.	Creates visual unity and a sense of balance and completeness. Harmony is greatest if the middle hue is a primary color (Figure 6.39).
Complementary color scheme 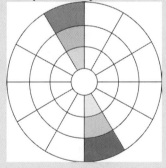	Uses two hues directly opposite each other on the color wheel, one warm and the other cool.	Gives the most intense contrast. It creates a vibrant look, especially with full hues. Generally, a small area of the warm hue will balance a larger area of the cooler hue (Figure 6.40).
Adjacent complementary color scheme 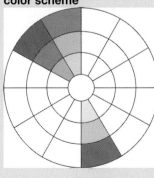	Uses three hues: two complementary hues and the hue next to one of them, for example, red and green and blue-green.	Produces a contrast without the extremeness of a complementary scheme. When using two cool colors, a small amount of a complementary warm color may provide a highlight and focal point.

(continued)

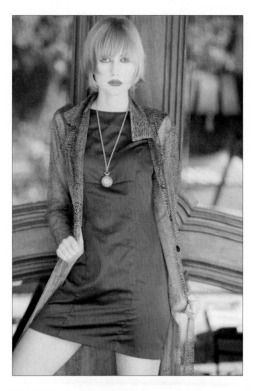

FIGURE 6.38 *This outfit is in a monochromatic color scheme; it has three different shades of brown. The color unites the ensemble to create harmony.*
Source: Rebecca DeVaney/Alamy

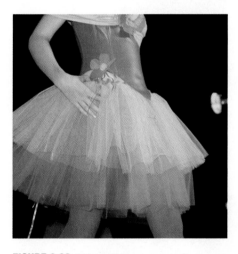

FIGURE 6.39 *This outfit has a sense of completeness and balance created by the analogous color scheme, including the adjacent colors, yellow, orange-yellow, orange, orange-red, red, red-magenta.*
Source: © Ronald Hudson/Fotolia

FIGURE 6.40 *The contrast created by the use of complementary colors creates a vibrant appearance.*

Source: Mikhail Lukyanov/Dreamstime

FIGURE 6.41 *The single split complementary color scheme of this dress creates contrast but a balanced harmony.*

Source: Inga Marchuk/Shutterstock.com

TABLE 6.2
Types of Color Schemes *(continued)*

Name and Example	Description	Effect
Single split complementary color scheme 	Uses three hues: one hue and the two on each side of its complement, for example, red and blue-green and yellow-green.	Produces a harmonious contrast that may be vibrant or mellow depending on the intensities of the hues (Figure 6.41).
Double complementary color scheme 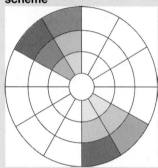	Four hues: two adjacent hues and their complements.	The contrast is less than that produced by a complementary scheme, and so less exciting, except when the hues are high intensity.
Double split complementary color scheme 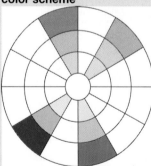	Four hues: with one hue on each side of complementary hues. For example, red and green are complementary colors, so red-orange and red-blue with yellow-green and green-blue would be a double split complementary scheme.	This is a rich color scheme with many variations. However, it is usually best if one color is allowed to dominate.
Tetrad color scheme 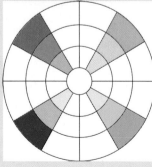	Has four hues equidistant from each other on the color wheel, for example, red, green, yellow-orange, and purple-blue.	This is the hardest scheme to balance and it is best to allow one color to dominate.

(continued)

TABLE 6.2
Types of Color Schemes *(continued)*

Name and Example	Description	Effect
Triadic color scheme	Has three hues arranged equidistant from each other around the color wheel, for example, red, blue, and yellow, or green, violet, and orange.	This scheme creates a strong visual contrast but appears more harmonious and balanced than a complementary color scheme (Figure 6.42).
Discordant color scheme	The colors are widely separated on the color wheel but not complementary, such as red and yellow-green.	These schemes are eye-catching and may be used to get attention. They may be visually disturbing when the colors seem to clash (Figure 6.43).

FIGURE 6.42 *This dress has a triadic color scheme. There are approximately equal amounts of each color, so the dress appears balanced, vibrant, and exciting.*
Source: podgorsek/iStockphoto

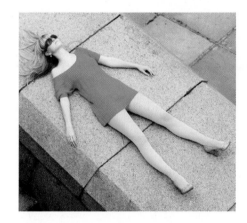

FIGURE 6.43 *This is an example of a discordant color scheme. The colors seem to clash, but the effect is eye-catching.*
Source: Goncharuk/Shutterstock.com

FIGURE 6.44 *The violet sweater and cool red scarf complement this woman's cool bluish-colored hair and bluish-pink skin tone, making her skin glow and hair appear shiny.*
Source: © Corbis/SuperStock

buy clothing in that color, and the fashion-forward move on to the next color. Eventually, a color becomes obsolete and is found only in the sale racks. How this works was explained in the movie *The Devil Wears Prada* (2006, 20th Century Fox), when the editor of a fashion magazine states:

> that sweater is not just blue, it's not turquoise, it's not lapis, it's actually cerulean. You're also blithely unaware of the fact that in 2002, Oscar De La Renta did a collection of cerulean gowns. And then I think it was Yves St Laurent, wasn't it, who showed cerulean military jackets? I think we need a jacket here. And then cerulean quickly showed up in the collections of eight different designers. Then it filtered down through the department stores and then trickled on down into some tragic casual corner where you, no doubt, fished it out of some clearance bin.

Color trend forecasting is performed by companies that research and evaluate economic and social changes, fashion in different parts of the world, trends in the entertainment business, and other factors. The predictions are sold to textile and design companies so that they have two or more years to create textiles and designs for a future season. Those who cannot afford to use a trend forecaster can usually find indications of trends for the coming one or two seasons in *Women's Wear Daily* and at various websites.

Personal Coloring and Clothing Design

A designer should consider creating each garment in several different color combinations, or use several different-colored groupings within a collection, because no one color looks good on everyone. How a color looks on an individual depends upon the person's combination of skin, hair, eye, and lip coloration. The color of clothing may make skin look clear and glowing and hair bright and healthy, or it may drain color from the skin and make the hair look drab.

There are several theories for analyzing personal coloring. Generally, people with cool coloring, skin with bluish or pink undertones and blond hair appear more attractive when wearing cool colors, as seen in Figure 6.44. People with warm coloring look better in warm colors.

People with little contrast in their personal colors look drab in bright intensities, but people with strong contrast in personal coloration can wear bright intensities and strong contrasts.

Colors for Special Occasions and Events

When selecting a color, a designer should consider the target market and the occasion for which a garment will be worn. Traditionally in any society, different colors are used for different events and activities. In Western societies, wedding dresses are usually white, cream, or ecru; Christening dresses and first communion dresses are white; and people wear black or dark, low-intensity colors for funerals. The colors of work clothing will tend to be more subdued than the colors of clothing worn for social and evening events. Cool dark colors are conservative and so appropriate for business and quiet events. Warm bright colors give a friendly feeling and so are appropriate for parties, recreation, and some occupations, such as nursery school teacher. For job interviews, it is traditional to wear suits in black, navy, or dark gray.

The Effects of Color on the Figure

In Western societies and those influenced by Western media, women want to look tall and slim. Warm, bright, and light colors make the figure appear larger and cool, dark, and dull colors make it appear smaller. Color contrasts draw the eye's attention. An outfit that is the same color from the shoulders to the knee or ankle is slimming. A vertical area of a cool or light color down the center of the body has a slenderizing effect and vice versa (Figure 6.20). An outfit with contrasting colors between the top and skirt or pants will cut the apparent height and have a broadening effect. Horizontal panels of a contrasting color, such as a belt or yoke, have a widening effect (Figure 6.22). A bright color worn near the face draws the eye vertically and creates a slenderizing effect (Figure 6.25).

Summary

Color sells. It is the first thing a customer looks at when selecting clothing.

The term *hue* means the name of a color. Value is the lightness or darkness of a color. Tints are lightened hues and shades are darkened ones. Black, white, and gray are true neutrals, with value but no hue. Intensity is the brightness of a color. Blue, green, and violet are cool colors. Red, yellow, and orange are warm colors.

Additive color theories relate to the effects of light and subtractive theories to pigments. Primary colors are ones that cannot be created by combining other colors. Secondary colors are created by combining two primary colors; tertiary colors are created by combining a primary color and an adjacent secondary color. Color systems are practical guides for color mixing and for discussing the visual impact of specific color combinations. In the Prang color system, the three primary colors are red, blue, and yellow; the secondary colors, violet, orange, and green. Complementary colors are opposite each other on the Prang color wheel. The CMYK color system is used in the print industry and by most computer printers.

Color can cause physiological effects. Red increases blood pressure, pulse, respiration, and body temperature, and blue lowers blood pressure, pulse, and respiration.

Light values, bright intensities, and warm colors make the body appear large, and dark colors will shrink the areas they cover. Light values and warm colors appear to advance, and dark and cool colors recede. Dark colors absorb more heat than light ones, so they are literally warmer. Dark values, cool colors, and dull intensities seem more humid and light values and bright intensities seem drier.

After-images may be seen when a viewer looks away from a bright image. A background color will push a hue toward the complement of the background.

Color has the most profound emotional effects of any of the aspects of design. Color affects our moods; our moods affect our clothing color choices. No color has any inherent intrinsic "meaning." The emotions associated with colors vary from culture to culture. In Western societies, bright colors and warm colors evoke happiness; dark, cool, and low-intensity colors suggest unhappiness. Warm bright colors are stimulating and suggest drama; cool, dark, dull colors are relaxing. Warm light colors are perceived as soft and feminine; cool, dark, and bright colors are considered masculine. Primary colors suggest youthfulness and vitality, whereas dull colors and shades suggest age and mellowness.

When selecting colors for a garment a designer should consider: the physical effects of colors; the physiological effects of color; the emotional effects of colors; colors appropriate for different seasons and climates; colors appropriate for the age of the customer; color schemes and how colors work together; fashion color trends and color forecasting; personal coloring; colors for different special occasions and events; and the effects of color on the figure.

A designer may use any combination of colors, but there are traditional color combinations that are thought to be harmonious. When using these color schemes, the intensity and value of colors and the amount of color that is used should be considered. Each season new colors become fashionable. Because people have a variety of skin, hair, and eye colors, no one color looks good on everyone.

terminology

adjacent complementary color
 scheme 75

after-image 67

analogous colors 63

analogous color scheme 75

chroma 62

CMYK color system 65

complementary colors 62

complementary color
 scheme 75

cool color 62

discordant color scheme 77

double complementary color
 scheme 75

double split complementary color
 scheme 76

hue 60

intensity 62

irradiation 68

luminosity 61

monochromatic color
 scheme 75

Munsell color system 64

neutral 62

physiological effects 65

pointillism 67

Prang color system 63

Prang color wheel 63

primary color 63

saturation 62

secondary color 63

shade 61

simultaneous contrast 65

single split complementary color
 scheme 76

tertiary color 63

tetradic color scheme 76

tint 60

tone 61

triadic color scheme 77

value 60

warm color 62

activities

1. Look at the selection of colors below. Now try and match the following names with the colors: candy apple red, cardinal, carmine, crimson, fire brick red, Ferrari red, fire engine red, orange/red, red, ruby, scarlet, tomato.

Compare within the class to see if everyone agrees on the color names. Check with the list of colors at http://en.wikipedia.org/wiki/List_ of_colors.These are the colors used by some computer operating systems and image editing software.

2. Digital, additive color mixing. On a PC, open Microsoft Paint (found in Accessories in Windows) or any other digital graphics software. In the edit color function, click in turn on each of the following colors; red, green, blue, yellow, cyan (turquoise),

magenta, orange, brown, black, gray, white. In a table format (as shown below) note the value of the hue, sat. (saturation), lum. (luminescence), red, green, and blue for each color.

Color Name	Hue	Sat.	Lum.	Red	Green	Blue
Red						
Green						
Blue						
Yellow						
Cyan (turquoise)						
Magenta						
Orange						
Brown						
Black						
Gray						
White						

3. Using magazines, catalogs, or the Internet find pictures of three different outfits. Mount each image on a separate sheet of paper. Write an explanation of the physical and emotional effects of the colors of each outfit.

4. Select a color scheme. Sketch a full-color outfit of your own design that uses this color scheme. Add a title that indicates the color scheme you are using and the customer you are designing

for. Write a paragraph explaining how the colors you used are appropriate for your customer and the physical and emotional effects of the color in the design.

5. In groups, use fabric swatches held against the face, to determine which colors are flattering for varying skin, hair, and eye coloration.

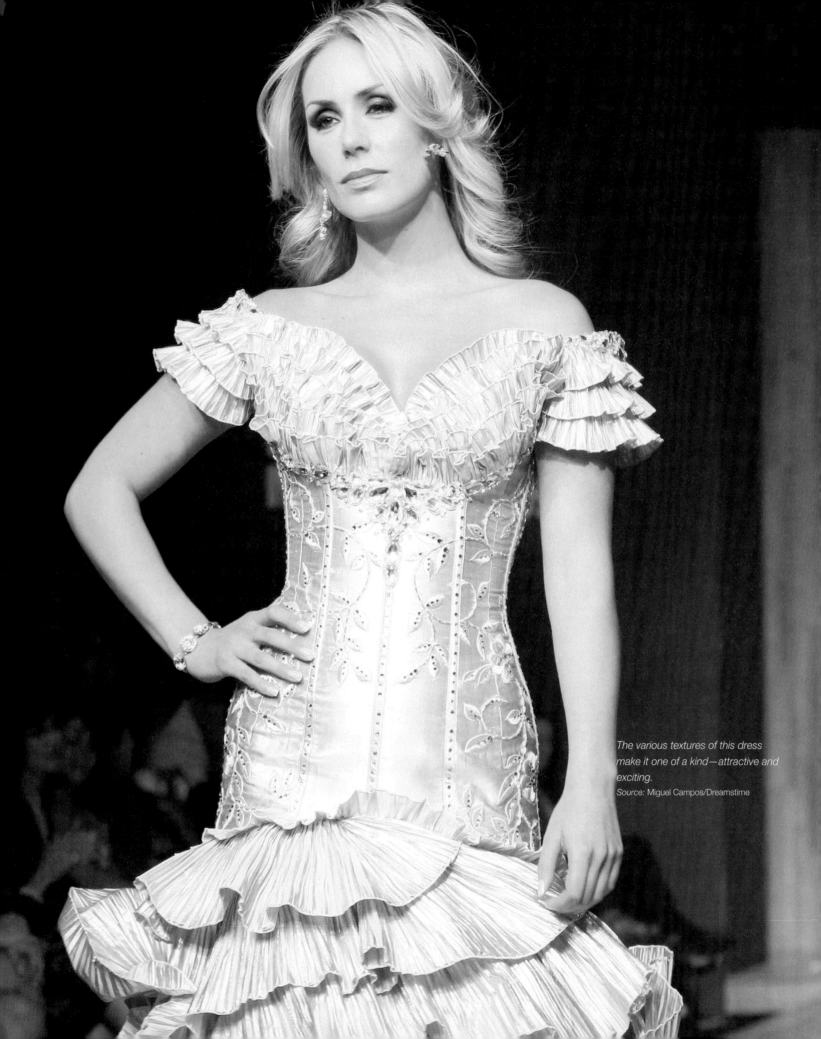

The various textures of this dress make it one of a kind—attractive and exciting.
Source: Miguel Campos/Dreamstime

TEXTURE

After studying this chapter you should be able to:

1. Define the concept of texture.
2. Evaluate how texture is created in fabrics.
3. Evaluate the physical effects of texture.
4. Evaluate the emotional effects of texture.
5. Discuss the application of texture in apparel.
6. Summarize texture as a design aspect.

7

Introduction to Texture

Every surface has texture. When we wear clothing, the body is in contact with the texture of the fabrics used. Knowledge of textures is important not only to create an aesthetically pleasing outfit but also to ensure the comfort of the person wearing the outfit. Texture appeals to the senses of touch, sight, and hearing.

Definition of Texture

Texture is the surface quality of an object. It can be perceived by touch or sight. In clothing, texture of fabric in motion can also produce sounds. **Hand** refers to the way a fabric feels, not just the surface, but the whole fabric as it is folded, crushed, squeezed, or otherwise manipulated. **Drape** is the way a fabric hangs or falls into soft or crisp folds.

The following are a few of the terms that describe texture:

airy	downy	lacy	porous	slippery
bristly	dull	leathery	prickly	smooth
bubbly	feathery	limp	puckered	soft
bulky	fine	lustrous	quilted	solid
bumpy	firm	lumpy	rough	stretchy
coarse	flexible	matte	rubbery	supple
compact	furry	metallic	sandy	thick
cool	fuzzy	nonstretchy	satiny	thin
crinkly	glossy	nubby	scaly	transparent
crisp	glazed	open	scratchy	tough
curly	hairy	opaque	shear	velvety
delicate	hard	pleated	shiny	woolly
dense	harsh	pliable	silky	warm

The properties of textures are described by their position on a continuum between opposite terms such as *smooth/rough, slippery/harsh*. Some of the physical properties of hand and drape, and the terms used to describe them are shown in Table 7.1.

TABLE 7.1

Textural Properties of Fabrics

Property	Definition	Range		Subjective Method of Assessment
Fabric Hand and Surface Properties				
Surface contour	Deviations from flatness	rough ⟷	smooth	Rub fingers across the fabric
Surface friction	Resistance to slipping offered by the surface	harsh ⟷	slippery	Slide the fabric over the back of your hand
Thermal character	Fabric temperature compared with skin temperature	cool ⟷	warm	Rest fabric on the arm for a minute
Drape and Hand				
Flexibility	Ease of bending	pliable ⟷	stiff	Bend the fabric between the hands

Property	Definition	Range		Subjective Method of Assessment
TABLE 7.1 Textural Properties of Fabrics *(continued)*				
Compressibility	Resistance to crushing	soft ←→ hard		Squeeze the fabric between the fingers
Extensibility	Ease of stretching	stretchy ←→ nonstretchy		Pull the fabric in opposite directions using two hands
Resilience	Ability to recover from bending and other deformation	springy ←→ limp		Squeeze the fabric into a ball, then release
Density	Weight for a unit volume	compact ←→ open		Hold the fabric up to the light
Thickness	The distance from one surface to the other	thick ←→ thin		Visually examine the edges of the fabric
Light Reactions				
Luster	The way light reflects from a surface	shiny ←→ dull		Visual examination
Opacity	The ability to block out light	opaque ←→ transparent		Visual examination

(a)

Creation of Texture in Clothing

In apparel, texture is created by the fabric, construction techniques, and the use of trims and embellishments such as embroidery and beading. A visual perception of texture can be created by a pattern printed on a fabric.

For fabrics, it is the combination of the fibers, yarns, method of fabric construction, finishes, and colorations that create texture. For example, wool fibers used for clothing are soft and flexible. If wool is twisted into a tight fine yarn and tightly woven, it will create a fine fabric with a smooth surface (Figure 7.1a). If the same wool is loosely twisted into a bulky yarn and loosely knitted to create a sweater, the texture will be soft and fluffy (Figure 7.1b).

Fiber and Yarn Structure

Fibers are the hairlike strands used to make fabrics. To make most fabric, fibers are combined into **yarns** by twisting, a process known as **spinning**. Figures 7.2a and 7.2b show silk and cotton fibers in their natural state. How the properties of fibers and yarns affect fabric texture are explained below:

1. *Fiber Length:* Short fibers such as cotton, wool, and cut manufactured fibers, known as **staple**, are twisted together tightly in order to make a yarn that does not fall apart. Staple yarns feel warm and fuzzy, and have a dull surface because of the many fiber ends (Figure 7.1b). Tightly twisted yarns are smoother and fairly shiny, but may be stiff. Long fibers, called **filaments**, like those of reeled silk and manufactured fibers, hold together with a loose twist to produce yarns with a high **luster** and smooth, cool feel. They usually create a soft, flexible fabric that drapes into soft pleats. Tightly twisting filament yarns reduces luster and flexibility.

2. *Fiber Surface:* Natural fibers (wool, cotton, linen, but not silk) have rough surfaces that appear dull and feel warm. Silk and round **synthetic fibers** (manufactured from chemi-

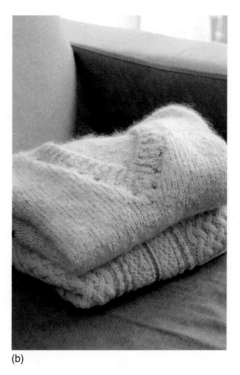

(b)

FIGURE 7.1 *Different effects created from the same fiber: (a) tightly twisted wool yarn woven to create smooth, firm worsted fabric used for this suit and (b) loosely twisted wool yarn was knitted to create warm, fuzzy sweaters.*

Source: (a) © Rubberball/Rubberball/Corbis (b) Fotosearch/Superstock

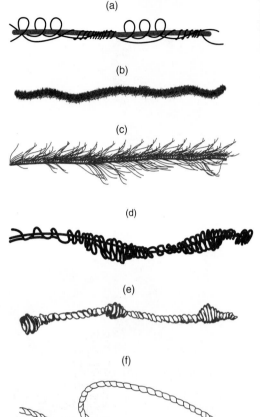

FIGURE 7.3 *Novelty yarns: (a) bouclé yarn, (b) chenille yarn, (c) eyelash yarn, (d) nub or knot yarn, (e) seed or flock yarn, and (f) slub yarn.*

FIGURE 7.2 *Fibers in their natural state: (a) shiny silk in a cocoon before spinning into yarn and (b) dull cotton fibers on a cotton boll.*

Source: (a) YasuhideFumoto/JupiterImages (b) Laurin Rinder/Shutterstock.com

cals) have smooth surfaces that appear shiny and feel smooth and cool. Synthetic fibers may be made or treated to appear dull and feel warm. Wool and some other animal fibers have a scaly surface and so look dull and may feel itchy.

3. *Fiber Crimp:* Wool fibers are naturally **crimped** or wavy. Some synthetic fibers are crimped by machine. Crimped fibers create soft, dull yarns with many air spaces. Because air is a good insulator, fabrics from these yarns keep the wearer warm.

4. *Fiber Thickness:* Thick fibers make stiff yarns and fabrics with little flexibility. If the fibers are staple, the yarn and fabric will be rough and scratchy.

5. *Novelty Yarns and Texture:* **Novelty yarns** have interesting textures; some have different thicknesses along their length and others have small lumps in the yarn structure. Many novelty yarns are created by twisting together two or more yarns to produce intricate patterns. Most novelty yarns produce dull, heavy, thick fabric that feels soft and warm. Novelty yarns are very popular with hand-knitters. Figures 7.3 a–f show a variety of novelty yarns, and Figures 7.4 a–c show fabrics made from novelty yarns.

(a)

(b)

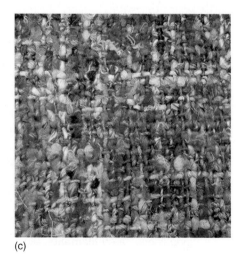

(c)

FIGURE 7.4 *Fabrics made from novelty yarns: (a) fabric knitted using bouclé yarn, (b) fabric knitted using eyelash yarn, and (c) fabric woven using several different slub yarns.*

Source: (a) from the collection of Julia Sharp, (b) Anne Kitzman/Shutterstock.com (c) Ragne Kabanova/Shutterstock.com

Fabric Structure

There are many ways to create fabrics. Knits and wovens are the most commonly used fabrics for clothing.

1. *Woven Fabric:* Woven fabric is created by interlacing two sets of yarns at right angles. Woven fabrics tend to be strong and stable, with almost no stretch. Generally they do not cling to the body. Weaving can produce many different textures, from smooth satin to the roughest tweed, depending on the type of weave and the yarns used (Figures 7.5, 7.6, 7.7).

2. *Knit Fabric:* Knitted fabrics are made by interlooping yarns. They tend to be soft and flexible, wrinkle resistant (resilient), and to conform to the body contours. Most are stretchy. There are many varieties of knits with different structures, surface textures, and hands, such as the smooth warp knits used for lingerie, smooth-surfaced weft knits used for T-shirts and sweatshirts, knit velvet and velour used for bathrobes, and the heavy cable knit used for sweaters (Figures 7.8 and 7.9).

3. *Other Types of Fabric:* Other types of fabrics such as lace, macramé, felt, films, and braids each have their own unique textures and hands (Figure 7.10).

(a)

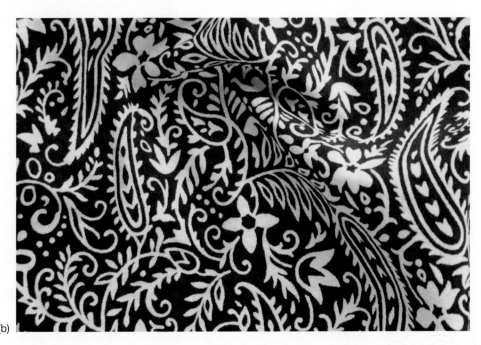
(b)

FIGURE 7.5 *(a) Diagram of a plain weave. (b) Part of a plain weave fabric bandana with a printed design. A plain weave fabric like this generally gives a firm fabric with a smooth surface. It may drape well or be fairly stiff, depending on the yarns used. It is a good surface for printing.*
Source: Alice Day/Shutterstock.com

(a)

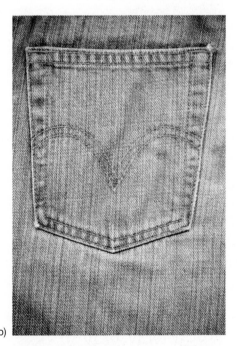
(b)

FIGURE 7.6 *(a) Diagram of twill weave. (b) Part of a pair of jeans made from a twill weave denim. Twill weaves wear well and are generally firm and rather stiff.*
Source: Laurent Dambies/Shutterstock.com

(a)

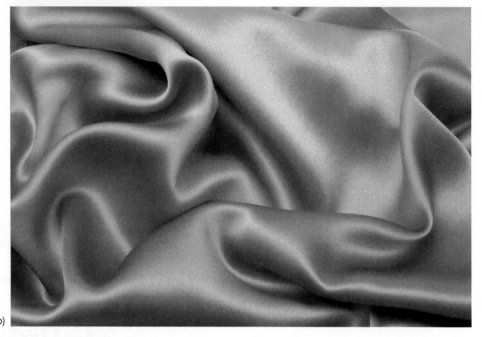

(b)

FIGURE 7.7 *(a) Diagram of a satin weave. (b) Satin fabrics like this are lustrous and sensuous. When woven tightly, satin fabrics have body and are firm. When loosely woven, the fabric is more pliable.*
Source: ultimathule/Shutterstock.com

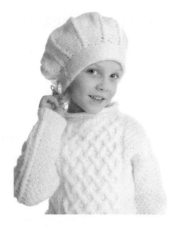

FIGURE 7.9 *This cute sweater and hat show a variety of textures created by the use of different knitting stitches.*
Source: Gladskikh Tatiana/Shutterstock.com

(a) (b)

FIGURE 7.8 *Different types of knits. (a) Diagram of plain Jersey weft knit. (b) Diagram of a warp knit.*

FIGURE 7.10 *This Chantilly lace evening gown by Yves St. Laurent is both delicate and sophisticated. (Image courtesy of the Godwin-Ternbach Museum, Queens College, the City University of New York.)*
Source: Godwin-Ternback Museum

Finishes

Finishes are processes used to alter fabric or fiber properties. They are used for either functional or aesthetics purposes but almost all influence texture. Heat and pressure are used when ironing to remove the wrinkles and smooth the surface of a woman's dress. Greater heat and pressure are used to create high-luster fabrics and moiré effects as seen in Figure 7.11.

Chemical treatments make cotton smoother. **Napping** (brushing a fabric) provides a soft fuzziness like the inside of a sweatshirt. Sometimes small fibers are glued to a fabric surface to form a texture either in the form of a pattern or to give the appearance of velvet. Some finishes are not permanent, and even those that are may relax or wear off with use and care, to leave a new set of textural properties.

Embellishments and Trim

Garment embellishments and trims such as lace, ribbons, braids, appliqué, beads, sequins, feathers, buttons, zippers, and even painting affect hand and drape, as do functional notions such as interfacing and boning. Figure 7.12 shows texture created by embroidery and beads. The texture of a notion can change the look of a garment. A blazer with shiny brass buttons will look masculine and sporty; the same blazer with buttons covered in glossy silk will look more feminine and dressy.

Appearance of Texture Created by Pattern

Patterns printed on a fabric may create an implied texture (Figure 7.13).

FIGURE 7.11 *Moiré—texture created by heat and pressure.*
Source: © Exactostock/SuperStock

FIGURE 7.12 *The texture on this bridal fabric is created by embroidery and beads.*
Source: lozas/Shutterstock.com

FIGURE 7.13 *The print on this outfit suggests a three-dimensional texture.*
Source: lenetstan/Shutterstock.com

Texture from Garment Structure

Seams, gathers, darts, pleats, ruffles, smocking, shearing, puckering, quilting, and fringing may create textural effects, as seen in the chapter opening image and Figure 7.14.

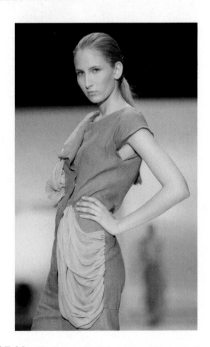

FIGURE 7.14 *The interest in this garment is created by the texture formed by the gathered chiffon.*
Source: Gordana Sermek/Shutterstock.com

Physical Effects of Texture

Color

Colors generally seem lighter on a shiny, smooth surface but they also appear flat. Colors on textured fabrics may appear dark because of shadows. The color on a napped fabric, such as velvet, may appear different when viewed from different directions. The colors of sheer fabrics can be changed by the color of a lining or the skin of the wearer being seen through the fabric.

Texture and Body Temperature

The thickness and **density** of a fabric may determine whether the wearer feels warm or cool. Thick, dense fabrics may prevent heat escaping from around the body. Air is a poor conductor of heat, so thick, loose fabrics, with many tiny air pockets, such as a knitted sweater, will keep a wearer warm when there is no wind (Figure 7.15). Fine, tightly woven fabrics may also keep the user warm by trapping a layer of insulating air between the skin and the clothing.

Illusions of Body Size

- Smooth, shiny fabrics increase apparent size and weight, as described in Chapter 6.
- Bulky, rough-textured fabric will conceal the figure but make the body seem larger (Figure 7.16).
- Stiff fabrics stand away from the body and visually add volume, enlarging a heavy figure and overwhelming a small one.
- The use of light- to medium-weight, dull, smooth, firm fabrics with one texture throughout the outfit creates the illusion of added height and decreased size and weight.

Emotional Effects of Texture

The look and feel of a texture can cause strong emotional reactions. When we are sick, we all want to curl up in a warm, fuzzy blanket; a bright, shiny metallic fabric may be stimulating in a club, but it will seem inappropriate in a workplace. The history of some fabrics has given them symbolic meanings. Velvet was very expensive to produce and so became associated with luxury. Before manufactured fibers, fabric made from silk, an expensive fiber, was the only fabric with a high luster. Today, fabrics that look like silk still suggest sumptuousness. Some of the more common emotions associations with different textures are listed below:

- Fuzzy—warm, approachable, relaxed, calming. Examples: blankets, sweatshirts, fake furs (Figure 7.17).
- Smooth—cool, controlled, sophisticated, simple. Examples: business suits and blouses, men's dress shirts (Figure 7.18).
- Smooth with a medium luster—feminine, sensuous. Examples: silk blouses, some wedding dresses.
- Shiny—formal. provocative, sensuous, fun. Examples: wedding and bridesmaids' dresses, formal evening wear, club wear.
- Coarse—casual, natural, unrefined, masculine. Examples: tweed jackets and vests, heavy knitted sweater.

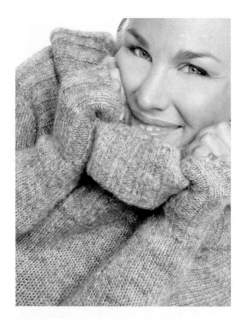

FIGURE 7.15 *This soft, flexible knit sweater is comfortable to wear and keeps the wearer warm.*
Source: Andrew Howard/Fotolia

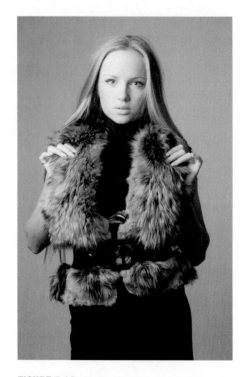

FIGURE 7.16 *Bulky fabric increases apparent size.*
Source: margo_black/Shutterstock.com

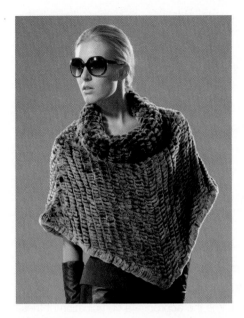

FIGURE 7.17 *The fuzzy surface of this garment suggests that it will be warm and comfortable to wear.*

Source: hifashion/Shutterstock.com

FIGURE 7.18 *Smooth textured fabrics are appropriate for business wear.*

Source: Mark Fairey/Dreamstime

FIGURE 7.19 *This shiny dress is young, fun, and provocative.*

Source: ardni/Shutterstock.com

- Thick—warm, lush, comforting. Examples: knitted sweaters, bathrobes.
- Thin and transparent—delicate, fragile. Example: lingerie.
- Lightweight—young, free-spirited.
- Feathers and feathery effects—delicate, sensuous (Figure 7.20).
- Fur—warm, comfortable, sumptuous.
- Lace—feminine and delicate, sometimes sensual (see Figure 7.10). Example: lingerie.
- Leather—boldness, strength, sensuality (Figure 7.21).

FIGURE 7.20 *Feathers may seem delicate, and sensuous.*

Source: Veronika Vasilyuk/Shutterstock.com

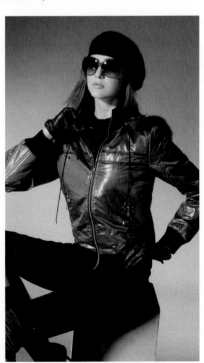

FIGURE 7.21 *Although this model looks feminine, the leather jacket suggests strength.*

Source: hifashion/Shutterstock.com

FIGURE 7.22 *A garment covered completely in sequins can appear harsh and make the wearer seem aloof and unfriendly.*

Source: Stephen Orsillo/Shutterstock.com

• Sequins and beads—boldness and strength or femininity, but may seem harsh if they cover a large area (Figure 7.22).

Textures project moods by their sounds as well as by touch and appearance. The crackle of leather seems sporty and earthy. The rasp of corduroy as it rubs against itself suggests casual, comfort, and country settings. The swish of satin and the rustle of taffeta seem refined and elegant. The jangle of necklaces and trim suggests lighthearted casualness.

The Applications of Texture in Apparel Design

The texture of a fabric determines its suitability for a garment style or purpose. All aspects of texture should be considered—softness, stiffness, smoothness, roughness, flexibility, stretchiness, density, thickness, sheerness, and so forth. It is the appropriate combination of these characteristics that is important for function and creating harmony within the garment and between the garment and the wearer.

Some of the factors a designer should consider when selecting fabric textures were discussed earlier in this chapter. These include: the effect of texture on the perception of body size, the effect of texture on body temperature, and the emotional effects of texture. Designers should also consider the following aspects of texture: texture and garment function, texture and ease of care, texture and comfort, the effect of texture on drape and fit, combining textures, and texture and personal attributes.

Texture and Garment Function

The fabric of a garment should be attractive and fashionable, but it must also have a texture that is serviceable, durable, and comfortable to wear. Abrasion on a fabric may create a new texture. For jeans, worn fabric is at times considered desirable (Figure 7.23).

• Smooth, firm fabrics wear well and are good for business wear, work clothing, and athletic wear.
• Novelty fabrics with highly textured surfaces may wear out quickly where bumps jut out above the surrounding fabric. They should be made out of a durable material such as polyester or used for special occasion wear. Thicker textured fabrics will last longer than thinner ones.
• Pile fabrics, such as velvet, velveteen, and corduroy, have soft comfortable surfaces but continuous pressure may flatten the surface. Corduroy with the lowest pile will flatten the least. Velvet is lovely for evening dresses when the wearer is standing up for some hours, but a truck driver wearing velvet pants to work will soon have a flattened posterior.
• High-contour fabrics and those with loose surface yarns, such as knits, lace, and satins, are subject to snagging. A snag occurs when a yarn is caught on a rough edge, such as a broken finger nail or damaged sewing needle. The yarn is pulled away from the fabric, leaving tight yarns on either side. The pulled yarn may break and in knitted fabrics this may lead to localized unraveling of the fabric. Expensive fabrics subject to snagging should be used with caution and are best when used for special occasion garments.

FIGURE 7.23 *When jeans are worn, a new, often desirable, texture is formed.*

Source: Jeff Thrower/Shutterstock.com

- The **surface friction** of a fabric is important. Coats and jackets with rough surfaces are hard to put on over other clothing so these garments are usually lined with a slippery lightweight fabric. To overcome the necessity of a lining, some textured fabrics are smoother on the inside or may have a smooth fabric glued to one surface.
- Athletic wear should be made of flexible, stretchy fabric that does not impede movement. Speedo sells swimsuits for racing, which are made out of LZR Pulse™ fabric that is not only flexible and stretchy but also reduces surface friction and water drag by up to 5 percent.

FIGURE 7.24 *Stiff rough sackcloth.*
Source: Photo Ambiance/Fotolia

Textures and Ease of Care

Knits tend not to wrinkle and so do not need to be ironed. Fabrics made from synthetic fibers and some novelty fabrics either do not wrinkle or do not show wrinkles. Smooth, firm, woven fabrics that contain cotton, linen, or rayon will wrinkle if they have not been treated with a wrinkle-resistant finish. Such fabrics will need to be ironed to maintain a firm crisp appearance.

Texture for Comfort

Soft, flexible, stretchy fabric is more comfortable to wear than a stiff, harsh fabric. Knits generally have more flexibility than woven fabrics (Figure 7.15). Stiff and heavy fabrics may restrict movement. Highly textured fabrics and fabrics made of stiff, staple fibers are often itchy. In biblical and medieval times people donned sackcloth (burlap, a heavy scratchy fabric) as a symbol of repentance and humility. Burlap is shown in Figure 7.24. As noted above, the texture of clothing can also help to maintain a comfortable body temperature.

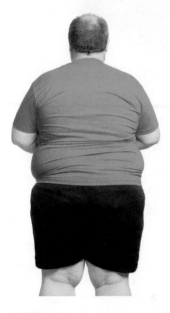

FIGURE 7.25 *Stretchy knit fabrics are comfortable to wear but often cling to the body.*
Source: Mark Hayes/Shutterstock.com

The Effect of Texture on Drape and Fit

The same garment design made in different fabrics may have very different appearances. A gathered skirt in a soft, flexible fabric will cling to the body; in a crisp, stiff fabric the same pattern will create a bouffant style that hangs away from the body.

- Soft, flexible fabrics tend to cling to the body contours. Because of the comfort of knits and the dictates of fashion, clothing made from thin, smooth, stretchy fabric is very popular. Such clothing reveals the *six-pack* of a fit, young man, but on some people may reveal less attractive body bulges as shown in Figure 7.25. A garment can be made less clingy by adding a lining.
- Soft draping fabrics that do not cling closely to the body will create garments with a curved, body-shaped silhouette and soft feminine gathers and folds as seen in Figure 7.26.
- Generally soft draping fabrics, and knits in particular, will not hold the pressed pleats and sharp edges of tailored garments.
- Medium-weight, smooth, firm, woven fabrics hold their shape. They skim over the body and can conceal the figure without adding the appearance of weight. Crisp fabrics do not need support from the body; the garment shape is created by seams, darts, pleats, and gathers. Firm, crisp fabrics can create silhouettes that stand out from the body such as full skirts and puff sleeves.

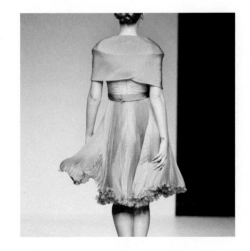

FIGURE 7.26 *This soft draping fabric creates feminine gathers and folds.*
Source: .shock/Shutterstock.com

Combining Textures

IN ONE GARMENT

Different textured fabrics are combined for functional or decorative purposes. In either case it is important that the fabrics are compatible; for example, a fabric that should be laundered should not be combined with one that needs dry cleaning.

- Interfacing, interlinings, and linings are used to change the properties of a fabric. Interfacing provides stability and body on collars, cuffs, necklines, and waistbands. Interlinings between a fashion fabric and a lining are usually, soft, flexible, loose-textured fabrics used to provide extra warmth. A lining provides an interior finish to a garment and allows the garment to slide smoothly over the body.
- Using stretchy and nonstretchy fabric on the same garment may lead to puckering and/or stretching of one of the fabrics.

An area of a different texture on a garment will attract attention to that area. Examples include a glossy piping around the edges of a dull jacket, lace on the yoke of a nightdress, feathers around the hem of a dress, and a sequined appliqué on a shoulder.

IN AN ENSEMBLE

Ensembles with more than one texture are more interesting than those with only one texture, but care should be taken to assure a harmonious and united effect, both physically and emotionally (Figure 7.27).

FIGURE 7.27 *All the textures of this dress suggest evening wear and the vibrancy of youth.*
Source: Lucky Business/Shutterstock.com

Texture and Personal Attributes

Care should be taken that clothing texture does not emphasize skin flaws by repetition or contrast. Satin will flatter young smooth skin, but make wrinkled or spotty skin appear more irregular. Lizard skin texture will emphasis old, wrinkled skin; tweeds and spotted textures may highlight freckles and zits or other skin imperfections.

summary

Texture is the surface quality of an object. Texture can be perceived by touch and sight; it is how a fabric feels (hand) and hangs (drape). The properties of a texture, which are expressed in opposite terms include: surface contour, surface friction, thermal character, flexibility, compressibility, extensibility, resilience, density, thickness, luster, and opacity. These qualities depend on a combination of fiber, yarn, fabric construction, and finishes. A visual perception of texture may be created by a pattern printed on a fabric.

The texture of yarns depends upon fiber length, surface texture, thickness, crimp, and the amount of twist in the yarn. Novelty yarns create fabrics with interesting textures. Fabrics created by weaving generally do not cling to the body and tend to be strong and stable, with almost no stretch. Knitted fabrics tend to be stretchy, soft and flexible, wrinkle resistant, and tend to conform to the body contours. Finishes alter fabric or fiber properties for either functional or aesthetics purposes. Seams, gathers, darts, pleats, ruffles, smocking, shearing, puckering, quilting, and fringing also create texture.

Texture can affect the perception of color and size. Thick textures with many air spaces are insulators.

Texture can cause emotional reactions. Fuzzy fabrics suggest calmness and relaxation; smooth, firm textures seem businesslike or sporty; shiny fabrics may be provactive; soft draping fabrics are feminine and sensuous; and coarse fabrics are masculine and casual. Textures also project moods by the sounds made by when fabrics rub together.

The texture of a fabric determines its suitability for a garment style or purpose. The fabric of a garment should be attractive and fashionable, but it must also have a texture that is serviceable, durable, and comfortable to wear. Designer should consider the emotional effects of texture; the effects of texture on color, the perception of body size, body temperature; comfort, ease of care, and drape and fit; the combination of textures; and how texture relates to personal attributes.

terminology

compressibility 95
crimp 86
density 90
drape 84
extensibility 95
fiber 85
filament 85

flexibility 95
hand 84
luster 85
napping 89
novelty yarns 86
opacity 95
resilience 95

spinning 85
staple 85
surface friction 93
synthetic fibers 86
texture 84
yarn 85

activities

1. Using magazines, catalogs, or the Internet, find pictures of five different garments: one formal business wear, one sportswear, one active wear, one evening wear, and one child's garment. Mount each image on a separate sheet of paper. Write an explanation of why the texture of the fabric used for each garment is appropriate for the garment function.

2. Pick three fabrics from a selection provided by your instructor. Describe the mood evoked by these fabrics and how the fibers, yarns, fabric construction, and finishes used contribute to your emotional response. Compare your responses with those of other members of your class.

3. Complete the following table:

Construction Technique or Style	The Surface and Hand Properties Needed for This Technique	Appropriate Fabrics for This Technique
Draping		
Flares		
Pressed pleats		
Unpressed pleats		
Smocking		
Puffed sleeves		
Tailored collar		

4. From the list of fabrics below, select three. Research the properties of each fabric. Design a garment appropriate for each of the fabrics. Sketch the garments and write an explanation about why the texture of your fabric is suitable for your design.

boiled wool	broadcloth	brocade
calico	canvas	chiffon
corduroy	double knit	flannel (cotton or wool)
gabardine (cotton or wool)	Jersey knit	lace
microfiber	organdy	polar fleece
satin	taffeta	terry cloth

5. Pretend you work for a pattern company and are responsible for listing recommended fabrics on the pattern envelopes. From a pattern book select two different patterns. For each select a fabric and then list its name, fiber content, and method of construction. Justify your choice, discussing the properties of the fabric as described in Table 7.1.

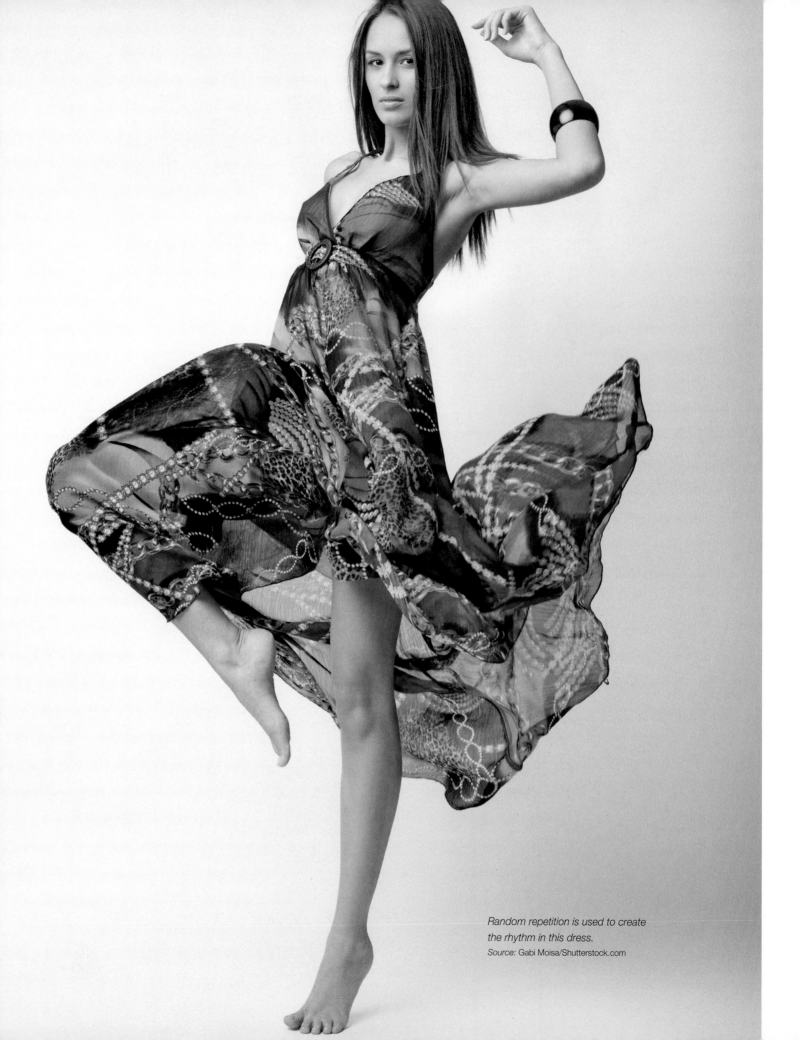

Random repetition is used to create the rhythm in this dress.
Source: Gabi Moisa/Shutterstock.com

REPETITION
and RHYTHM

After studying this chapter you should be able to:

1. Define repetition.
2. Evaluate the creation and effects of:
 - Repetition
 - Parallelism
 - Alternation
 - Sequence
 - Gradation
 - Radiation
 - Concentricity
3. Define rhythm.
4. Evaluate the physical effects of rhythm.
5. Evaluate the emotional effects of rhythm.
6. Discuss the application of rhythm in apparel.
7. Summarize the uses of repetition and rhythm as aspects.

8

Introduction to Repetition and Rhythm

Repetition is the use of the same thing more than once in different locations. **Rhythm** created by repetition has a powerful effect that may range from monotonous to startling. Repetition and rhythm help the mind find order in a design. They may be very simple or extremely complex.

Repetition

Lines, shapes, colors, textures, and patterns may be repeated in an irregular manner or in a variety of organized ways including **parallelism**, **alternation**, **sequence**, **gradation**, **radiation**, and **concentricity**. Repeated patterns create rhythm.

Repetition can occur in structural elements such as pleats, ruffles, and tucks; as repeat motifs in a fabric; or as applied trim, such as lace, fur, braids, and even buttons, which are functional as well as decorative (Figure 8.1). Because the two sides of a human body are similar, each side of a garment is usually a mirror repetition of the other, as shown in Figure 8.2.

FIGURE 8.1 *(a) Repetition of lines in garment structure draws the eye across. (b) Repetition of shape emphasizes the direction of the repeat. (c) Repetition in trim causes the eye to jump from place to place. (d) Repetition of decoration creates unity.*

FIGURE 8.2 *Like the human body, one side of this garment is a mirror image of the other, giving the impression of stability and balance.*

Source: © Duane Osborn/Somos Images/Corbis

The Effects and Application of Repetition in Apparel Design

- Emotional effects
 - Good repetition produces visual consistency and a sense of reassurance (Figure 8.1).
 - Regularly repeating a design aspect pulls a garment together and creates harmony.
 - Widely scattered repeats may appear spotty and unrelated, and cause confusion (Figure 8.3).
- Humans tend to seek similarities, and so the eye moves from one element to its repeat (Figures 8.1 and 8.4). Repeats should go in the direction to be emphasized. Buttons placed down the front of a garment will guide the eye in a vertical direction and create an elongating effect (Figure 8.5). With horizontal repetition, such as pleats and epaulets, the eye will jump across, making the body seem wider (Figure 8.6). Use of matching trims on the neckline and hem of a garment will have a shortening effect, as the eye jumps from one to the other.
- Repeating an aspect of design reinforces its effects. For example, repeating delicate curved lines reinforces the impression of feminine gracefulness.
- Different sizes and placements of repeats affect the balance of a garment. Large elements at the top of a dress countered by repeated smaller versions at the hem will make the body look top-heavy. However, carefully placed repeats can create an interesting asymmetrical balance.
- Symmetrical garments, such as the one in Figure 8.2, where one side is a mirror image of the other suggest stability and balance. Asymmetrical garments, where garment components are not repeated, such as one-shouldered dresses, can be interesting, exciting, and eye-catching.

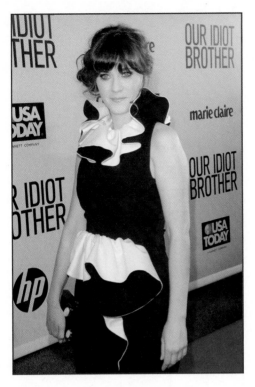

FIGURE 8.3 *The repetitions in this dress are eye-catching but disconcerting.*

Source: Dee Cercone/Newscom

FIGURE 8.4 *The eye follows the direction of a repeat.*

Source: © Eyecandy Images/Alamy

FIGURE 8.5 *The color and placement of these buttons creates an implied line and an elongating effect.*

Source: Tiplyashin Anatoly/Shutterstock.com

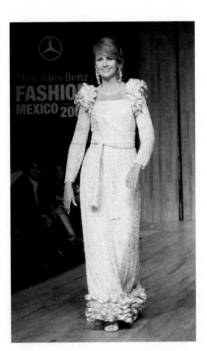

FIGURE 8.6 *This interesting shoulder decoration causes the eye to jump from side to side widening the shoulders to create balance with the hips.*

Source: Miguel Campos/Dreamstime

- Repeating colors or texture in accessories may tie an outfit together, or such repetition may be patchy and create undesired effects. In the past, hats, pocketbooks, gloves, and shoes were expected to match. This is no longer the case. A brightly colored hat and matching shoes will draw the eye from one to the other with a shortening effect. A bag the same color as a skirt may widen the look of the hips. Shoes that repeat the color of the legs (panty hose or trousers) will give the impression of long legs.

Parallelism

Parallelism is the use of lines, in the same plane, that are equidistant apart at all points. Structural parallelism is seen in the straight lines of seams (Figure 8.7) and pleats, shirring, straight waistbands and belts, cuffs and pockets, and in the curves of cowl necklines. Parallelism is used decoratively as pattern in fabric, applied trim, bindings, and topstitching.

Parallelism leads the eye either in the direction of the parallel lines or from line to line, as described in Chapter 2. The more parallel lines, the weaker the directional effect. Figures 8.8 and 8.9 show the effects of the use of parallelism.

Alternation

Alternation is a pattern in which two different lines, shapes, colors, textures, or patterns are repeated in turn, for example, dark-light-dark-light. The units alternating and the distance between them are consistent. Its use is usually decorative rather than structural. Parallelism may be a form of alternation (Figure 8.8).

The regularity of alternation can be reassuring, or it may be boring. Its emotional effects are strongest when alternating items convey the same mood (Figure 8.10). Alternation can contribute to rhythm, emphasis, balance, harmony, and unity (Figure 8.11).

FIGURE 8.7 *Seams are used to create parallelism and an elongating effect.*

FIGURE 8.8 *These closely spaced parallel lines have a mild elongating effect.*

Source: © Terry Vine/Blend Images/Corbis

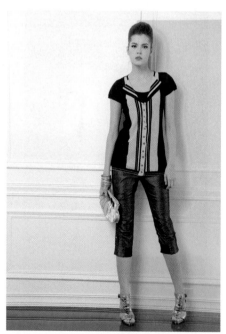

FIGURE 8.9 *The parallel vertical pattern in the upper area of this outfit increases apparent height as the eye moves up and down.*

Source: 101imges/Shutterstock.com

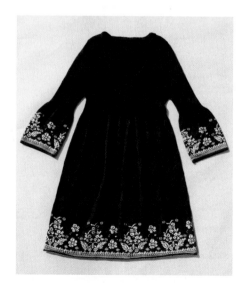

FIGURE 8.10 *The two alternating flower motifs create a gentle decorative effect.*

Source: © Jasonjung | Dreamstime

Sequence

Sequence is a serial arrangement in which things follow in a casual or logical order. Lines, colors, shapes, textures, or patterns may be arranged sequentially. If each unit in a sequence has a meaning that determines its position, such as letters and numbers, the series does not have to be repeated to achieve a sequence. Sequence is more easily used as decoration than structure.

Like parallel lines, sequenced items may lead the eye across or along the sequenced items creating a widening or elongating effect. Sequencing may build to a climax, release, and then repeat (Figure 8.12).

Gradation

Gradation is a more complex type of repetition. It is the use of a series of gradual/transitional changes in the use of an aspect, for example, a transition from lighter to darker colors or a series of shapes consecutively changing in size. Gradation can be structural, such as changes in the length of darts, tucks, draping, or the tiers of a skirt. It may also be decorative, created by fabric colors or patterns or applied ornamentation.

Gradation has a linear effect. Gradation draws the eye in the direction of change and can draw attention towards a body feature; it can also disguise body features, as the pattern creates a climax. In size gradation, the larger motifs seem to enlarge and small ones minimize (Figure 8.13). It is usual to place small items near the neck and waist and larger ones at the shoulders and hem. Color gradation should be used with care. It is usual to have the darker shades near the hem. This can lead to the hips appearing large since lighter colors enlarge (Figure 8.14). Emotionally gradation suggests assertiveness and straightforwardness.

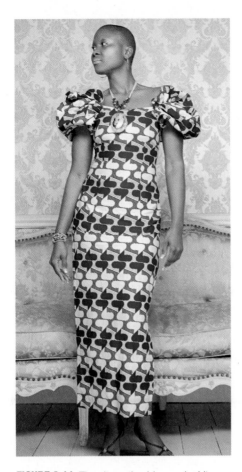

FIGURE 8.11 *The alternating blue-and-white motifs in this dress creates cohesion and a strong regular rhythm like the beat of a drum.*
Source: IS969/Alamy

FIGURE 8.12 *In the hat and sweater, the sequence of colors builds to a focal climax at the darker shades.*
Source: © Colleen Cahill/Design Pics/Corbis

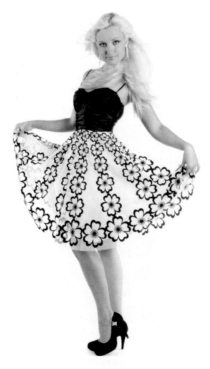

FIGURE 8.13 *The gradation of the motif draws the eye down and makes the waist look small.*
Source: VitCOM Photo/Shutterstock.com

FIGURE 8.14 *This gradation of color with the light at the top and the dark on the hips enlarges the shoulders and makes the hips look smaller.*
Source: coka/Shutterstock.com

(a)

(b)

Radiation

Radiation is the use of design lines that spread out in all directions from a central point (Figure 8.15a). Sometimes the lines do not start at an actual central point but if they were continued they would converge, for example, accordion/sunray pleats on a skirt stop at the waist, but if they continued upwards, they would meet at a central point (Figure 8.15b). For radiation effects, the lines may be decorative, created by patterned fabric or applied embellishments, or they may be structural, such as seams, darts, some pleats, and draping.

Radiation has a variety of effects and commands attention. Usually, it leads the eye out from the central point (Figure 8.16), but it may lead the eye inwards (Figure 8.17). Areas at the center of radiation appear reduced in size and those at the outer edge appear enlarged. Lines should start and end where attention is desired. Care should be taken that the center is not in an awkward spot such as one breast or the crotch. Radiation contributes to rhythm and emphasis.

Concentricity

Concentricity is a progressive increase in size of layers of the same shape, each with the same center, like a target. It is perpendicular to radiation. Most uses of concentricity are decorative.

Although concentricity is a form of repetition, it does not usually lead to rhythm in a garment. It forces attention to the central point of the design motif. Concentric designs are bold and demanding. They draw attention to the areas they cover, so great care must be taken in the placement of them (Figure 8.18).

FIGURE 8.15 *Radiation: (a) The radiation effect caused by the gathers in this dress creates a focal point at the waist. (b) The radiation effect of the gathers in this top draws the eye to the face.*

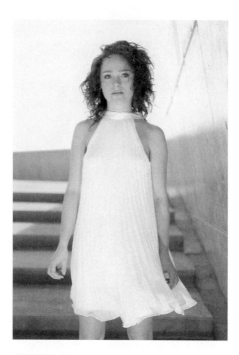

FIGURE 8.16 *The radiating pleats draw attention away from the face.*

Source: Rune Johansen/Photolibrary

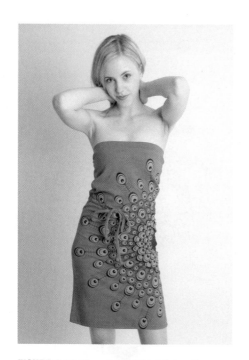

FIGURE 8.17 *The effect of this fabric with design motifs radiating from a central point is to draw the eye to the left hip.*

Source: Cindy Hughes/Shutterstock.com

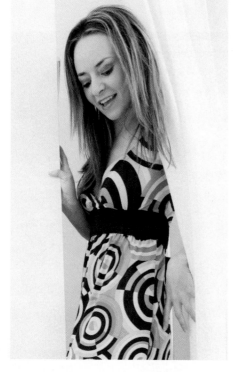

FIGURE 8.18 *Concentricity draws the eye to the center of the motif.*

Source: © Ryan Smith/Somos Images/Corbis

Rhythm

Definition of Rhythm

Rhythm is the feeling of organized movement. It is the movement of the eye across a repeating pattern. It may be created by structural details but is most often the result of fabric design as seen in Figure 8.19. Rhythm suggests motion, but the rhythmic feel should exist when the wearer is standing still. Like rhythm in music, visual rhythm has beats and accents (Figure 8.20).

Terms that describe rhythm in music are used to describe visual rhythm and include the following:

animated	jumpy	smooth	swirling
bouncing	lilting	staccato	syncopated
bounding	marching	stately	tripping
energetic	military	swaying	undulating
flowing	sedate	sweeping	vibrating
jerky	skipping	swinging	whirling

Physical Effects of Rhythm

- Rhythm emphasizes the direction in which the movement flows.
- By its size, direction, and energy rhythm influences the apparent dimensions of an area.
- Active rhythms draw attention and enlarge.

Emotional Effects of Rhythm

The main emotional satisfaction of rhythm is its predictability and the perception of order (Figure 8.21). It decreases complexity and pulls an ensemble together.

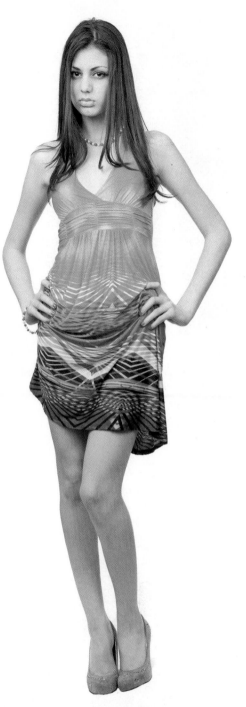

FIGURE 8.19 *The variation in color and pattern of this dress creates a complex rhythm. The top of the dress with the irregular orange and yellow pattern suggests a staccato rhythm, while the large curves near the hem produce a lilting, flowing effect.*
Source: Catalin Petolea/Shutterstock.com

FIGURE 8.20 *The repetition of the sleeve colors in the headdress and the radiation effects of the sleeves give this dance outfit an animated rhythm.*
Source: © Jack Hollingsworth/Blend Images/Corbis

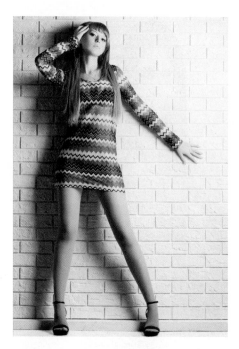

FIGURE 8.21 *The alternation of colors in this dress produces a regular rhythm like a heartbeat—predictable and reliable. The zigzag effect gives the outfit vitality.*

Source: Perov Stanislav/Shutterstock.com

The emotions evoked by rhythms depend upon the patterns and repetitions. They can range from boredom to excitement or from playful to forceful.

- Barely suggested rhythm seems sophisticated.
- Too much rhythm is irritating.
- If the eye has to jump to follow the rhythm, the effect is tiresome and confusing.
- Unequal-sided objects such as paisleys create dynamic rhythms.
- Different rhythms and emotions are developed by different types of line:
 - Thin lines create a tripping rhythm and a feeling of lightness.
 - Scalloped lines give a lilting effect and may suggest youth.
 - Broken lines suggest a staccato rhythm.
 - Irregular lines give a lively syncopated effect.
 - Gently curved lines suggest an undulating rhythm (Figure 8.22).
 - Irregular curves (like frills) suggest youth and gaiety.
 - Jagged and zigzag lines suggest jerky vibrations.
- Rhythms and emotions produced by repetition:
 - Short and smooth repetitions and rhythms are calming.
 - Parallelism and alternation suggest order and regimented rhythms (Figure 8.21).
 - Gradation leads to rhythmic climax and seems exciting and assured.

Application of Rhythm in Apparel Design

The designer should create a rhythm in a garment that evokes the image and mood desired. The style and personality of prospective customers should also be considered. Sometimes a rhythm can be overwhelming on a more introverted person (Figure 8.23). Rhythm can be created by structure or decoration. It can be produced by a single line, or the perception of a line, such as the edges of a frill (Figure 8.24). More often, it is caused by repetition of lines, color, texture, shape, or pattern, or a combination of these. The repetitions can be irregular, parallel, alternating, sequenced, graded, or radiating.

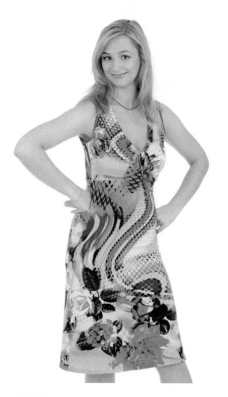

FIGURE 8.22 *Although the colors of this dress are vibrant, the sweeping curved lines from top to bottom suggest a swaying, undulating rhythm.*

Source: TEA/Shutterstock.com

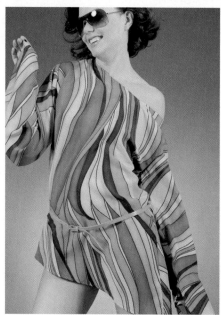

FIGURE 8.23 *The rhythm of this dress could be overwhelming on a shy or introverted person.*

Source: Timurpix/Shutterstock.com

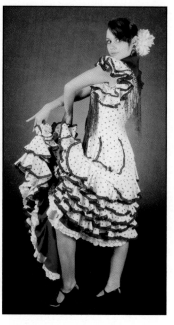

FIGURE 8.24 *A light tripping rhythm created by the edges of a frill.*

Source: Anneka/Shutterstock.com

summary

Repetition is used to organize a design. It is the use of the same thing more than once in different locations. Items may be repeated in an irregular manner or in a variety of organized patterns including parallelism, sequence, alternation, gradation, radiation, and concentricity. Regular repetition pulls a garment together and creates harmony. Repetition is directional; it leads the eye either in the direction of the repetition or in some cases across the repetition. In clothing, repetition can be produced structurally by seams, darts, pleats, draping, and so forth or it may be created by decoration in the colors and patterns of fabric or by applied embellishments.

Rhythm is the feeling of organized movement. It emphasizes the direction in which the movement flows, and can influence the apparent dimension of an area by its size, direction, and energy. It can be created by a single line, but is more often produced by repetition. The emotions evoked by rhythms depend upon the patterns and types of repetition used. They can range from boredom to excitement and from playful to forceful. Rhythm in apparel can be created by structure or decoration.

terminology

alternation 100
concentricity 100
gradation 100

parallelism 100
radiation 100
repetition 100

rhythm 100
sequence 100

activities

1. Sketch a full-color outfit of your own design that uses repetition to produce one of the following effects— sophistication, youth, happiness, calmness. Add a title to indicate which effect you are creating. Write a paragraph explaining the effect of the repetition in your design.

2. In groups of two or three, try on your clothing with different accessories such as shoes, bags, gloves, and hats. Take digital photographs of six different combinations. Place the images in PowerPoint slides. For each, write a description of the effects observed. In particular note:

 - The effect of using the same color and/or texture in different accessories
 - The effect of wearing clothing and accessories with the same color or texture as the clothing
 - The effect of using accessories with a different color from that of the clothing

3. Online, find a fabric with a printed repeating pattern. Print a copy of the fabric. Design and sketch in color an outfit that uses this fabric. Write an explanation of the physical and emotional effects produced by your design.

4. Find images that represent two of the following design aspects: alternation, concentricity, gradation, parallelism, radiation, repetition, rhythm, sequence. Mount each image on a separate sheet of paper and create backgrounds that reinforce the principle in the image. Add a title.

5. Listen to several pieces of music provided by your instructor. Use one of the musical selections as inspiration to design an ensemble with rhythm. Draw a color sketch of the outfit. Add a title indicating which music was your inspiration. Write an explanation of how the eye moves across the rhythm of your design and the emotional effect your design evokes.

6. Find four images, one to represent each of the following:

 - Rhythm created by alternation
 - Rhythm created sequence
 - Rhythm created by gradation
 - Rhythm created by radiation

 Place your images in PowerPoint slides or paste them to separate sheets of paper. Add an appropriate title. Write a paragraph for each image. Describe the following:

 - Which aspects are used to create the rhythm
 - How the eye follows the rhythm
 - The physical and emotional effects of the rhythm

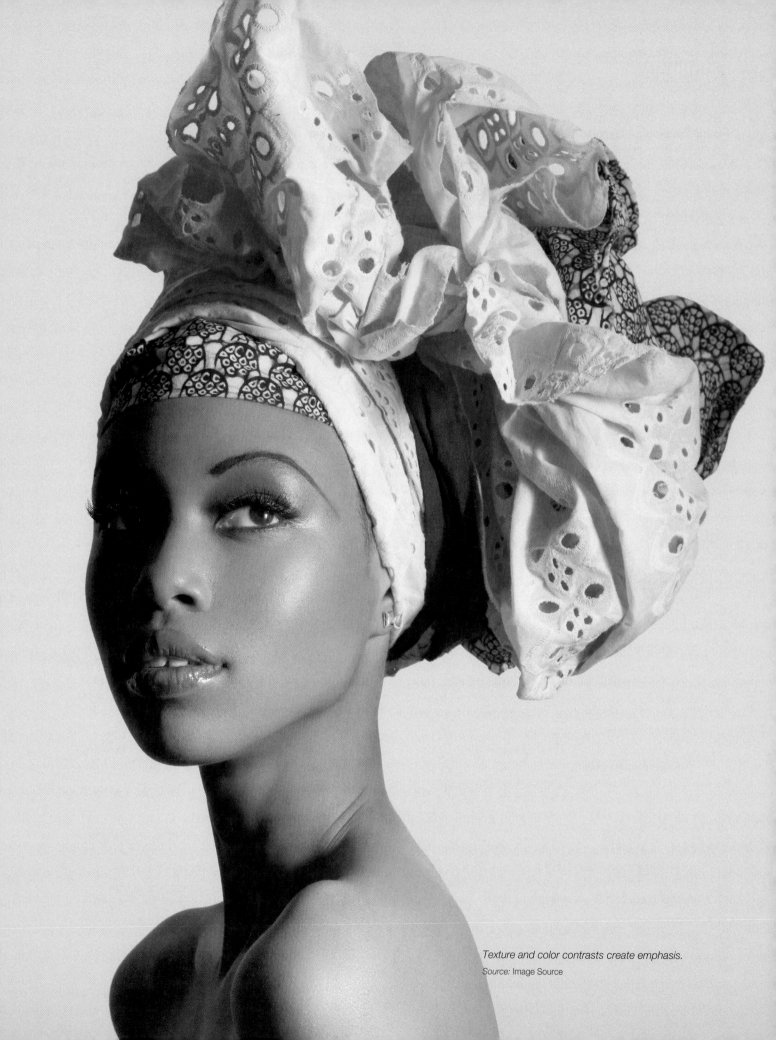

Texture and color contrasts create emphasis.
Source: Image Source

CONTRAST
and EMPHASIS

After studying this chapter you should be able to:

1. Define contrast and emphasis.
2. Evaluate the physical effects of contrast and emphasis.
3. Evaluate the emotional effects of contrast and emphasis.
4. Evaluate the application of contrast and emphasis in apparel design.
5. Discuss the importance of the contrast continuum.
6. Summarize the use of contrast and emphasis as design aspects.

9

Introduction

Contrast and emphasis are important aspects of design because they can be used to attract attention and stimulate the observer. As a result, the observer is encouraged to look further and examine the overall outfit. All previously presented aspects of design can be used to create contrast and emphasis.

The aspects of contrast and emphasis are presented together, because contrast is often used to create emphasis. For example, silver earrings and a silver pin on the lapel of a black wool suit use the contrasts of texture, light, and color to guide the observer's eye to the area of emphasis. In Figure 9.1 the contrast between the pattern of the blouse and the plain gold jewelry creates emphasis at the neck and face.

FIGURE 9.1 *The plain gold jewelry contrasts with the pattern of the blouse to create emphasis.*
Source: © Ocean/Corbis

Definitions of Emphasis and Contrast

Contrast is the sense of distinct difference or opposition. **Emphasis** is the creation of a center of interest or a focal point. Contrast and emphasis highlight, or draw attention, to an area. Contrast contributes to emphasis since the eye is drawn to the area where difference occurs. Contrast will be discussed first.

Contrast

Physical Effects of Contrast

Contrast is one of the most powerful of the design aspects. It commands attention. Since it draws attention to the area where it occurs, that area will tend to appear to be larger. It can also create a break that divides space. For example, a tall woman wishing to appear shorter would create waist interest with an interesting belt or sash. A short woman wishing to appear taller should avoid any break at the waist. The clothing displayed in Figure 9.2 would be appropriate for a woman wishing to appear shorter.

FIGURE 9.2 *The belt interest creates a division of space that counters apparent height.*
Source: hifashion/Shutterstock.com

Emotional Effects of Contrast

In general, contrast is dramatic and stimulating. Without contrast, garments will appear to be incomplete. Most viewers will experience the feeling that something is missing and will want to add something. For example, a simple black dress seems to need a pin, necklace, or scarf. The decorative necklace provides interesting contrast to the green top in Figure 9.3.

Contrast must agree with the overall feel of the garment. The stronger the contrast, the more aggressive the effect. Assertive contrast will overpower a delicate atmosphere. Gentle contrast will be lost in a bold garment. Compare the use of contrast in Figure 9.4. Contrast uses opposites but the overall effect needs to be harmonious. A good axiom to remember is that there should be enough contrast for interest, but not so much as to be overpowering.

Use of Contrast in Apparel

Contrast can be used structurally or decoratively. Contrast can apply to every aspect of design that has been presented. The designer can manipulate contrast to create the desired

FIGURE 9.3 *The decorative necklace provides interesting contrast.*
Source: Mihai Blanaru/Shutterstock.com

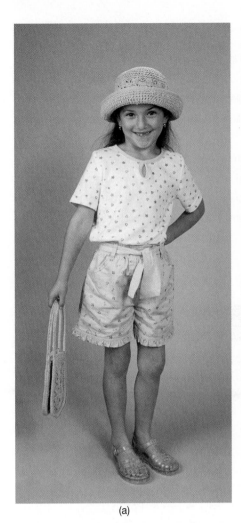

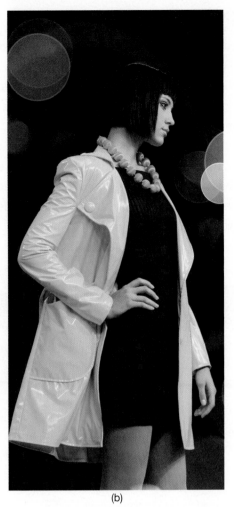

(a) (b)

FIGURE 9.4 *Compare the use of color and texture in (a) and (b). The little girl's outfit (a) is softer and more juvenille than the more aggressive contrasting colors and textures in (b).*
Source: (a) © Corbis / SuperStock (b) mashe/Shutterstock.com

FIGURE 9.5 *Use of contrast can be culturally, socially, and historically based.*
Source: Kiselev Andrey Valerevich/Shutterstock.com

mood. Each aspect of design can be used in preferred amounts and variations, and in combination with other aspects. Contrast must be used carefully in apparel. Too much contrast is confusing, whereas too little contrast is boring. Appropriate use of contrast can be culturally, socially, and historically based. See Figure 9.5.

STRUCTURAL AND DECORATIVE CONTRAST

Structurally, every garment has directional contrast. The silhouette edges are primarily vertical and shoulders, waistlines, and hems are primarily horizontal. Choice of fabric as well as construction details such as darts, pleats, and seams all provide opportunity for contrast. See Figure 9.6.

The designer is free to experiment with decorative contrast to achieve the desired appearance. Fabric pattern and color, applied trims, buttons, and so forth, all contribute to contrast. Even though there are multitudes of ways to incorporate decorative contrast into a garment, the designer is cautioned to use it carefully.

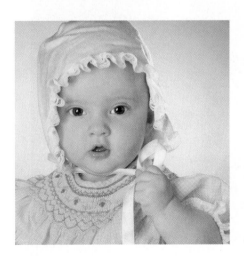

FIGURE 9.6 *The construction details of the smocking provide contrast.*
Source: Jason L. Price/Shutterstock.com

Contrast and emphasis **111**

CONTRAST CONTINUUM

Each aspect and each of its variations can be thought of as being on a continuum. For example, review Figure 3.14 to see some of the unlimited possibilities of contour. On a continuum of line contour, lines may be completely even or completely uneven. Lines may be straight, curved, jagged, looped, or wavy. Another example of a line continuum is line direction: A line may be vertical, horizontal, or at any angle in between.

See Table 9.1, Contrast Continuum, for examples of the many varieties of contrast. Either end of the continuum represents extremes. For example, lines may be very long as opposed to very short. The points between the extremes represent the levels of contrast that the designer can control. Both the physical and emotional effects of each aspect and variation of the aspect move along the continuum.

TABLE 9.1

Design Aspect	Contrast
	Continuum
Space	Filled ◄——► Unfilled
	Advancing ◄——► Receding
Line	
Direction	Any
Length	Long ◄——► Short
Thickness	Thick ◄——► Thin
Contour	Straight ◄——► Uneven
Texture	Solid ◄——► Porous
Shape and Form	Geometric ◄——► Organic
	Ordered pattern ◄——► Random pattern
Light	
Direction	Any
Brightness	Any
Color	
Value	Tint ◄——► Shade
Intensity	High intensity ◄——► Low intensity
Texture	Dull ◄——► Shiny
	Transparent ◄——► Opaque
	Smooth ◄——► Rough
	Thick ◄——► Thin
Balance	Symmetrical ◄——► Asymmetrical
	Horizontal ◄——► Vertical
Repetition and rhythm	Monotonous ◄——► Startling
	Simple ◄——► Complex

The color contrast continuum is important since people have an immediate response to color. Please review Chapter 6 Color very carefully. Contrast in value is especially important. Pure black and white contrasts, with no middle values, have the most impact. See Figure 9.7. When shades of gray are used, the impact is lessened and the result is softer. Too little contrast in value may be dull.

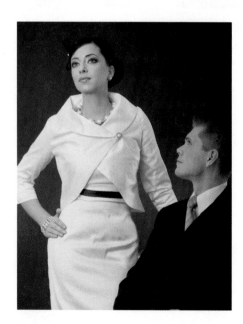

FIGURE 9.7 *The color contrast of black and white has the most impact.*
Source: StockLite/ SuperStock

Emphasis

Physical Effects of Emphasis

Because emphasis focuses attention where it occurs, it is important to consider carefully what is emphasized. All of the previously presented design aspects can be used to create emphasis. The physical effects of each should be reviewed carefully. Emphasis may be used to draw attention to the characteristic that the wearer considers to be most attractive. It is interesting to note that emphasizing a positive characteristic also takes attention away from negative characteristics.

Generally the face and neck are recommended as appropriate focal points. For most people, the face is the primary means of establishing identity. Additionally, more money and time is spent on facial and hair grooming than on any other part of the body. Neckline and collar treatments and jewelry are often used to direct attention to the face. See Figure 9.8.

Even though there can only be one center of attention, other areas of the body can be emphasized. As fashion trends evolve, areas of emphasis may shift. For example, the full bust was emphasized by the plunging necklines of the early 2000s, the very small waist was emphasized in the 1800s, and long thin legs were emphasized in the 1960s. Covering or uncovering a body part can contribute to emphasis. When styles demand a body part that has been previously covered be exposed, this contributes to emphasis due to the novelty of seeing it.

Repetition and contrast can be used effectively to create emphasis. In general, repetition can provide subtle emphasis and contrast can provide aggressive emphasis. Repetition can effectively reinforce desirable wearer characteristics or counter undesirable ones. On the other hand, they may do just the opposite.

FIGURE 9.8 *Neckline and hair decorations direct attention to the face.*
Source: Angela Hawkey/Shutterstock.com

Emotional Effects of Emphasis

Emphasis suggests organization and completion, but lack of emphasis suggests disorganization and uncertainty. As with the physical effects of emphasis, the emotional effects of all the previously presented design aspects should be reviewed carefully.

Countering and reinforcing are important components of the emotional effects of emphasis. If all the elements of a garment have similar qualities, they will reinforce each other. For example, a shiny nylon sports outfit with wide diagonal stripes of red and yellow suggests action, forcefulness, and energy. If the stripes were pale blue and pink, the overall effect would be reduced or countered by the choice of colors. Pale blue and pink are less forceful than red and yellow.

Use of Emphasis in Apparel

Effective use of emphasis in apparel depends on effective use of the previously presented design aspects. In well-executed designs, one aspect will dominate; others will be subordinate.

Here are some suggested guidelines for effective use of emphasis in apparel. These guidelines summarize concepts presented in other chapters.

1. A line dominates the area it divides.
2. Shape emphasizes the area it occupies.
3. Extremes in fullness or fit will emphasize the areas they cover.

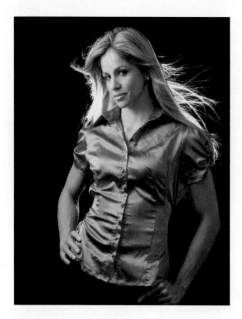

FIGURE 9.9 *A shiny blouse draws attention to and enlarges the bodice.*
Source: GeoM/Shutterstock.com

FIGURE 9.10 *The texture of the lace draws attention to the bust.*
Source: Luba V Nel/Shutterstock.com

4. Shiny highlights enlarge and draw attention to the areas they cover. See Figure 9.9.

5. Dull surfaces minimize size.

6. Unusual textures or advancing hues highlight an area. See Figure 9.10.

7. Advancing and receding spaces are effective in creating emphasis.

8. Countering and reinforcing are effective in creating emphasis.

9. Placement of emphasis will influence balance.

10. The scale of motifs will affect emphasis. (See Chapter 11 for additional discussion of scale.)

11. Garment edges emphasize the body parts they are near.

12. Trim and jewelry are more noticeable on plain backgrounds than on patterned ones.

summary

Contrast and emphasis are used to attract attention and stimulate the observer who is encouraged to look further and examine the overall outfit. All aspects of design can be used to create contrast and emphasis. Contrast is the sense of distinct difference or opposition. Emphasis is the creation of a center of interest or a focal point.

Contrast is one of the most powerful of the design aspects because it commands attention. Because it draws attention to the area where it occurs, that area will tend to appear to be larger. Contrast uses opposites, but the overall effect needs to be harmonious. Contrast can be used structurally or decoratively. Structurally, every garment has directional contrast. The silhouette edges are primarily vertical; shoulders, waistlines, and hems are primarily horizontal. Choice of fabric as well as construction details such as darts, pleats, seams, and so forth all provide opportunity for contrast. Fabric pattern and color, applied trims, buttons, and so forth all contribute to contrast.

Each aspect and each of its variations can be thought of as being on a continuum. Both the physical and emotional effects of each aspect and variation of the aspect move along the continuum.

It is generally recommended that the face and neck are appropriate focal points because the face is the primary means of establishing identity. Emphasis suggests organization and completion, whereas lack of emphasis suggests disorganization and uncertainty. Effective use of emphasis in apparel depends on effective use of the previously presented design aspects.

terminology

contrast 110
emphasis 110

activities

1. Do an Internet search to find images of the following works of art:
 a. *Mourning Picture*—Edwin Romanzo Elmer
 b. *Laziness*—Felix Vallotton
 c. *Dancing in Colombia*—Fernando Botero

 Discuss how the artist creates contrast/emphasis in these works of art.

2. Using construction paper and patterned paper, each student should create examples of contrast/emphasis. Analyze the examples for physical and emotional impact.

3. Using a variety of fabrics of different colors and patterns, evaluate the use of contrast/emphasis. Determine the physical and emotional effects. Suggest appropriate end uses for the fabrics.

4. Using historic and ethnic costume books, find examples of contrast/emphasis in historic and ethnic apparel. Analyze the physical and emotional impact of the use of contrast/emphasis in the apparel.

5. Using magazines, catalogs, or the Internet, find examples of contrast/emphasis in contemporary apparel. Analyze how the designer's use of contrast/emphasis affects the emotional and physical impact.

6. Using fellow students as models, the class members can evaluate the use of contrast/emphasis in each other's apparel and discuss the impact of the contrast/emphasis.

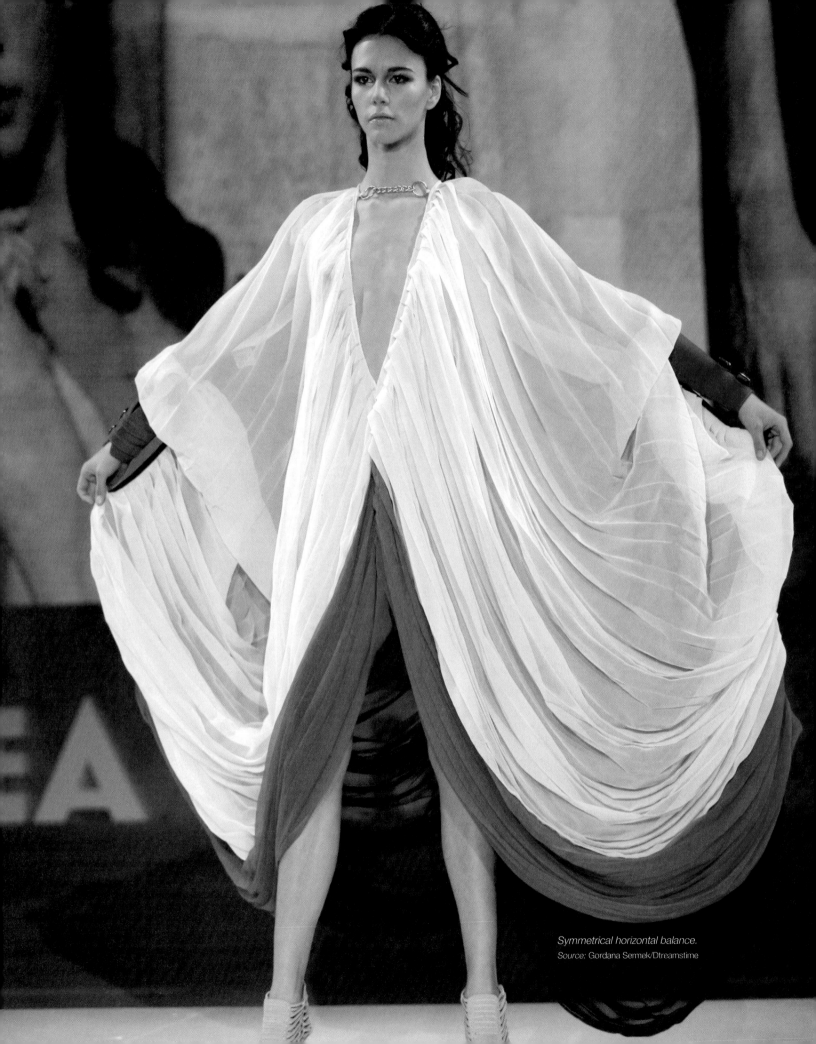

Symmetrical horizontal balance.
Source: Gordana Sermek/Dtreamstime

BALANCE

After studying this chapter you should be able to:

1. Define balance and identify the three types of balance: horizontal, vertical, and radial.
2. Examine the characteristics of the three types of balance.
3. Evaluate the physical effects of the three types of balance.
4. Evaluate the emotional effects of the three types of balance.
5. Discuss the application of balance in apparel design.
6. Summarize the use of balance as a design aspect.

10

FIGURE 10.1 *Symmetrical horizontal balance.*

Introduction

In order to keep from falling down, humans have developed a strong sense of balance. We constantly evaluate and adjust to visual input in order to maintain our balance. Most humans will subconsciously look for visual balance or a sense of stability in the world around them. Consider the unbalancing experience of visiting the "House of Mirrors" at a carnival where visual input is distorted. Additionally, we have learned to avoid a dangerously leaning tree or ladder. Since most people find the lack of balance to be uncomfortable, designers need to create balanced apparel.

Definitions of Balance

Balance is the sensation of evenly distributed weight. Properly used, balance gives the feeling of equilibrium and stability. Balance encourages the eye to examine the whole garment to find equilibrium. Each part of a garment must work with all the others to achieve equilibrium and stability. The various weight relationships of other aspects of design such as line, color, space, texture, shape, and form contribute to balance.

Types of Balance

The three types of balance are symmetrical, asymmetrical, and radial. All can be used to create desired effects by the designer.

Symmetrical Balance

Symmetrical balance is sometimes called **formal balance**. It requires that both sides of a central axis are the same. One side of the design mirrors, or very nearly mirrors, the other. Symmetrical balance may be horizontal or vertical. In symmetrical horizontal balance both sides of a vertical axis are the same. See Figure 10.1. Symmetrical horizontal balance is very appealing. Human bodies are basically symmetrical so people intuitively understand symmetrical horizontal balance. See Figure 10.2. Symmetrical vertical balance is achieved when both sides of a horizontal axis match. This can be achieved in fabric patterns but is not usually possible with garments since the top half of the human body is very different from the bottom half.

Asymmetrical Balance

Asymmetrical balance is sometimes called **informal balance**. It requires that both sides of a central vertical axis are different, but that the overall effect is that there is equal visual attraction on each side. It is possible to create asymmetrical balance through the use of texture, size, position, and shape. See Figure 10.3, 10.4, and 10.5. Figure 10.3a is darker and smaller than Figure 10.3b, but both are equal in visual attraction. Figure 10.4 uses position. Both are textured, but the square is lower on the diagram than the rectangle. Figure 10.5 uses shape. The larger shape (a) is balanced by the smaller more complicated shape (b).

FIGURE 10.2 *Symmetrical horizontal balance in clothing.*
Source: Tomalu/Fotolia

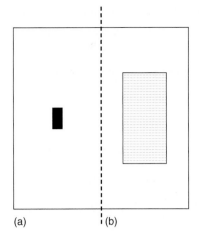

FIGURE 10.3 *Asymmetrical balance: one side is smaller but darker than the other.*

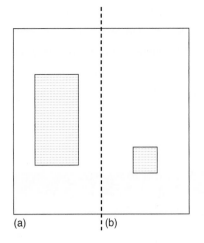

FIGURE 10.4 *Asymmetrical balance: The square in (b) is lower in the diagram than the rectangle in (a).*

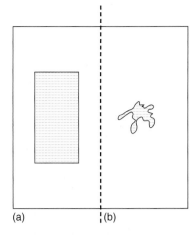

FIGURE 10.5 *Asymmetrical balance: (b) is smaller but is more complicated than (a).*

It is more difficult, but also more interesting, to achieve asymmetrical balance. See Figure 10.6. Asymmetrical balance is complex and requires critical analysis by the designer. Any weight appears heavier when it is placed closer to the bottom. Asymmetrical vertical balance, which is frequently found in apparel, can be used to prevent top-heavy or bottom-heavy effects. See Figure 10.7.

Radial Balance

Radial balance integrates all parts around a center. Everything radiates out from a common center point. This outward movement creates a feeling of weight that is equally

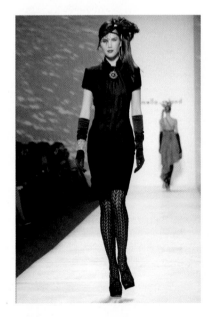

FIGURE 10.6 *Asymmetrical balance in clothing.*
Source: NataliaYeromina/Shutterstock.com

FIGURE 10.7 *The vertical asymmetrical balance draws attention to the top, thus minimizing the bottom.*
Source: © Andres Rodriguez/Alamy

FIGURE 10.8 *Radial balance.*
Source: Gilmanshin/Shutterstock.com

distributed around the center. Examples of radial balance from nature include a snowflake or the radiating rays of the sun. The concentration of weight is in the center. In general, radial balance is more complex and interesting than symmetrical balance. Although it can be seen in garment structure, it is seen more often in accessories, such as broaches, or fabric patterns. See Figure 10.8.

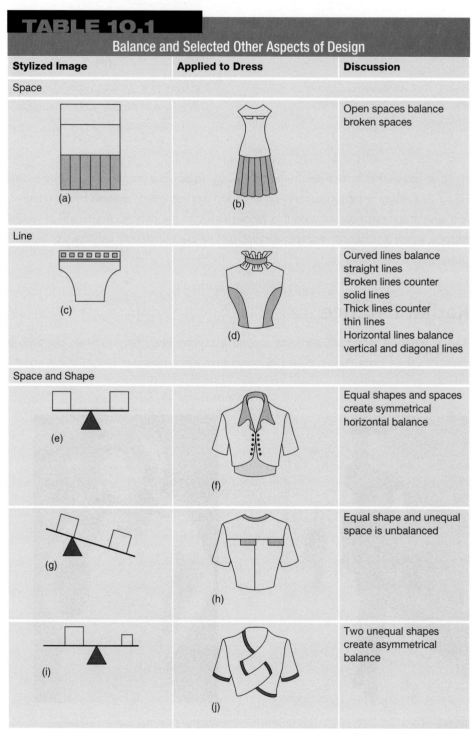

TABLE 10.1		
Balance and Selected Other Aspects of Design		
Stylized Image	**Applied to Dress**	**Discussion**
Space		
(a)	(b)	Open spaces balance broken spaces
Line		
(c)	(d)	Curved lines balance straight lines Broken lines counter solid lines Thick lines counter thin lines Horizontal lines balance vertical and diagonal lines
Space and Shape		
(e)	(f)	Equal shapes and spaces create symmetrical horizontal balance
(g)	(h)	Equal shape and unequal space is unbalanced
(i)	(j)	Two unequal shapes create asymmetrical balance

(continued)

TABLE 10.1

Stylized Image	Applied to Dress	Discussion
Color		
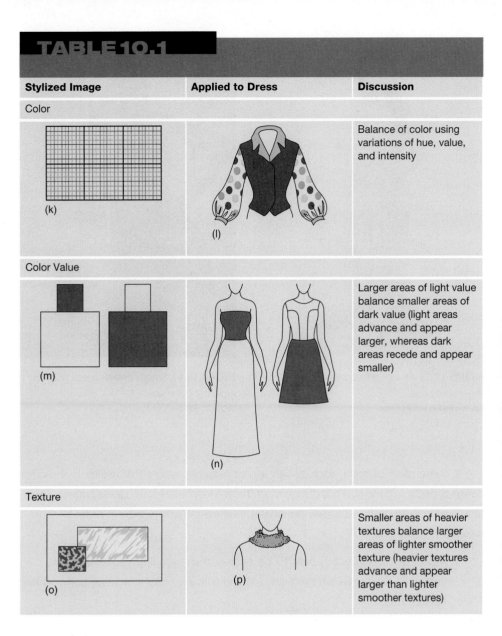 (k)	(l)	Balance of color using variations of hue, value, and intensity
Color Value		
(m)	(n)	Larger areas of light value balance smaller areas of dark value (light areas advance and appear larger, whereas dark areas recede and appear smaller)
Texture		
(o)	(p)	Smaller areas of heavier textures balance larger areas of lighter smoother texture (heavier textures advance and appear larger than lighter smoother textures)

Physical Effects of Balance

As a unifying aspect of design, balance leads the eye around the figure to determine the relationship between the weights. All the aspects of design contribute to balance. Please refer to Table 10.1 for examples of how selected design aspects can contribute to balance.

The eye is looking for stability or equilibrium. If the eye does not find them, the overall effect is that the figure is leaning, top-heavy, or bottom-heavy. See Figure 10.9. Without horizontal balance, the figure appears ready to fall over. One side is far heavier than the other. Physical irregularities are emphasized by symmetrical horizontal balance of shapes. Asymmetrical horizontal balance will help to camouflage them, because it will be harder to make exact comparisons. See Figure 10.10. Asymmetrical vertical balance creates a firmly based figure. If there is too much weight on the bottom, it appears bottom-heavy. Likewise, if there is too much weight on the top, it appears top-heavy. See Figure 10.11. With radial balance, the figure is stabilized in the middle.

FIGURE 10.9 *Unbalanced design.*

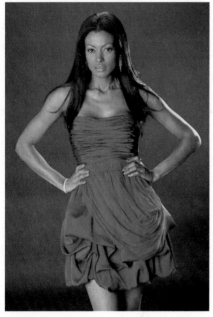

FIGURE 10.10 *Asymmetrical horizontal balance can hide figure irregularities.*
Source: Juanmonino/iStockphoto

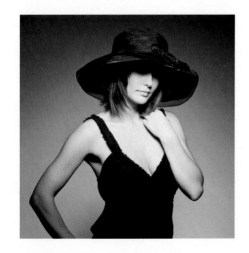

FIGURE 10.11 *The large hat creates extra weight on the top.*
Source: Andreas Gradin/Shutterstock.com

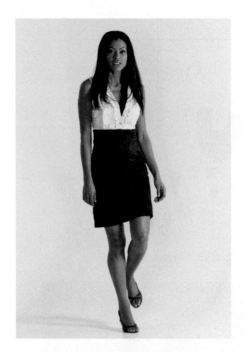

FIGURE 10.12 *Smaller advancing space balances larger receding space.*
Source: Juanmonino/iStockphoto

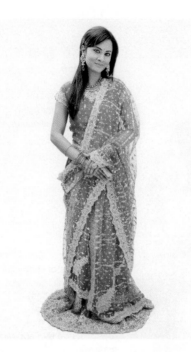

FIGURE 10.13 *Smaller shiny spaces balance larger dull spaces.*
Source: Paul Hakimata/Fotolia

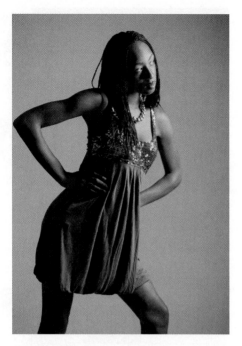

FIGURE 10.14 *Smaller broken space balances larger unbroken space.*
Source: © Eyecandy Images / SuperStock

Within a given garment, each design aspect assumes weight that relates to the other design aspects. In general, areas of a garment that are emphasized will appear heavier. Therefore, areas of emphasis will usually be smaller than the remaining areas in order to achieve balance. For example:

1. Advancing space will appear to be heavier than receding space, so advancing space will need to be smaller than receding space in order to achieve balance. See Figure 10.12.
2. A shiny area will attract attention and appear heavier than a larger dull area, so shiny areas will need to be smaller than dull areas in order to achieve balance. See Figure 10.13.
3. Broken spaces appear heavier than open spaces, so broken spaces will need to be smaller than unbroken spaces. See Figure 10.14.

Emotional Effects of Balance

Balance is important to the emotional sense of security and stability. Imbalance creates discomfort that may be difficult to describe but can be sensed easily. See Figure 10.9. Well-designed apparel will retain balance as the wearer moves through a variety of positions: standing, sitting, bending, and walking. Athletic apparel will retain balance through all the motions of the sport: running, throwing, and so forth.

The positive emotional effects of formal balance are that it is regal and dignified. The negative effects are that it may be obvious and passive. On the other hand, informal balance is casual, dynamic, and more complex. It can also suggest drama. Informal balance is more active and more original than formal balance. Radial balance suggests stability, control, and discipline. It requires a focal point.

Application of Balance in Apparel Design

As stated earlier, effective use of balance requires thorough understanding of all the aspects of design. Please review all the previously presented design aspects carefully. This section will briefly review space, line, shape and form, light, color, and texture. Also, please review Table 10.1.

Space, Line, Shape, and Form

Because line and space are used to create shape and form, these will be addressed together. The advancing and receding qualities of space need special attention when evaluating balance. The advancing space will appear to be larger than the receding space, so the designer will adjust the actual size of the space to create a well-balanced garment.

The five characteristics of line (direction, length, thickness, contour, and texture) need careful use of balance since straight lines are balanced by curved lines, short lines are balanced by long lines, vertical lines are balanced by horizontal lines, and so on. For stability, a garment with vertical lines needs some horizontal lines for balance.

Areas within and among shapes are used for two-dimensional (shape) balance. The eye seeks balance between the collar and cuffs of a shirt or between the pattern motif and its background space. Grouping of shapes, such as accessories, is successful if the groups are small and relate to the whole garment. For example, in general, accessories that are far from the center axis of the body need to be lighter and smaller in order to maintain radial balance. Fashion trends for large handbags and hats, and brightly colored shoes may create unbalanced outfits. See Figure 10.15. Three-dimensional (form) balance in apparel seeks to equalize the concavities and convexities of the human body. They need to complement each other so that the form appears stable (that it will not crumple nor expand).

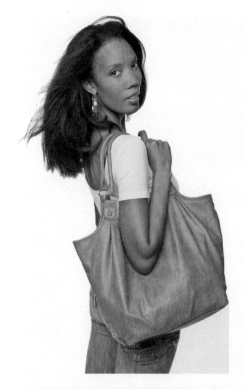

FIGURE 10.15 *The figure can be unbalanced by large handbags.*
Source: David Gilder/Shutterstock.com

Light and Color

Because light and color are mutually dependent, these design aspects will be discussed together.

The designer needs to take into account the various situations in which a garment is worn. Usually, light cannot be controlled but its effects can be controlled by manipulating the surfaces it touches. The effect of light on color and texture are especially important in apparel design. The interplay of light and texture can influence advancing and receding qualities, apparent size, and the transparency of the fabric. As the lighting changes, the overall effect on the balance should be evaluated.

Color is especially important to balance. The color schemes presented in Chapter 6 are guidelines to achieving color balance. An effective color scheme intermingles hues, values, and intensities of appropriate amounts to achieve interest and beauty. A pleasing color scheme will combine all three dimensions of color. Color distribution, or where color is located on the body, is also important. See Figure 10.16. Colors can be used in various ways in a garment or ensemble. For example, it can be:

1. A solid garment, such as a black suit.
2. Intermingled within a fabric pattern or in applied trim.
3. Distributed among parts of a garment, for example, contrasting pockets on a shirt.

FIGURE 10.16 *Effective color distribution.*
Source: Paul Hakimata Photography/Shutterstock.com

Texture

Because texture has both density and weight, balance must be considered from both aesthetic and functional perspectives. The function and structure of the garment will determine many design decisions. Garments are made from fabrics that have texture, so texture is integral to structural design. See Figure 10.17. For example, lightweight rain jackets are often made from smooth, thin nylon fabric because warmth is not needed and the smooth nylon fibers will shed the rain quickly. Textural weight must balance with the weight and size of the wearer. For example, a petite woman would be overwhelmed by a stiff, heavyweight wool winter coat.

General Guidelines for the Use of Balance

The designer can consider three general guidelines for the effective use of balance in apparel. These are only suggestions and not rules. The designer should carefully evaluate the overall effect within the context of current fashion trends.

1. It is usually best to avoid extremes. There should be enough balance to avoid boredom, but not so much as to be overpowering.
2. Generally lighter-weight design aspects are used higher on the body and heavier weight aspects are used on the bottom half of the body. For example, lighter textures are often used for blouses and heavier weights are usually used for slacks or pants.
3. Both formal and informal balance can be used in one garment but with restraint. One kind of balance should predominate to avoid confusion.

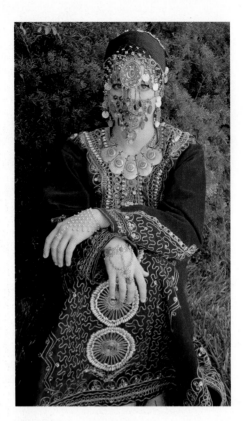

FIGURE 10.17 *Interesting use of textural balance.*

Source: Brian Chase | Dreamstime.com

summary

Balance is the sensation of evenly distributed weight. It gives the feeling of equilibrium and stability. Balance encourages the eye to examine the whole garment to find equilibrium. The three types of balance are symmetrical, asymmetrical, and radial.

Symmetrical balance, or formal balance, requires that both sides of a central axis are the same. Symmetrical balance may be horizontal or vertical. In symmetrical horizontal balance both sides of a vertical axis are the same. Symmetrical vertical balance is achieved when both sides of a horizontal axis match. Asymmetrical balance, or informal balance, requires that both sides of a central vertical axis are different but that the overall effect is that there is equal visual attraction on each side. It is more difficult, but also more interesting, to achieve asymmetrical balance. Radial balance integrates all parts around a center. Everything radiates out from a common center point.

Balance leads the eye around the figure. Figure irregularities are emphasized by symmetrical horizontal balance. Asymmetrical balance will help to camouflage them because it will be harder to make exact comparisons. Balance is important to the emotional senses of security and stability. Well-designed apparel will retain balance as the wearer moves through a variety of positions and activities. The positive emotional effects of formal balance are that it is regal and dignified. The negative effects are that it may be obvious and passive. Informal balance is casual, dynamic, and more complex. It is more active and more original than formal balance. Radial balance suggests stability, control, and discipline. It requires a focal point.

Effective use of balance requires thorough understanding of all the aspects of design. The advancing and receding qualities of space need special attention when evaluating balance. The characteristics of line (direction, length, thickness, contour, and texture) need careful use of balance. Areas within and among shapes are used for two-dimensional (shape) balance. Three-dimensional (form) balance in apparel seeks to equalize the concavities and convexities of the human body. The interplay of light and texture can influence advancing and receding qualities, apparent size, and the transparency of fabric. An effective color scheme intermingles hues, values, and intensities of appropriate amounts to achieve interest and beauty. Because texture has both density and weight, balance must be considered from both aesthetic and function perspectives.

The designer can consider three general guidelines for the effect use of balance in apparel. The designer should carefully evaluate the overall effect within the context of current fashion trends.

terminology

asymmetrical balance 118
balance 118

formal balance 118
informal balance 118

radial balance 119
symmetrical balance 118

activities

1. Do an Internet search to find the following works of art:
 a. *Church of Le Sacré Coeur, Montmartre et Rue Saint Rustique*–Maurice Utrillo
 b. *Feast in the House of Levi*–Paolo Veronese
 c. *The Surrender of Lord Cornwallis*–John Trumbull
 d. *The Cup of Tea*–Mary Cassatt
 e. *York Minister, into the South Transept*–Frederick H. Evans

 Discuss how the artists manipulated balance in these paintings.

2. Using construction paper and patterned paper, each student will create examples of horizontal, vertical, and radial balance. Analyze the examples for physical and emotional impact.

3. Using the images on graphic T-shirts, evaluate the use of balance. Determine the physical and emotional effects.

4. Using historic and ethnic costume books, find examples of balance in historic and ethnic apparel. Analyze the impact of the use of balance.

5. Using magazines and catalogs, find examples of balance in contemporary apparel. Analyze the designer's use of balance.

6. Using fellow students as models, the class members can evaluate the use of balance in each other's apparel and discuss its impact.

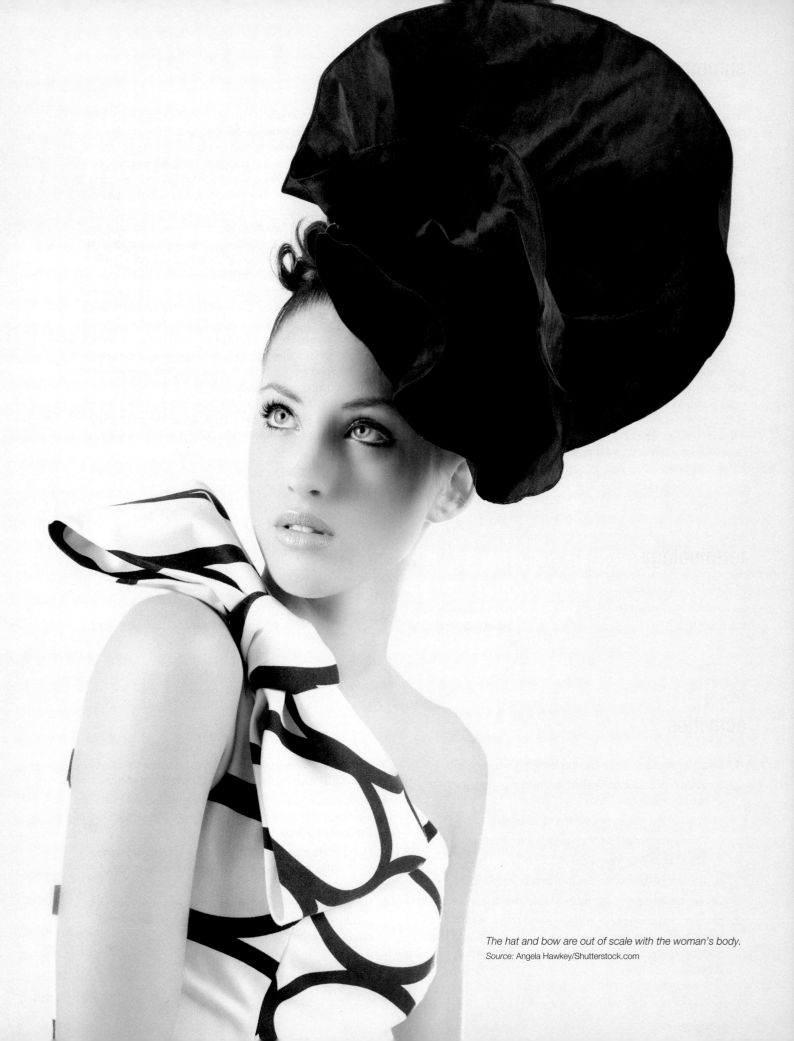

The hat and bow are out of scale with the woman's body.
Source: Angela Hawkey/Shutterstock.com

SCALE
and PROPORTION

After studying this chapter you should be able to:

1. Define scale and proportion.
2. Evaluate the physical effects of scale and proportion.
3. Evaluate the emotional effects of scale and proportion.
4. Discuss the application of scale and proportion in apparel design.
5. Discuss the application of the "golden mean" in apparel design.
6. Summarize the use of scale and proportion as design aspects.

11

FIGURE 11.1 *The extended body of a fashion illustration.*
Source: Aledeane/Dreamstime

Introduction

Scale and proportion are design terms that refer to size. Within the context of well-designed apparel, the designer is challenged to consider the various details of a garment and how they relate to the overall silhouette and the person wearing the clothing. The body style of the wearer determines how the designer will apply the aspects of scale and proportion.

Artistic representation of garments in fashion often distorts the body. The **croquis**, the stylized figures used as the basis for fashion illustration, are 8 to 11 heads tall. See Figure 11.1. The average body height is 7 heads tall. The longer silhouette provides more space to show garment details. The designer must keep in mind actual human proportions, so the clothing will fit and flatter the ultimate consumer.

Definitions of Scale and Proportion

Scale is a consistent relationship of sizes to each other and to the whole regardless of shapes, whereas **proportion** is the comparative relationship of not only sizes but also distances, amounts, or parts. Scale and proportion encourage the viewer to investigate the entire composition. Scale will be discussed first.

Scale

Scale is another word for "size." Things can be large scale (big in size), medium scale (moderate in size), or small scale (small in size.) The images are the same but the effects created by the scale in Figure 11.2 are very different. The word *large* is meaningless unless there is standard for comparison. For example, whether a handbag is large or not is determined by the sizes of other available handbags and the size of the person carrying the handbag. See Figure 11.3.

Physical Effects of Scale

In apparel design, scale usually refers to the sizes of shapes and spaces, such as accessories, trims, or other style features, when they are compared to the main parts of the garment and to the size of the wearer. The collar of a simple bodice may be small, medium, or large scale in relation to the size of the bodice or the size of the person wearing the bodice. Objects can be "scaled up" or made to take up more space. Conversely, objects can be "scaled down" or made to take up less space. When objects are the appropriate size, they are described as being "in scale."

Scale must be used carefully because it can either reinforce or counter wearer characteristics. In Figure 11.4 the small pattern emphasizes, or reinforces, the large figure by contrast (a) and the large pattern emphasizes, or reinforces, the large figure by repetition (d). Conversely, the small pattern emphasizes, or reinforces, wearer characteristics by repetition (b) and the large pattern emphasizes, or reinforces, wearer characteristics by contrast (c).

FIGURE 11.2 *Similar images presented in different scale.*

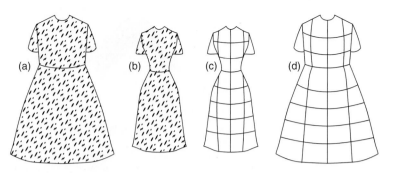

FIGURE 11.4 *Compare the effects of the small pattern on a large figure (a) and on a small figure (b). Likewise, compare the effects of a large pattern on a small figure (c) and on a large figure (d).*

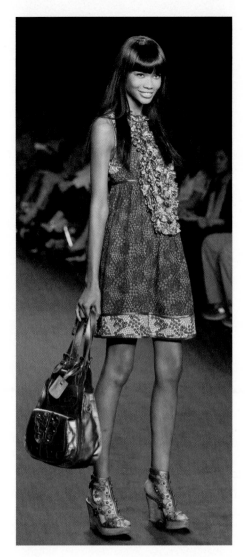

FIGURE 11.3 *Whether the handbag is large or not depends on the size of the person carrying it.*
Source: lev radin/Shutterstock.com

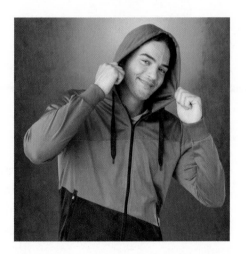

FIGURE 11.5 *Use of large scale in men's wear.*
Source: Yuri Arcurs/Shutterstock.com

FIGURE 11.6 *Use of a large-scale motif in casual clothing for teenage girls.*
Source: Dean Bertoncelj/Shutterstock.com

Sizes of style features such as pockets, collars, and other such items; patterns; notions; jewelry; accessories; and so forth should be carefully evaluated so that positive effects are created.

Emotional Effects of Scale

When a garment and all its components and accessories are in scale, there is a sense of agreement. When objects are out of scale, there is a general feeling of dissatisfaction. The observer notices that something is wrong.

In Western cultures, smaller patterns are perceived to be dainty and feminine and are common in women's wear and children's wear. Large-scale patterns are considered to be aggressive and bold. They are often used in men's wear. See Figure 11.5. In women's wear large-scale patterns can be used where daintiness is less important, such as in tailored and casual wear. See Figure 11.6.

FIGURE 11.7 *The large-scale pattern enlarges the wearer.*
Source: Viktor Ivannikov/Shutterstock.com

FIGURE 11.8 *The small-scale ruffles are appropriate for a toddler.*
Source: Anatoliy Samara/Shutterstock.com

Use of Scale in Dress

In general, the scale of all of previously presented aspects of design should be considered when developing a design. Although scale most commonly refers to shape and space (see earlier discussion in this chapter), it can also refer to color and texture. The advancing qualities of color and texture suggest a larger scale, whereas their receding qualities suggest a smaller scale.

Several guidelines for the use of scale in apparel have been developed. They are the following:

1. People of either extreme in size should avoid extremes of scale in dress, accessories, or pattern. Oversized clothing will have much the same effect as large-scale accessories or patterns.

2. In general, the larger a motif, the more it will enlarge the wearer. See Figure 11.7.

3. In general, large scale is reserved for men's wear or casual women's wear. Small scale is commonly used in children's wear and women's wear. See Figure 11.8.

4. In general, it is advisable to keep smaller style features in scale with larger garment parts. See Figure 11.9. The small pockets (a) appear too small for the space, the large pockets (c) overpower the space, and the medium pockets (b) are well matched.

5. Notions such as buttons should also be in scale with garment parts. See Figure 11.10. Small buttons are appropriate on a blouse. Medium-size buttons are appropriate on a skirt and large buttons seem best on a coat. The texture of the fabric affects the selection of buttons. Thick fabric needs large buttons, but small buttons are suitable for thin fabric.

FIGURE 11.9 *Compare the scale of the pockets: (a) too small, (b) in scale, (c) too large.*

FIGURE 11.10 *Compare the effect of (a) small buttons on a blouse (in scale), (b) small buttons on a skirt (somewhat small), and (c) small buttons on a coat (too small).*

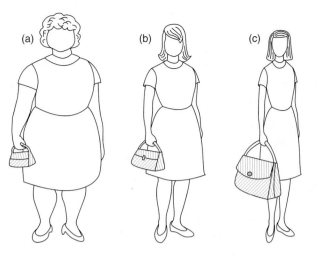

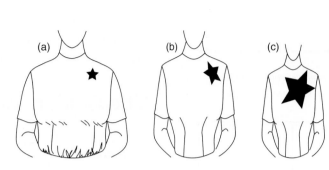

FIGURE 11.11 *Compare the effects of small, medium, and large handbags.*

FIGURE 11.12 *Compare the effect of small, medium, and large pins.*

6. Accessories, such as handbags, should be in scale with the wearer. See Figure 11.11. The small handbag reinforces the size of the large woman by contrast (a), whereas the large handbag reinforces the size of the small woman by contrast (c). The medium-scale handbag (b) is appropriate for all sizes because it neither reinforces nor counters body size.

7. Jewelry should be in scale with garment parts and the wearer's characteristics because it can also repeat or contrast the wearer's size. See Figure 11.12. The small pin (a) contrasts with the large figure, making it appear larger, whereas the large pin (c) contrasts the small figure, making it appear smaller. The medium-size pin is appropriate for all body sizes. Figure 11.13 demonstrates the effect of large-scale earrings.

Fashion trends often do not follow the guidelines for the use of scale. For example, the large jewelry of the 1980s was out of scale with the wearer. Other examples include large handbags (see Figure 11.13), and platform shoes. See Figure 11.14.

FIGURE 11.13 *A model wearing large scale earrings*
Source: Christi Tolbert/Shutterstock.com

FIGURE 11.14 *A model wearing platform heels.*
Source: Stefanos Kyriazis/Fotolia

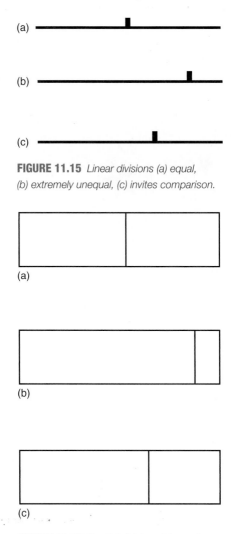

FIGURE 11.15 *Linear divisions (a) equal, (b) extremely unequal, (c) invites comparison.*

FIGURE 11.16 *Spatial divisions (a) equal, (b) extremely unequal, (c) invites comparison.*

Proportion

Proportion refers to the comparative relationship between the size of the parts to the whole and to each other. It can apply to lines, shapes, and forms. In general, unequal proportions are more interesting and aesthetically pleasing than equal proportions. Good proportion has its roots in the early architecture of the Egyptians and Greeks. The ancient pyramids and the Greek Parthenon are examples of good proportion.

The Golden Mean

Classically, the proportion of 3:5:8 is considered to be good. This is called the "**golden mean**" or the "**golden section**." The smaller space relates to the larger space in the same way that the larger space relates to the whole. In other words, 3 relates to 5 in the same way that 5 relates to 8. This sequence of ratios can be expanded further. For example, 5:8:13, 8:13:21, and so on. Adding the first two numbers equals the next number.

The key to good proportion is to have divisions that invite the viewer to examine the design to determine the relationship between the parts or between the parts and the whole.

Divisions of one half or a very large part and a very small part are less interesting because the eye is not encouraged to examine the whole. See Figures 11.15 and 11.16. In both cases (c) invites comparison because the differences in size need to be examined closely to determine the difference. Figure 11.17 demonstrates how the golden mean is applied to apparel. Again, (c) follows the golden mean with a 3:5 ratio. Neither part is overwhelming nor is one part too large or too small when compared to the other.

Proportion usually deals with lines, shapes, and forms, but the design aspects of color and texture also need to be evaluated for varying amounts. In general, color should be used in uneven amounts. When several colors are used, one should dominate. See Figure 11.18.

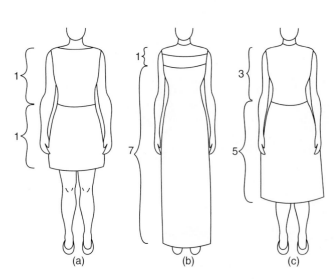

FIGURE 11.17 *Clothing design divisions: Spatial division (a) is equal and (b) is extremely unequal, but (c) invites comparison.*

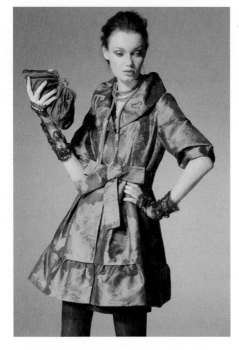

FIGURE 11.18 *The blue color dominates in this dress but the spatial division is equal.*
Source: crystalalfoto/iStockphoto

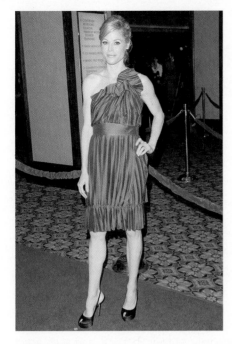

FIGURE 11.19 *The texture of the pleating is in proportion to the model's body.*
Source: Adam Orchon/Everett Collection/Alamy

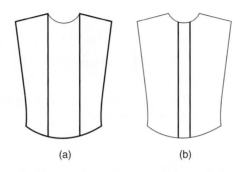

(a)　　　　　　　　　(b)

FIGURE 11.20 *Compare the effect of the widths of the panels on the apparent size of the bodice.*

The density and bulk of garment textures need to be considered in relation to the space the texture occupies in the garment and in relation to the wearer. The texture of the clothing should work well with the garment design and also be in proportion to the body style of the wearer. See Figure 11.19.

Even though good proportion can be mathematically calculated, it is better to develop an "eye" for good proportion. Often, proportion that is driven by numbers is less interesting than one created by eye.

Physical and Emotional Effects of Proportion

The skillful use of proportion by the designer can create the desired appearance. When the silhouette is established and the internal space is divided, the designer manipulates the proportions of the garment and the apparent proportions of the wearer. See Figure 11.20. The wide center panel widens the figure, whereas the narrow center panel (b) lengthens and narrows the figure. Because proportion deals with the design aspects of color, texture, and space, it affects the physical properties of all apparel. Effective use of proportion in a garment provides the viewer with a sense of stability and steadiness. In general, large spaces dominate and smaller spaces are of less importance.

Use of Proportion in Dress

In apparel design it is important to keep the function of the garment in mind. Creation of a beautifully proportioned garment that is uncomfortable or cannot be worn is pointless. Proportion is evident in both the structure and decoration of a garment. Each seam, dart, and edge affects the overall proportion of the garment. Placement and size of each garment detail such

FIGURE 11.21 *One-to-one ratio in apparel.*
Source: Makarova Zhanna/Fotolia

as collars, cuffs, pockets, and so forth affect proportion. All trims, buttons, and such affect proportion. Structure and decoration seem to merge when the eye compares the various relationships.

Although good proportion has remained constant throughout history, sometimes the fashion trends do not conform to the golden mean. For example, in the 1960s the extremely short miniskirts often created a 1:1 (one-to-one) proportion. See Figure 11.21. The short skirt/long jacket women's suits of the 1990s and the large boots of the early 2000s are other examples of poor proportion in apparel.

General guidelines for the use of proportion in apparel are:

1. In general, the spatial proportions of a garment should follow the natural divisions of the body. Examine the proportions of Figure 11.17. Dress (a) has equal proportions, dress (b) has very unequal proportions, and dress (c) has golden mean proportions of 3:5. The lines of the garment also follow the natural divisions of the body.
2. The perceived proportions of the body can be modified by the part-to-part and part-to-whole proportions of the garment silhouette, placement of garment details, color and texture of the fabric(s), and placement of decorative trims and notions.

summary

Scale and proportion are design terms that refer to size. The body style of the wearer determines how the designer will apply the aspects of scale and proportion. The designer must keep in mind actual human proportions, so the clothing will fit and flatter the final consumer.

Scale is a consistent relationship of sizes to each other and to the whole regardless of shapes, whereas proportion is the comparative relationship of not only sizes but also distances, amounts, or parts. Scale and proportion encourage the viewer to investigate the entire composition.

Things can be large scale (big in size), medium scale (moderate in size), or small scale (small in size.) Scale must be used carefully because it can either reinforce or counter wearer characteristics. When a garment and all its components and accessories are in scale, there is a sense of agreement. Several guidelines for the use of scale in apparel have been developed.

Proportion refers to the comparative relationship between the size of the parts to the whole and to each other. It can apply to lines, shapes, and forms. The proportion of 3:5:8 is considered to be ideal. It is referred to as the "golden mean" or the "golden section." Proportion usually deals with lines, shapes, and forms, but the design aspects of color and texture also need to be evaluated for varying amounts. Even though good proportion can be mathematically calculated, it is better to develop an "eye" for good proportion.

When the silhouette is established and the internal space is divided, the designer manipulates the proportions of the garment and the apparent proportions of the wearer, while being mindful of the function of the garment. Proportion is evident in both the structure and decoration of a garment.

terminology

croqui 128

golden mean 132

golden section 132

proportion 128

scale 128

activities

1. Do an Internet search to find images of the following works of art:
 a. *The Industrial Scene*, center panel of *Tribute to the American Working People*—Honoré Sharrer
 b. Emperor Otto II from the *Registrum Gregorii*
 c. *White Trumpet Flower*—Georgia O'Keefe

 Discuss how the artist has used scale/proportion in these works of art.

2. Using construction paper and patterned paper, each student should create examples of scale/proportion. Analyze the examples for physical and emotional impact.

3. Using a variety of fabrics of different colors and patterns, evaluate the use of scale/proportion. Determine the physical and emotional effects. Suggest appropriate end uses for each fabric.

4. Using historic and ethnic costume books, find examples of scale/proportion in historic and ethnic apparel. Analyze the physical and emotional impact of the use of scale/proportion in the apparel.

5. Using magazines, catalogs, or the Internet, find examples of scale/proportion in contemporary apparel. Analyze how the designer's use of scale/proportion affects the emotional and physical impact.

6. Using fellow students as models, the class members can evaluate the use of scale/proportion in each other's apparel and discuss the impact of the scale/proportion.

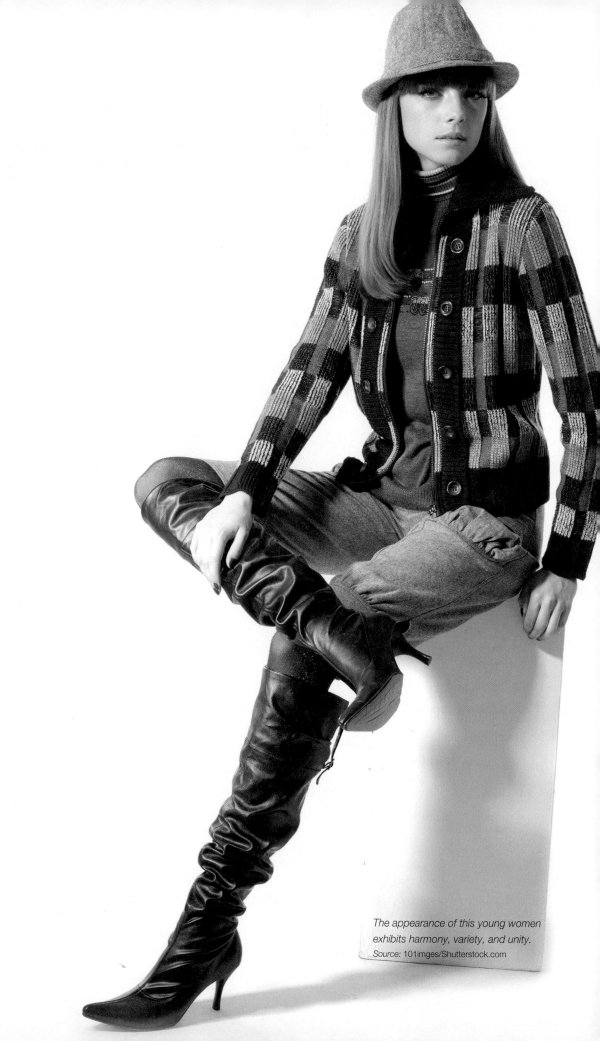

The appearance of this young women exhibits harmony, variety, and unity.
Source: 101imges/Shutterstock.com

HARMONY, VARIETY, and UNITY

After studying this chapter you should be able to:

1. Define harmony.
2. Evaluate the effects of harmony.
3. Discuss the application of harmony in apparel design.
4. Define variety.
5. Evaluate the effects of variety.
6. Discuss the application of variety in apparel design.
7. Define unity.
8. Evaluate unity and the Gestalt theory.
9. Evaluate the effects of unity.
10. Discuss the application of unity in apparel design.
11. Summarize harmony, variety, and unity as design aspects.

12

Introduction to Harmony, Variety, and Unity

The ultimate goal of a designer is to create a clothing ensemble that has **unity**—the appearance of completeness, where all the design components serve the same functional purpose and work together to complement the key theme. To create unity; harmony and variety are required.

Harmony

Definition of Harmony

Harmony means agreement or accord. In fashion design, it means that all the parts of an ensemble relate to and complement each other to create an aesthetically pleasing whole. Each part of the design is important in itself but all must work together to achieve harmony. To achieve harmony, the functional, structural, and decorative aspects of a garment must be in agreement. All aspects of design can be used to create harmony.

Although there are generally accepted criteria of how harmony is created, the perception and appreciation of harmony is dependent on personal taste and culture. For example, the ceremonial outfit from Greenland shown in Figure 12.1, with its variety of patterns, might not seem to be a harmonious to non-Greenlanders.

The idea of what is harmonious also changes with time. Textiles and decorations that currently might not be considered compatible have often been used together and accepted as harmonious—tulle frills have hung below the hem of business dresses and skirts; silk blouses have been worn with jeans; rhinestones have been attached to denim jackets.

The Effects of Harmony

Garments with harmony look uncomplicated. Harmony bestows a feeling of psychological satisfaction and stability. It can be very calming. However, harmony can give a feeling of predictability and staleness. Too much sameness can be monotonous. A little variety is essential to prevent tedium.

The Application of Harmony in Dress

In order to create a harmonious garment, the designer should consider its purpose and the climate, fashion, and culture of the place where the garment will be worn. The stylist should also consider the gender, age, size, personal colorings, personality, and lifestyle of the wearer.

For a garment to have functional harmony, it should be safe, healthy, comfortable to wear, move as needed, and be appropriately durable. Visually, harmony is achieved by using similar features throughout the design. These features can be structural, such as style lines and seams, or decorative. Repetition emphasizes visual unity for a feeling of agreement and consistency.

The following are some things to consider when trying to create harmony.

1. All areas and features of a garment need to reflect the same mood and purpose. For example, crisp, slightly stiff fabric can be combined with sharp pleats, and a jacket with

FIGURE 12.1 *Perception of harmony is dependent on culture. Not everyone would agree that the variety of patterns in this Greenlandic costume, worn for special occasions, creates harmony.*
Source: © Yvette Cardozo / Alamy

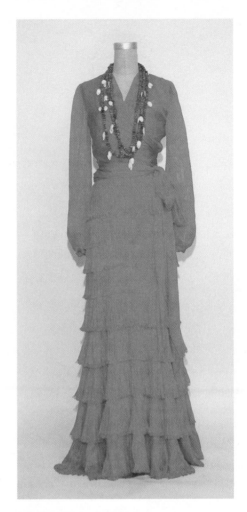

FIGURE 12.2 *The functional, structural, and decoratiive aspects of this silk Oscar de la Renta couture dress combine to create harmony.*

Source: Courtesy of the Godwin-Ternbach

FIGURE 12.3 *Harmony in design, mood, and function. The skirt on the right is too casual and flouncy for the formal, tailored, business-style jacket.*

FIGURE 12.4 *Harmony in proportion and scale. The buttons, epaulets, and cuff bands on the coat on the right are too large for the garment.*

FIGURE 12.5 *Harmony in shapes and spaces. On the right, the square shape of the pockets and vertical lines on the sleeves are not consistent with the curved silhouette and collar of the jacket.*

FIGURE 12.6 *Harmony in style lines. The style lines on the bodice and skirt of the dress on the right do not match, so they create a disharmonious effect.*

straight lines for business wear; soft, flexible fabric cut on the bias, a graceful undulating hemline, and a gentle curved neckline reinforce the sensuous mood of an evening dress. The soft fabric, draped bodice, flounced skirt, and transparent sleeves of the dress in Figure 12.2 combine to form harmony in function, structure, and decoration. The skirt has a Caribbean feel that is reinforced by the bead and shell necklace. Figure 12.3 illustrates harmony and disharmony in design and function.

2. The back and front of the garment should work together.

3. All aspects of design contribute to visual harmony.

4. Scale and proportion should be pleasing within the culturally accepted norms (see Figure 12.4).

5. Shapes and spaces created by pockets, collars, cuffs, and seams create harmony if they are consistent in style (see Figure 12.5).

6. Style lines, seam lines, and trim lines should match and be consistent on every area of a garment or accessory (see Figure 12.6).

7. Stripes and plaids should match (see Figure 12.7).

8. Textiles and textures should match garment function and mood. If more than one fabric is used in an outfit, compatibility in weight, stretch, thickness, suppleness,

FIGURE 12.7 *For harmony, stripes should match.*

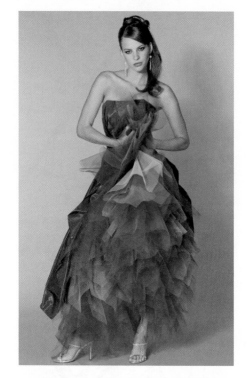

FIGURE 12.8 *The fabrics used in this dress work well together and are appropriate for the function of the dress. The colors are harmonious in hue, intensity, and value.*
Source: Rakoskerti/iStockphoto

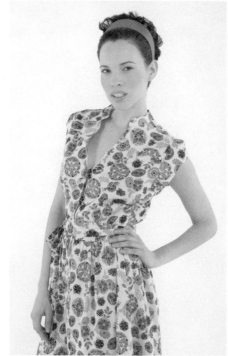

FIGURE 12.9 *The motifs in this patterned fabric create harmony because they have a similar theme and are complementary in shape and color.*
Source: © Mike Watson/moodboard/Corbis

performance, and method of cleaning is necessary for harmony (see Figure 12.8). It is usually best not to combine glamorous and utilitarian fabrics.

9. Harmony in pattern occurs when motifs:

 a. have a similar theme and complementary shapes,

 b. create a design that is well balanced with pleasing proportions, and

 c. are appropriate for the occasion of use and the age and gender of the wearer.

 The pattern in Figure 12.9 meets these criteria.

 Whether a particular combination of patterns is perceived as being in harmony depends on fashion, cultural, and personal taste (see Figure 12.1). Generally, combining different types of pattern motifs such as realistic and stylized flowers or fish and cow motifs creates a jarring effect.

10. Color harmony depends on hue, value, and intensity. Monochromatic and adjacent color schemes harmonize. Complementary colors can harmonize if used with intermediary colors that link them. Colors with the same levels of intensity and value are the most harmonious (see Figure 12.8).

Variety

Definition of Variety

Variety is the use of dissimilar aspects, or the use of variations of one aspect. In apparel design, introducing variety as a small, unexpected, contrasting detail creates interest and uniqueness. In Figure 12.10, the red gloves and belt add interest to the outfit.

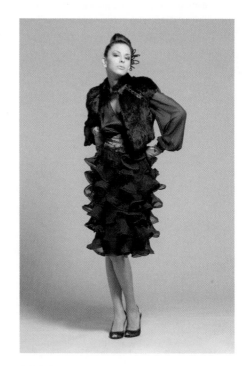

FIGURE 12.10 *The red belt and gloves add variety and interest to this outfit.*
Source: © Latin Stock Collection/Corbis

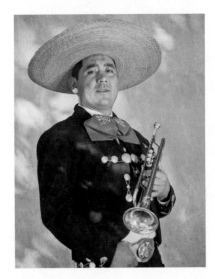
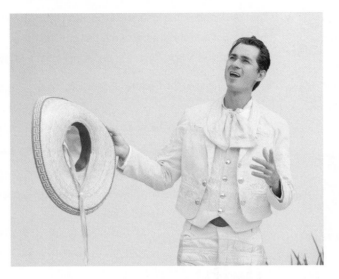

FIGURE 12.11 *The Mariachi outfit on the right is harmonious, but rather monotonous. The one on the left, with the red scarf adding variety, is lively and interesting.*
Source: (left) cristianl/iStockphoto (right) JoseGirarte/iStockphoto

The Effects of Variety

Variety is the complement to harmony and is needed to create visual interest. Without harmony, a clothing ensemble is chaotic and unreadable; without variety, it is dull and uninteresting (Figure 12.11).

Use of Variety in Dress

For good design, there are many ways variety and contrast can be added while still maintaining the mood and theme of a garment, for example, by repeating a shape in a different color, size, or texture, as seen in Figure 12.12. When adding variety, care must be taken not to create confusion and fragmentation.

FIGURE 12.12 *Using a repeat of the circle in different sizes adds variety and interest.*
Source: Buturlimov Paul/Shutterstock.com

FIGURE 12.13 *Variety has been be added to this simple black dress by the use of the contrasting hat and jewelry.*
Source: Marina Kocharovskaya/Shutterstock.com

A designer may use any aspect to create contrast and variety. Varied components must relate to the overall theme of the design. The best way to do this is to alter one of the aspects of the design. Ways to vary aspects include the following:

- Changing the thickness, direction, value, color, or length of one or more style or decorative lines
- Changing the size, color, orientation, texture, or type of a shape
- Changing the hue, value, or intensity of an area of the design
- Changing texture by adding smoother or rougher trim
- Using contrasting jewelry or other accessories (see Figure 12.13)

FIGURE 12.14 *Unity: The outfit is seen as a whole; nothing can be added or taken away without destroying the integrity of the design.*
Source: iofoto/Shutterstock.com

Unity

Definition of Unity

Unity is a feeling of completeness that is achieved through the effective use of the elements and aspects of design. It occurs when a design is seen as a whole, and not as separate elements; when all aspects of the design complement one another rather than compete for attention; and when nothing can be added, taken away, or altered without destroying the integrity of the design (Figure 12.14).

Harmony and unity are not the same. Unity without harmony is impossible, whereas it is possible to have harmony without unity. A design may be beautifully harmonized but may lack the sense of completion that a united design displays.

Unity and the Gestalt Theory

The **Gestalt theory** of perception explains how people tend to organize seemingly disconnected visual elements into a unified whole. The theory was developed by German psychologists in the 1920s. It is also known as the Law of Simplicity because it states that every stimulus is perceived in its simplest form. The theory proposes that visual information is understood holistically (in its entirety) before the separate parts are examined; in other words, the whole is greater than the sum of its parts. An appreciation of unity can be achieved by understanding the Gestalt principles that describe how the mind groups elements by proximity, similarity, continuation, and closure.

FIGURE 12.15 *Proximity.*

- **Proximity:** Objects or shapes that are close to one another appear to form groups, even if the shapes, sizes, colors, or textures of the objects are completely different. Proximity clearly indicates relatedness. Elements that are grouped together create the illusion of shapes, even if the elements are not touching (Figure 12.15).
- **Similarity:** Gestalt theory states that things sharing visual characteristics such as shape, size, color, or texture are seen as belonging together, and a viewer may try to attach a meaning to them as seen in Figure 12.16.
- **Continuity:** When the eye follows a line or the edge of a shape, it will continue in that direction beyond the ending point until it meets up with another element, making a smooth transition between elements (Figure 12.17).

FIGURE 12.16 *Similarity.*

- **Closure:** When a familiar image or pattern is incomplete, the mind will fill in the missing information and recognize the image. In Figure 12.18 a square is seen, although not outlined.

The Effect of Unity

1. When an outfit has unity, the eye sees the whole before the individual aspects.
2. With unity the theme of a design is clearly communicated.
3. Emotionally, unity evokes a sense of completeness and order.
4. Wearing a unified ensemble creates a favorable first impression.

Use of Unity in Dress

Unity is subtle and difficult to define and analyze. It is a personal feeling of completeness. However, within a culture, people tend to agree on whether a design has unity or is disorganized. To create unity, it is necessary to have a clear idea of the message a design will communicate to the viewer. Everything used in the design must complement the message and theme. A unified composition is achieved by the perfect balance between harmony and variety, and the perfect application of all the aspects of design—space, line, color, texture, shape, balance, proportion, emphasis, contrast, and rhythm.

Unity is an equilibrium between harmony and variety. In order to feel comfortable with a visual design, the mind looks for connections between the individual parts. At the same time, it demands variety, excitement, and novelty. The mood of a design is determined by the balance between harmony and variety. A garment in which all the parts are in harmony may appear boring. If, for instance, a small area of a contrasting color is added to a monochromatic garment,

FIGURE 12.18 *Closure.*

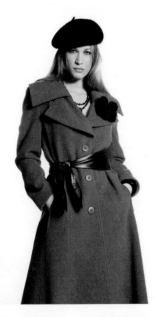

FIGURE 12.19 *A formal outfit with unity. All the parts of this ensemble go together well. The black belt, flower, and necklace add variety and interest.*
Source: coka/Shutterstock.com

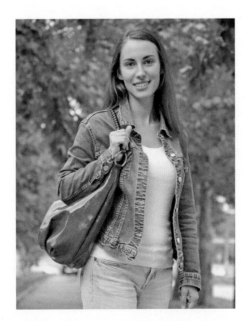

FIGURE 12.20 *A casual outfit that has unity in function and design.*
Source: Mihaela Ninic/Alamy

it will appear more interesting and dynamic; the greater the contrast, the greater the level of excitement. Garments with the least contrast are generally thought of as classics.

Often, it is thought that unity need only apply to formal wear and special occasion clothing such as seen in Figure 12.19. Casual outfits usually have functional unity, such as jeans, a T-shirt, a jacket, and sneakers used for running errands. However, they are often not unified in style and decoration. Figure 12.20 shows a casual outfit that exhibits unity. The wearer looks "put together" and organized.

summary

Unity is a sense of completeness and is the ultimate goal of a designer. It is a balance between harmony and variety. Harmony means agreement or accord—that all the parts of a design relate to and complement each other. To achieve harmony, the functional, structural, and decorative aspects of a garment must be in agreement. The perception and appreciation of harmony is dependent on personal taste and culture. Visually, harmony is achieved by using similar features throughout the design. These features can be functional, such as style lines and seams, or decorative. Repetition emphasizes visual unity for a feeling of agreement and consistency. Garments with harmony look uncomplicated but may feel monotonous. Introducing variety as a small, unexpected, contrasting detail creates interest and uniqueness in a design.

Unity occurs when a design is seen as a whole, and not as separate aspects—when nothing can be added, taken away, or altered without destroying the integrity of the design. Harmony and unity are not the same. The Gestalt theory of perception explains how people tend to organize seemingly disconnected visual elements into a unified whole, and how the mind groups elements by proximity, similarity, continuation, and closure.

For unity, everything used in a design must complement the message and theme. A unified composition is achieved by the perfect balance between harmony and variety, and the perfect application of all the aspects of design. The mood of a design is determined by the balance between harmony and variety.

terminology

closure 143
continuity 142
Gestalt theory 142

harmony 138
proximity 142
similarity 142

unity 138
variety 140

activities

1. Do an Internet search to find images of the following works of art:

 a. *Several Circles*—Wassily Kandinsky
 b. *The Three Sphinxes of Bikini*—Salvador Dali
 c. *Starry, Starry Night*—Vincent Van Gogh
 d. *Water Lilies*—Claude Monet

 Discuss how the artists created harmony, variety, and unity in these works of art. Use the terms *similarity*, *proximity*, *continuity*, and *closure*. Consider shapes, colors, lines, repetition, and placement of shapes.

2. Using magazines, catalogs, or the Internet, find pictures of three different outfits that you consider to have poor harmony. Mount each image on a separate sheet of paper. Write an explanation of why you think the harmony is poor, what aspects of the design conflict, and what you would change to improve the harmony.

3. Find pictures of people wearing a business outfit, an evening dress, and a casual outfit. Mount each image on a separate

sheet of paper or place them in PowerPoint slides. For each, write a description of how functional, structural, and decorative harmony is achieved, or not.

4. Find images of clothing that demonstrate the use of proximity, similarity, closure, and continuity, and explain how these help to create unity.

5. Sketch a full-color design for an outfit that exhibits unity in function, structure, and decoration. First, determine your customer. Then list the following information:

Gender	Height	Occasion or activity for which the outfit will be worn
Age	Size	
Facial coloring	Personality	
Hair color	Occupation	

When the design is complete have another student look at it and complete the same list. Compare your description of your customer to the perception of your fellow student.

Yves St. Laurent Collection
Source: INTERFOTO/History/Alamy

INDIVIDUALISM
and COLLECTION
DEVELOPMENT

After studying this chapter you should be able to:

1. Discuss designing and selecting clothing for individuals including:

 Fashion and social expectations

 Price and quality

 Occasion for which the garment will be worn

 Customer's size, body shape, coloring

 Taste, personality, and individual expression

2. Discuss collections and lines and the differences between them.

3. Evaluate the overall effect of a collection.

4. Discuss the creation of a collection.

5. Discuss the criteria for a successful collection.

13

Introduction

A tailor/dressmaker or student designer often creates one outfit for a special occasion or for a class. A stylist usually needs to select garments for a single person for a particular purpose, whether it is a business suit for work, or a glamorous dress for the Oscars. To some extent, we are all fashion designers. Each morning, we get up, shower, and then select items from our wardrobes to design an ensemble that is comfortable, suitable for our day's activities, and reflects our personality or mood for that day.

On the other hand, a professional fashion designer or senior design student will create a group of garments for each season. Most college fashion programs require students to create a group or collection of garments as a final project for graduation.

FIGURE 13.1 *Japanese Goth style.*
Source: © Image Source/Corbis

Designing and Selecting Clothing for an Individual

There is no "right" or "wrong" in designing or selecting clothing. What is important is that the wearer is happy with the way he/she looks and feels, and with his/her ability to function in the clothing. (Some women are happy in beautiful 4½-inch high-heeled shoes, even if their feet hurt and walking is difficult.)

Every customer will consider her/his own personal preferences when determining what to purchase. Selecting appropriate, flattering clothing can be difficult. Most people will admit to having some mistakes in their wardrobe. Even celebrity stylists make mistakes. Every year newspapers and the Internet have images of the worst-dressed celebrities at entertainment industry award ceremonies.

When selecting clothing or designing for an individual, many factors need to be considered. These include: fashion and social expectations; price and quality; the occasion for which the garment will be worn; the customer's size, body shape, coloring; and the individual's taste, personality, and desire for self expression.

FIGURE 13.2 *Japanese Goth Lolita style.*
Source: Jose Antonio Sánchez Reyes/Dreamstime

Fashion and Social Expectations

In clothing, **fashion** refers to currently popular styles—clothing that is temporarily adopted by members of a social group because it is considered to be socially appropriate for the time and situation. A good designer should be aware of fashion trends within a social context.

What is considered fashionable will vary with time and place. Even within a country, at a particular time, fashion is not the same for everyone. For example, in Japan there are many fashion subcultures (Figures 13.1, 13.2, 13.3, and 13.4).

In the United States, a sixty-year-old teacher in Wisconsin, a wealthy fourteen-year-old girl in Beverley Hills, and a thirty-five-year-old lawyer in New York will not have the same concept of current fashion. In addition, these three customers will have different body types that will be flattered by different styles of clothing. Members of some religious groups may appreciate current mainstream fashions but require that their clothing be more modest. Other religious women (and to some extent men) follow fashion trends in clothing appropriate to their beliefs (Figure 13.5).

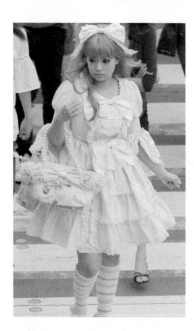

FIGURE 13.3 *Japanese Lolita fashion.*
Source: Photo Japan/Alamy

On a local scale, in any high school, there are several different social groups, each of which has its own style of dress. Clothing for sale varies from very fashion-forward styles that may change as frequently as every three months or less, to traditional classic styles that will be worn for many years. What a customer selects to buy will be based on personal preference and often a desire to conform to the fashion expectations of a particular social group.

Price and Quality

Consideration of the price of a garment is an integral part of the design process. All garments should be well designed, but must also be affordable for the intended customer. The price of a garment depends upon the cost and quality of the materials, the complexity of the design, the cost of construction, retail overhead, and the cost of merchandising, which, for designer label clothing, includes the cost of advertising. Consumers under twenty-five have comparatively low incomes but spend a greater percentage of their income on clothing than older consumers. Teens and tweens tend to like trendy clothing that is thrown out at the end of one season. Because of this, clothing for this group is usually inexpensive and made from poor-quality materials. Classic styles designed for older customers are expected to last for several seasons and so are usually high quality and expensive.

The Occasions for Which a Garment Will Be Worn

The occasions for which a garment will be worn determine the style and color of the garment, the fabric used, and the price. What is considered appropriate work wear varies with places of employment. Generally, low necklines, short skirts, very tight pants, and body-hugging styles are not appropriate for office workers. For casual, everyday wear denim and stretchy knit fabrics are very popular (Figure 13.6). They are durable and comfortable to wear.

When designing athletic wear, great care needs to be taken to ensure that the fabrics used help maintain the athlete's body temperature have sufficient stretchiness and durability, and that the style allows the athlete to function. For evening wear, whether for formal parties or for clubbing, a wide variety of colors, fabrics, and styles may be used. Special occasions such as weddings, funerals, Quinceañeras (Figure 13.7), sweet sixteen parties, christenings, bar and bat mitzvahs, and job interviews may require special clothing.

Designers should study the world around them, the Internet, television, and magazines to observe what is currently being worn for different occasions.

Personal Attributes: Size, Body Shape, and Coloring

The earlier chapters of this book discuss the use of design aspects to create flattering clothing for different types of individuals. The "ideal" body image varies between cultural groups, within ethnic groups, and within any other group to which one belongs. Western societies are obsessed with thinness, fitness, and youth. Female runway models are typically 5'10" and between 100 and 120 lbs. Male models are generally over 6', with a weight between 140 and 165 lbs., with well-toned muscles. According to the Center for Disease Control, for American

FIGURE 13.4 *Japanese rockabilly fashion.*
Source: peeterv/iStockphoto

FIGURE 13.5 *A fashion conscious Muslim woman.*
Source: Distinctive Images/Shutterstock.com

FIGURE 13.6 *Denim and knits are comfortable for everyday wear.*
Source: StockLite/Shutterstock.com

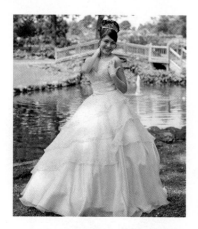

FIGURE 13.7 *Latina wearing a Quinceañera dress to celebrate her fifteenth birthday. In many countries it is a tradition for the girl to wear a dress made of a gauzy, pastel-colored fabric representing innocence and elegance.*

Source: GemaBlanton/iStockphoto

FIGURE 13.8 *The silhouette of a fashion model compared with a more typical American woman.*

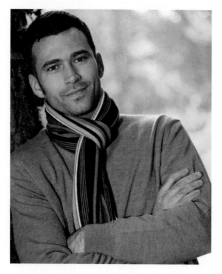

FIGURE 13.9 *"The best color in the whole world, is the one that looks good, on you!" Coco Chanel.*

Source: StockLite/Shutterstock.com

women the average height is 5' 3.8" and the average weight is 164.7 lbs. For men, height is 5' 9.4", and the average weight is 194.7 lbs. Figure 13.8 compares the silhouettes of a fashion model and a typical American woman.

The aim of most Western women is to have culturally acceptable, appropriately fashionable, flattering clothing that makes them look tall and slim. Men want to look tall and muscular. Clothing should reinforce desirable attributes and counter undesired ones. Use of line, proportion, space, and color in clothing can create optical illusions that affect the perception of body size and shape. For the most flattering look, clothing should fit. Clothes that are too tight lead to bulges and lumps. Clothes that are too large make the body look bigger. In Table 13.1 are some suggestions for changing apparent body shape and size. To look shorter or wider, do the reverse of what is suggested in the table. For more details and images, consult previous chapters.

Selecting a color for a garment depends on the individual's personal coloring—hair, skin, and eyes. To review personal coloration, see Chapter 6. There are usually enough color options within a contemporary fashion palette to find flattering colors for each individual. However, to quote Coco Chanel, "The best color in the whole world, is the one that looks good, on you!" (Figure 13.9).

TABLE 13.1

How to Look Taller and Slimmer

To Look Taller	To Look Slimmer or Narrower
One-piece dresses	V or deep U necklines
Straight long vertical lines	Contrasting long scarves, ties, or pendants
Longer skirts	Narrow jacket lapels and ties
Vertical unbroken structural lines	Accent near the face (jewelry, etc.)
Pressed pleats	Gently fitted styles
Straight or slightly flared skirts	Long, slender garments
Vertical collar lines	Long pants gently fitted
Narrow front panels or trim	A-line or pencil skirts
Narrow ties	Empire waist dresses
The same color for upper and lower garments	Avoid upper and lower garments that are the same length
Shoes the same color as panty hose or pants	Longer jacket that hangs just below the hips
Socks the same color as pants	Vertical lines
Avoid upper and lower garments that are the same length	Cool, dark, or dull colors and dull textures
Avoid cuffs on pants	Shoulders that fit (not too big) with soft square shoulder pads

Taste, Personality, and Individual Expression

Clothing is an expression of personality and individual taste and is a form of nonverbal communication (Figure 13.10). It always says something about the wearer, although the message perceived may not be the one intended. A young woman in a black suit and white button-down blouse is implying that she is professional and competent. The message perceived when a student arrives at class in pajamas is that she was partying the night before and is too tired or hungover to find day clothing.

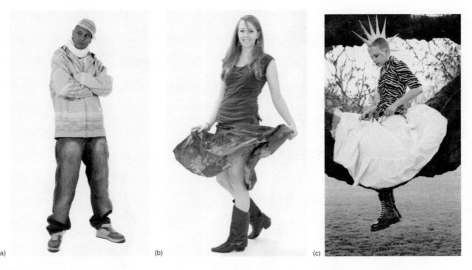

(a) (b) (c)

FIGURE 13.10 *These three young people are using clothing to express their individual tastes and/or their affiliation to a social group.*
Source: (a) Martin Allinger/Shutterstock.com, (b) AZP Worldwide/Shutterstock.com, (c) Judith Erwes/Alamy

Attributes that clothing may reveal include:

- Personality
- Social group membership
- Authority
- Occupation
- Age
- Income
- Rank and privilege
- Social status
- Religious affiliation

Collections and Lines

Definition of Collection and Line

The term **collection** is used for a group of garments that are designed with a common theme for a particular season (Figure 13.11). It is used primarily for couture designs and expensive clothing. Groups of clothing designed for the mass market are generally referred to as **lines**. Lines may be made up of different groupings of clothes.

Haute couture houses (Parisian companies that design made-to-order garments for private clients) are required by their governing body, the **Chambre Syndicale de la Haute Couture**, to present to the press two collections per year. Each collection must have at least fifty outfits designed around a unifying theme. New design houses are allowed to show only twenty-five outfits. There are no rules governing the number of outfits created for a designer's ready-to-wear collection. Some have had as many as 140. These collections may also have more than one theme. Independent designers often create collections of as few as seven to ten complete looks. Design companies that sell to mass-market stores may create several lines

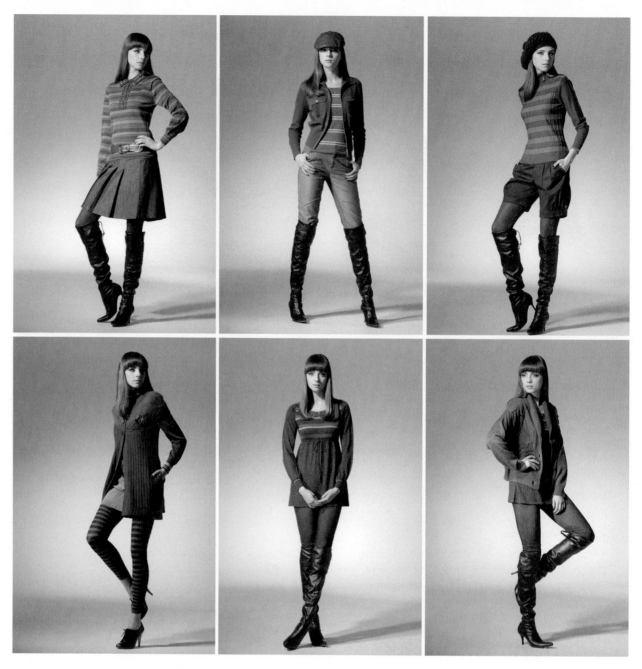

FIGURE 13.11 *A collection of garments with a cohesive theme.*
Source: 101imges/Shutterstock.com

and many groupings per season, each catering to a different market segment. Sometimes a company will have different divisions responsible for different categories of apparel or different markets. Typically a line will cater to only one gender, size range, and price range, and be made up of clothing from one category, such as lingerie, evening wear, or sportswear. A grouping of dresses generally has three or five pieces. Most coordinated sportswear lines have between six and sixteen pieces, which make up three to ten looks based on a single theme.

The Overall Effect of a Collection or Line

The purpose of a collection or line of clothing is to sell apparel, primarily to stores that will sell to retail customers. Couture designs are bought directly from the designer. Some design

companies such as Ralph Lauren, Betsy Johnson, Gucci, and Prada sell their clothing in department stores and boutiques but also have their own retail outlets. Buyers for department stores, boutiques, and mass-market stores prefer to buy pieces from a collection, rather than unrelated individual pieces. A coherent collection with items that relate to each other creates visual impact. Collections with unity are also easy to advertise and to use in window displays (Figure 13.12).

In retail stores, collections sell better than individual pieces. The customer can see how pieces go together and as a result may buy several pieces, thus increasing sales (Figure 13.13).

Most designers and retailers have created distinctive brand images in an attempt to distinguish their products from the mass of similar ones. For example, Ralph Lauren, Versace, Donna Karan, Louis Vuitton, and Burberry each has a distinct and unique identity. Designer brands bear the name of the original designer and represent the designer's philosophy. The collections of Ralph Lauren are inspired "by the dream of America—families in the country,

FIGURE 13.12 *Collections with unity are easy to use in window displays.*
Source: cycreation/Fotolia, cycreation/Fotolia

FIGURE 13.13 *This collection of children's clothing may increase sales as customers see how items go together.*
Source: Pavel Losevsky/Fotolia

weathered trucks and farmhouses; sailing off the coast of Maine; following dirt roads in an old wood-paneled station wagon." The Versace customer is sophisticated, sexy, smart, and dynamic, with Mediterranean glamour. Burberry uses a copyrighted plaid (Figure 13.14) and many Louis Vuitton bags are decorated with the company's initials and distinctive design (Figure 13.15). Each collection of a brand will have the same basic style and aesthetic underlying the trends of the season. Thus, a customer knows what to expect and will develop brand loyalty. If a collection strays too far from the brand core identity, it will not sell.

A collection with pieces that are inconsistent in function, style, color, size range, price, or target market suggests that the designer has no clear idea about fashion trends. Such collections will be ignored by store buyers and even interesting pieces will not be purchased. If two pieces in a collection are too similar, one will draw sales from the other and so the total number of items sold will be reduced.

The Stages in the Creation of a Collection

The steps in creating a collection are similar to those used in the apparel design process described in Chapter 1:

FIGURE 13.14 *Burberry's copyrighted plaid.*
Source: MARKOS DOLOPIKOS/Alamy

FIGURE 13.15 *A bag with the distinctive Louis Vuitton pattern.*
Source: Peter Horree/Alamy

1. Define the problem—in this case the target market, season, and category.
2. Research outside influences—fashion trends.
3. Make a plan—find sources of inspiration.
4. Execute the plan.
5. Evaluate the collection.

Determine the Target Market

A target market is the group of consumers a manufacturer or retailer wants to reach. It is important to know the demographics and psychographics of the prospective customer. **Demographics** are the physical characteristics of a population such as age, gender, marital status, family size, ethnicity, education, geographic location, and occupation. **Psychographics** is the study of personality, values, attitudes, interests, opinions, and lifestyle. To be commercially successful, a collection should be targeted to a specific market area and customer. It is not sensible to try to design a collection for everybody. A collection designed for everyone usually suits no one and does not sell. As the designer Bill Blass put it, "you have to understand people in order to make clothes for them."

Research Trends

Every market has different trends. A designer needs to be aware of what trends affect his/her market. It is possible to predict color and style trends by looking at current styles, reading newspapers, magazines, and *Women's Wear Daily*, and by studying the couture shows, which are now available on television and the Internet. Big design companies subscribe to forecasting services, such as Pantone and The Color Marketing Group, both of which forecast color trends,

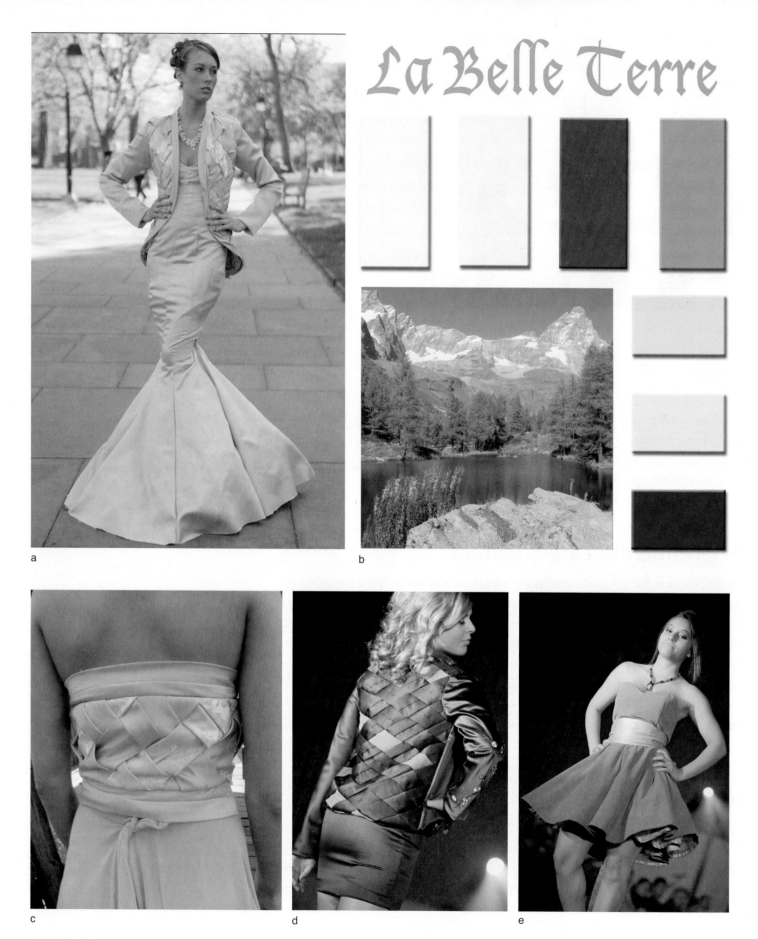

FIGURE 13.16 *Garments inspired by the concept "La Belle Terre."*

Source: a. Christopher String Photography; b. Lazar Mihai-Bogdan Davis/Shutterstock.com; c. Christopher String Photography; d. Jessie Davis/Heart & Sohl; e. Jessie Davis/Heart & Sohl

and Stylesight, Fashion Snoops, WGSN (Worth Global Style Network), Trendzine, and Mudpie Design, which predict style trends. These services are expensive. Some of these companies allow registered students free Internet access to some aspects of their services. Many college and university libraries subscribe to services, such as WGSN and Stylesight, which can be accessed through Internet databases. There are also several other websites that provide some forecasting information.

Inspiration

A collection should be innovative and original with all the garment designs based on the same theme. What inspires a designer's collection is very personal. It may be a beautiful scene, a foreign country, a piece of fabric, a historical time, a poem, a piece of music, almost anything. Figure 13.16 shows part of a collection and its source of inspiration. Sometimes a collection is inspired by a fabric or group of fabrics. See figure 13.17. Many designers create **inspiration boards**. These are collages, which may have **tear sheets** (cuttings from magazines), fabric scraps, trimmings, poem words, or any other inspiration source.

Execute the Plan

Most designers start with a sketch of one outfit and then develop many more designs based on that garment. By sketching a hundred or more ensembles based on one theme, and then selecting a few of those designs, the designer can maintain consistency and cohesiveness.

FIGURE 13.17 *The beginning of a fashion collection; a sketch inspired by fabrics.*

Source: slaven/Shutterstock.com

FIGURE 13.18 *A design team discussing colors for a collection.*

Source: AISPIX/Shutterstock.com

Fabric may be selected before or after the designs are sketched. Care should be taken to ensure that fabrics are compatible in color, pattern, and function (see Figure 13.18). In the fashion industry, merchandisers and sales representatives will assist in the process of editing a collection and deciding which sketches should be developed into garments. Patterns and sample garments are then developed to show to buyers either in showrooms or runway shows (Figure 13.19).

FIGURE 13.19 *A student designer creating a sample.*

Source: Artpose Adam Borkowski/Shutterstock.com

Evaluate the Collection

Evaluation should occur throughout the design process, but particularly after sketches are completed and sample garments are produced. Outfits that do not fit in with a collection or with the intended market should be discarded.

Criteria for a Successful Collection

1. **Trends** Does the collection reflect the contemporary trends? Is it sufficiently different from the other contemporary collections to be exciting and compelling?

2. **Target Market** Is the collection appropriate for the target market? The styles and level of fashion trendiness should be age appropriate—generally clothing for older women is less fashion forward, with slightly longer skirts and less body-conforming styles. The collection in Figure 13.20 would not suit most women over forty-five. Price should be within the financial means of the targeted customers.

3. **Function** Are the collection pieces appropriate for their function? Although an haute couture designer may put both sportswear and evening wear in a collection of fifty designs, it is best for students to stick to one category of clothing in a six to twelve piece collection. Do the pieces allow the customer to move as necessary? Are the properties of the fabrics used appropriate for the garment function? For example, fabric for active wear is often stretchy; delicate fabrics used for evening wear are not suitable for day wear; fabrics for children's clothing should be washable.

4. **Time and Place** Is the collection appropriate for the season and place of sales? Are the fabrics, styles, and colors suitable for the weather conditions? Obviously, long-sleeved

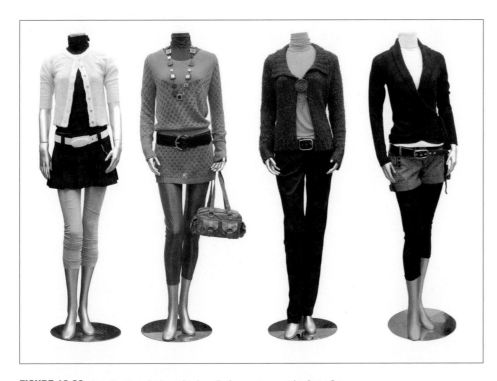

FIGURE 13.20 *A collection designed primarily for women under forty-five.*

Source: Alexander Kalina/Shutterstock.com

wool dresses will be uncomfortable on a hot humid day in Florida. Traditionally light-colored clothing is used in hot sunny places, because it reflects light and keeps the wearer cool. Fashion often dictates dark colors for winter and for autumn—deep, rich colors like ruby red, burgundy, sapphire blue, purple, dark turquoise, and hunter green. Of course, a designer may choose any color for any season, but should consider whether sportswear in colors like buttercup yellow and mint green will sell in the middle of a Minnesota winter.

5. **Unity** Does the collection tell a story? Do the pieces have an underlying theme and a consistent, cohesive look? Do the styles have a consistent visual image? Does the collection have unity and harmony in the styles, silhouettes, fabrics, colors, and decorations used? There are no rules for determining this. Designers must judge for themselves. A collection that uses several different fabrics or colors may be unified by using the same basic silhouette in many pieces. A collection with different silhouettes may be unified by the use of very few colors. Often collections are unified by the use of the same decorative motif on all pieces or, in some cases, variations on a decorative motif.

6. **Variety** Does the collection have enough variety to be interesting and to cater to the needs and tastes of different customers within the target market? If all the designs in a collection are very similar, the collection will be boring and will not attract customers. A collection needs to use several different but coordinating colors in order to appeal to people with different personal coloring. There should also be some variety in silhouette/style to accommodate different body shapes.

7. **Saleability** Was the collection bought by store buyers and retail customers? Did the collection make a profit?

summary

To some extent, we are all fashion designers when each day we select a combination of garments to wear. A dressmaker creates one garment at a time for an individual customer. A professional designer and senior fashion students create a groups of garments for an intended target market. There is no "right" or "wrong" in designing or selecting clothing. What is important is that the customer can function and is happy with his/her appearance.

Factors to consider when designing or selecting clothing for an individual are: fashion and social expectations; price and quality; the occasion for which the garment will be worn; the customer's size, body shape, and coloring; and the individual's taste, personality, and desire for self expression.

A collection is a group of garments that are designed with a common theme for a particular season. The term is used for expensive clothing. A group of less-expensive clothing for the mass market is called a line. The purpose of a collection or line of clothing is to sell apparel, primarily to stores, which will sell it to retail customers. Buyers for department stores, boutiques, and mass-market stores prefer to buy pieces from a collection with a consistent theme, because they sell better than individual pieces, show better in a store, and are easier to advertise.

The stages in creating a collection are: to determine the target market; to research trends; to look for sources of inspiration; to execute the plan (select fabrics, sketch designs, edit designs, develop patterns, and make sample garments); and to evaluate the collection.

A successful collection reflects contemporary trends, is suitable for the target market, has pieces that are appropriate for their function, is appropriate for time and place, has unity and variety and is purchased by customers.

terminology

Chambre Syndicale de la Haute Couture 151
collection 151
demographics 155

fashion 148
haute couture 151
inspiration board 157

line 151
psychographics 155
tear sheets 157

activities

1. Search the Internet for photographs of famous people attending entertainment awards shows. Find pictures of two people who do not look good in their clothing. Explain how the styles could be improved to be more flattering.

2. Sketch a full color design of one of the following:

 a. A prom dress for a petite young woman (under 5' 4")
 b. A business suit for a plus-size twenty-five-year-old woman
 c. A casual outfit for a very thin, nonmuscular twenty-year-old man

 Write an explanation about why your garment is flattering.

3. Search the Internet, magazines, and any available databases to find the color and fashion trends for the season after next. Compile a collection of images that illustrate these trends for a particular market.

4. Create an inspiration board for a possible future collection.

5. On the Internet, find a collection from your favorite designer. Select five outfits. Print copies of these. Explain how the outfits work together to form a consistent collection. Describe who you think is the target market for this collection. Explain why.

glossary

additive color theory—the system of mixing different colors of light to produce other colors. Combining the primary light colors—red, blue, and green—creates the perception of white light

adjacent complementary color scheme—a color scheme with three hues, two complementary hues and the hue next to one of them

advancing space—Draws attention to the area of the body that it covers and increases apparent size.

aesthetic design—See **decorative design**.

after-image—the illusion created if one looks at a colored area for more than a few seconds and then looks at something else. The image is the same shape as the viewed object but the complementary color.

alternation—a pattern in which two different units repeat in turn

ambient lighting—the available light in a space.

analogous color scheme—a color scheme with three of more hues that are next to each other on a 12 hue color wheel

analogous colors—colors that are next to each other on a color wheel

applied design—design that is both aesthetic and functional

asymmetrical balance—balance in which both sides of a central vertical axis are different but the overall effect is that there is equal visual attraction on each side. It is sometimes called **informal balance**.

balance—the sensation of evenly distributed weight

Bezold-Brücke shift—the changes in color perception created by changes in the level of illumination

Chambre Syndicale de la Haute Couture—the organization that sets the rules for haute couture design houses

chroma—the purity of a hue in relation to gray

closure—in the Gestalt theory the idea that when a familiar image or pattern is incomplete, the mind will fill in the missing information and recognize the image

CMYK color system—a color system used in the print industry and by most computer printers. The primary colors are **C**yan, **Y**ellow, **M**agenta, and **B**lack.

collection—in fashion, a group of garments that are designed with a common theme for a particular season—used primarily for expensive clothing.

color-blindness—the inability to distinguish between two or more primary colors (usually red and green)

complementary color scheme—a color scheme with two hues directly opposite each other on the color wheel, one warm and the other cool

complementary colors—colors that when mixed together will become gray (usually opposite colors on a color wheel)

compressibility—resistance to crushing

concentricity—the use of design lines that spread out in all directions from a real or suggested central point

cone cells—cells in the eye that are sensitive to color and fine detail

continuity—an uninterrupted succession or flow; in the Gestalt theory, the idea that the eye will follow a line or the edge of a shape beyond the ending point until it meets up with another element, making a smooth transition between elements

contrast—the sense of distinct difference or opposition

cool color—a color that gives a physiological or emotional feeling of coolness (green, blue, violet)

crimp—wavy

croquis—the stylized figure used as the basis for fashion illustration is 8 to 11 heads tall; a quick sketch of a live model. Now frequently used to mean a body template on which a designer can sketch clothing.

decorative design—purely visual design. It is secondary to functional and structural design. Decorative design does not affect fit or performance, but it may contribute to the overall performance of the garment. Also called **aesthetic design**.

decorative lines—lines created by woven-in or knitted-in designs and decorative trim such as top stitching, lace, and so forth

demographics—the physical characteristics of a population such as age, gender, marital status, family size, ethnicity, education, geographic location, and occupation

density—weight for a unit volume

design—the deliberate creation of a visual experience

design elements—the building blocks of design. They include line, space, form, light, color, and texture.

design principles—the manipulation of design elements to create an effect, such as rhythm, proportion, balance, and so forth

discordant color scheme—a color scheme that is visually disturbing; where the colors seem to clash. The colors are widely separated on the color wheel but not complementary.

double complementary color scheme—a color scheme with four hues, two adjacent hues and their complements

double split complementary color scheme—a color scheme based on four hues, with one hue on each side of complementary hues

drape—the way a fabric falls or hangs

emphasis—the creation of a center of interest or a focal point

extensibility—ease of stretching

fashion—currently popular styles that are temporarily adopted by members of a social group because they are considered to be socially appropriate for the time and situation

fiber—the hair-like substances from which fabrics are made

filament—a long fiber

flat space—See **shape**.

flexibility—ease of bending

fluorescent lamp—a lamp that produces light by exciting the atoms of a gas by the use of electricity

fluorescent light—light, often with a bluish tone, produced by a fluorescent lamp

foot-candle—a unit of measure of the intensity of light

form—three-dimensional space. It has length, width, and volume

formal balance—See **symmetrical balance**.

functional design—allows the clothing to perform in the manner that the wearer expects

gels—the colored filters placed in front of a lamp that colors the light seen

geometric shapes—simple shapes studied in basic geometry. With the exceptions of circles and ovals, they have straight lines and angles.

Gestalt theory—explains how people tend to organize seemingly disconnected visual elements into a unified whole.

golden mean—The proportion of 3:5:8 is considered to be good, also called the **golden section**.

golden section—See **golden mean**.

gradation—the use of a series of gradual/transitional changes in adjacent units

halogen bulb—a bulb that produces light by heating a wire filament until it glows. The halogen inside the bulb makes the light brighter than that from a traditional incandescent bulb.

hand—the way a fabric feels

harmony—agreement or accord; in design, all the parts complement each other to create an aesthetically pleasing whole

haute couture—high-sewing, high-quality garments made to order, and often hand-sewn. In France the term is protected by law and can be used by only the members of the Chambre Syndicale de la Haute Couture.

high-intensity discharge (HID) lamp—a very efficient lamp that produces light by exciting atoms of a gas by the use of an electric discharge

hue—the name of a color

incandescent bulb—a lamp that produces light by heating a wire filament until it glows

informal balance—See **asymmetrical balance**.

inner lines—lines that decorate the fabric or separate the body and garment into smaller parts

inspiration board—a collage of images you put together that represent the colors/styles/themes for a collection

intensity—the brightness or dullness of a hue

irradiation—the perception that light from light areas spills into darker areas and as a result makes light areas appear larger

light-emitting diode (LED)—a lamp that creates light by using electricity to excite atoms in a solid material. It is a very efficient source of light that does not get hot.

line—an extended mark that connects two dots. *Real lines*, or *actual lines*, exist in space

lines—groups of garments designed for the mass market for a particular season

lumen—a unit used to measure the intensity of light

luminosity—the brightness or value of a color on a computer or television screen

luster—the way light reflects from a surface

metal halide bulb—a bulb that produces bright light by passing electricity through a mixture of gases

monochromatic color scheme—a color scheme with one hue in a variety of values (light to dark) or intensities (dull to bright)

Munsell color system—a pigment color theory with five principal hues organized into a sphere to show the relationships between hues, values, and intensities

nanometer—a measure of distance; one nanometer, nm, is 0.000000001 meters or 0.00000004 inches

napping—brushing a fabric to produce a soft finish

neutral—without color—white, grays, and black; they have value but no hue, only varying amounts of white light are reflected from them. In a colloquial sense, the term *neutral* is often used for beige, ivory, and taupe, but these are really hues, as they absorb some specific wavelengths of light

Newton's color wheel—a wheel with the seven colors of the visible spectrum pasted on the surface. When it is spun quickly it appears white.

opacity—the ability to block out light

ordered pattern—a pattern that is systematic and regular

organic shapes—curvilinear shapes that are similar to figures found in nature

outer lines—lines that establish the edge between the environment and the body and garment

parallelism—the use of lines, in the same plane, that are equidistant apart at all points

physiological effects—actually changes in the body, such as changes in blood pressure, respiration, and so forth

pointillism—visual mixing of tiny dots of different colors when viewed from a distance

Prang color system—a pigment color theory based on three primary colors, red, yellow, and blue

Prang color wheel—a disc based on the Prang color system, with segments of the primary colors, red, blue, and yellow, placed equidistance apart

primary color—a hue that within a color theory cannot be created by mixing other hues

prism—a wedge-shaped piece of glass

proportion—the comparative relationship of not only sizes but also distances, amounts, or parts

proximity—nearness; according to the Gestalt theory, objects or shapes that are close to one another appear to form groups, even if the shapes, sizes, colors, or textures are different

psychic line—a line that is psychologically created between two objects

psychographics—the study of personality, values, attitudes, interests, opinions, and lifestyle

Purkinje effect—as light intensity decreases, red objects are perceived to fade faster than blue objects of the same brightness

radial balance—balance in which all parts are integrated around a center. Everything radiates out from a common center point.

radiation—the use of design lines that spread out in all directions from a central point

random pattern—a pattern that has no organization or uniformity

receding space—background and reduces apparent size

repetition—the use of the same thing more than once in different locations

rhythm—the feeling of organized movement

rod cell—a cell in the eye that is sensitive to light, particularly dim light

saturation—the degree of purity of a hue; the ratio of the dominant wavelength to other wavelengths in the color; similar to intensity

scale—a consistent relationship of sizes to each other and to the whole regardless of shapes

secondary color—a hue created by mixing two primary hues

sequence—a serial arrangement in which things follow in a casual or logical order

shade—a hue with black added

shape—two-dimensional space; also called **flat space**. It has length and width

silhouette—the shape of the outline or boundary of an image

similarity—Sameness; the Gestalt theory states that things sharing visual characteristics such as shape, size, color, or texture are seen as belonging together, and a viewer may try to attach a meaning to them.

simultaneous contrast—the apparent brightening of colors that occurs when complementary colors are placed next to each other

single split complementary color scheme—a color scheme with three hues, one hue and the two hues next to its complement

space—the area that the designer has to work with. This space may be filled with color, line, pattern, and texture; or the space may be left unfilled.

spinning—twisting fibers together to make a yarn

staple short fibers—fibers half an inch to about 4 inches long

structural design—the construction of the garment and includes fabric, seams, collars, pockets, and so forth

structural lines—construction lines, edges of garment parts, and folds or creases in the garment

subtractive color theory—the mixing of dyes or pigments to create a range of colors. Mixing more pigments together means more light waves are absorbed or "subtracted" and less are reflected, changing the color of the light reflected.

suggested line—a line that is the result of the eye "connecting the dots"

surface friction—the resistance to slipping offered by the surface

symmetrical balance—balance in which both sides of a central axis are the same. It is sometimes called **formal balance**.

synthetic fibers—fibers such as nylon, polyester, and acrylic, which are manufactured from chemicals

tear sheets—cuttings from magazines used for inspiration and to make inspiration boards

tertiary color—a hue created by mixing a primary hue with a neighboring secondary hue

tetradic color scheme—a color scheme with four hues equidistant from each other on a color wheel

texture—the surface quality of an object

tint—a hue with white added

tone—the value or lightness or darkness of a hue

triadic color scheme—a color scheme with three colors arranged equidistance from each other around the color wheel

unity—the feeling of completeness in which all the design components serve the same functional purpose and work together to complement the key theme

value—the relative lightness or darkness of a color

variety—use of dissimilar elements, or the use of different aspects of one element

visible spectrum—the section of the electromagnetic spectrum that can be seen by the human eye

warm color—a color that gives a physiological or emotional feeling of warmness (red, orange–yellow, and yellow-green)

wavelength—the distance between two corresponding points on any two consecutive waves. For visible light, it is very small. Different colors of light have different wavelengths.

white light—light that is a combination of all of the wavelengths of visible light (colors of the rainbow). Sunlight is white light.

working—functional

yarn—a long continuous length of interlocked fibers

index

A

Accessories, 131
Additive color theory, 48–50, 63
Advancing space, 15–17
Aesthetic design, 7–8
After-image, 67
Age, color and, 73
Alternation, 102–103
Ambient lighting, 46
Analogous, 64
Apparel design. *See also* Design
 balance in, 123–124
 color in, 74–78
 contrast in, 110–112
 emphasis in, 113–114
 form in, 41–42
 harmony in, 138–140
 light in, 55–56
 line use in, 29–31
 proportion in, 133–134
 repetition in, 101–102
 rhythm in, 106
 scale in, 130–131
 shape in, 16–17, 41–42
 space in, 15–19
 texture in, 92–94
 unity in, 143–144
 variety in, 141–142
Applied design, 4
Asymmetrical balance, 118–119

B

Balance
 application in apparel design, 123–124
 defined, 118
 emotional effects of, 122
 physical effects of, 121–122
 types of, 118–121
Body shape, 149–150
 color effects on, 78
Body size, 149–150
 color and, 68
 lines and, 30
 texture and, 90
Broken space, 15

C

Chambre Syndicale de la Haute Couture, 151
Chroma, 62
CMYK color system, 65
Collection(s)
 criteria for successful, 159–160
 defined, 151
 overall effect of, 152–154
 stages in creation of, 154–159
Color
 apparent movement and, 68–69
 apparent size and, 68
 application in apparel design, 74–78
 balance and, 121, 123
 CMYK system, 65
 culture and, 70–72
 defined, 60
 effects on figure, 78
 emotional effects of, 70–72
 hue, 60
 Munsell system, 64
 Newton's color wheel, 47
 perception of, 47–50
 physical effects of, 65–70
 physiological effects of, 65
 Prang system, 63–64
 temperature and moisture, 69–70
 value, 60–62, 69
 warm and cool, 62
Color forecasting, 74, 77
Color gels, 52
Color intensity, 62
Color mixing, 48–50, 67
Color perception, light intensity and, 54
Color schemes, 74–77
Color theory
 additive, 48–50, 63
 subtractive, 50, 63
Color value, balance and, 121
Color-blindness, 48
Coloring, personal, 77, 149–150
Complementary colors, 62
Concentricity, 104
Cone cells, 46, 47
Continuity, 142

Contrast
 application in apparel design, 110–112
 defined, 110
 emotional effects of, 110
 physical effects of, 110
Contrast continuum, 112
Contrasting color schemes, 74
Cool colors, 62, 69–70, 72
Creativity
 defined, 9
 design and, 9–10
Crimped, 86
Croquis, 128
Culture, color and, 70–72

Decorative contrast, 111
Decorative design, 7–8
Decorative lines, 29
Demographics, 155
Density, of fabric, 90
Design. *See also* Apparel design
 as process, 8–9
 as product, 9
 creativity and, 9–10
 decorative, 7–8
 defined, 4
 evaluation of, 10
 functional, 6–7
 structural, 7
Design elements, 4
Design principles, 4–5
Diffuse light, 52
Drape
 defined, 84
 texture and, 93

Embellishments, 89
Emotional effects
 of line contour, 28
 of line direction, 25–26
 of line length, 26–27
 of line texture, 28–29
 of line thickness, 27–28
 of balance, 122
 of color, 70–72
 of contrast, 110
 of emphasis, 113
 of light, 55
 of proportion, 133
 of rhythm, 105–106
 of scale, 129–130
 of shape and form, 40
 of space, 15–16
 of texture, 90–92

Emphasis
 application in apparel design, 113–114
 defined, 110
 emotional effects of, 113
 physical effects of, 113
Enclosing line, 16–17
Evaluation
 of collection, 159
 of design success, 10

Fabric
 density of, 90
 finishes, 89
 knit, 87–88
 structure, 87–88
 woven, 87
Fashion
 defined, 148
 social expectations and, 148–149
 to look slimmer, 150
 to look taller, 150
Fiber, synthetic, 86
Fibers, 85–86
Filaments, 85
Finishes, fabric, 89
Flat space, 14
Fluorescent light, 51, 55
Foot-candles, 52
Form
 application in apparel design, 41–42
 balance and, 123
 defined, 14, 36
 emotional effects of, 40
 human, 39
 physical effects of, 40
 shape relation to, 36
 types of, 38–40
Formal balance, 118
Functional design, 6–7

Gels, color, 52
Gender, color and, 72–73
Geometric shapes, 37
Gestalt theory, 142–143
Golden mean, 132–133
Golden section, 132–133
Gradation, 103

Halogen bulbs, 51
Hand, defined, 84
Harmony
 application in apparel design, 138–140

defined, 138
effects of, 138
Haute couture, 151
Heat
 color and, 69–70
 light and, 55
High-intensity discharge (HID) lamps, 51
Hue, 60
 contrasting, 65–67
Human form, 39

Incandescent bulbs, 51
Individual expression, 150
Individualism, 148–151
 cost and, 149
 occasion and, 149
 personal attributes and, 149–150
Informal balance, 118–119
Inner lines, 29
Inspiration boards, 157
Inspiration, sources of, 157
Intensity, color value and, 69
Irradiation, 68

Jewelry, 131

Knit fabric, 87
LED lamps, 51

Light
 application in apparel design, 55–56
 balance and, 123
 color perception and, 54
 defined, 46–47
 diffuse, 52
 direction of, 53
 emotional effects of, 55
 heat and, 55
 illumination level, 53–54
 perception of, 47–50
 physical effects of, 52–55
 sharp, 52
 sources of, 51–52
 surface texture and, 54
 white, 46
Lightbulbs, types of, 51
Light-emitting diode (LED) lamps, 51
Lighting, ambient, 46
Line contour, 27–28, 31
 application in apparel design, 28
Line direction, 25–26, 31
 application in apparel design, 26

Line length, 26–28, 31
 application in apparel design, 27
Line texture, 28–29, 31
Line thickness, 27–28, 31
 application in apparel design, 27
Line(s)
 as collection, 151
 balance and, 120, 123
 defined, 24
 emotional and physical effects of, 31
 in apparel design, 29–31
 types of, 24–25
 visual effects of, 30
Lumens, 52
Luminosity, 61
Luster, 85

Metal halide lamps, 51
Moisture, color and, 69–70
Mood, color and, 72–73
Movement, color and, 68–69
Munsell color system, 64

Nanometers, 46
Napping, 89
Neutrals, 62
Newton's color wheel, 47
Novelty yarns, 86

Ordered pattern, 38
Organic shapes, 37
Outer lines, 29

Parallelism, 102
Pattern
 ordered, 38
 random, 38
Personal attributes, 149–150
Personal coloring, 77, 149–150
Personal taste, 150
Personality, 150
Physical effects
 of line contour, 28
 of line direction, 25–26
 of line length, 26–27
 of line texture, 28–29
 of line thickness, 27–28
 of balance, 121–122
 of color, 65–70
 of contrast, 110
 of emphasis, 113

Physical effects (continued)
 of light, 52–55
 of proportion, 133
 of rhythm, 105
 of scale, 128–129
 of shape and form, 40
 of space, 15–17
 of texture, 90
Physiological effects
 of color, 65
 of light, 55
Plan execution, 157–158
Pointillism, 67
Prang color system, 63–64
Prang color wheel, 63–64
Price, quality and, 149
Primary color, 48
Prism, 46
Proportion
 application in apparel design, 133–134
 defined, 128
 golden mean, 132–133
 physical and emotional effects of, 133
Proximity, 142
Psychic line, 25
Psychographics, 155

Q

Quality, price and, 149

R

Radial balance, 119–120
Radiation, 104
Random pattern, 38
Receding space, 15–17
Related color schemes, 74
Repetition
 alternation, 102–103
 application in apparel design, 101–102
 concentricity, 104
 defined, 100
 gradation, 103
 parallelism, 102
 radiation, 104
 sequence, 103
Rhythm
 application in apparel design, 106
 defined, 100, 105
 emotional effects of, 105–106
 physical effects of, 105
Rod cells, 47

S

Saturation, 62
Scale
 application in apparel design, 130–131
 defined, 128
 emotional effects of, 129–130
 physical effects of, 128–129
Seasons, color and, 74
Sequence, 103
Shades, 61
Shape(s)
 balance and, 120, 123
 defined, 14, 36
 emotional effects of, 40
 in apparel design, 16–17, 41–42
 physical effects of, 40
 relation to form, 36
 types of, 37
Sharp light, 52
Silhouette
 defined, 24, 38
 in apparel design, 38–39
Similarity, 142
Simultaneous contrast, 65
Size perception, color and, 68
Slimmer, clothing to look, 150
Social expectations, fashion and, 148–149
Sophistication, color and, 73
Space
 application in apparel design, 15–19
 balance and, 120, 123
 defined, 14
 emotional effects of, 15–16
 physical effects of, 15–17
 variations of, 15
Spinning, 85
Staple, 85
Structural contrast, 111
Structural design, 7
Structural lines, 29
Subtractive color theory, 50, 63
Suggested lines, 24–25
Surface texture. See also Texture
 light and, 54
Symmetrical balance, 118
Synthetic fibers, 86

T

Taller, clothing to look, 150
Target market, 155, 159
Tear sheets, 157
Temperature
color and, 69–70
texture and, 90

Texture
 application in apparel design, 92–94
 balance and, 121, 124
 combining, 94
 defined, 84
 drape and, 93
 embellishments, 89
 emotional effects of, 90–92
 fabric structure, 87–88
 fiber and yarn structure, 85–86
 from garment structure, 89
 function and, 92
 light and, 54
 physical effects of, 90
 properties of, 84–85
 temperature and, 90
 trim, 89
Tint, 60
Tone, 61
Trends, 155–157, 159
Trim, 89

U Unbroken space, 15
Unity
application in apparel design, 143–144
 defined, 138, 142
effects of, 143

Gestalt theory and, 142–143
of a collection, 160

V Variety
 application in apparel design, 141–142
 defined, 140–141
 effects of, 141
of a collection, 160
Visible spectrum, 46
Visual effects, of lines, 30

W Warm colors, 62, 72
Wavelength, 46
White light, 46
Working design, 6–7
Woven fabric, 87

Y Yarn
 novelty, 86
 structure of, 85–86